EMANCIPATIO

ON: THE UNFINISHED PROJECT OF LIBERATION

AMON CARTER MUSEUM OF AMERICAN ART Fort Worth

WILLIAMS COLLEGE MUSEUM OF ART Williamstown

UNIVERSITY OF CALIFORNIA PRESS Oakland

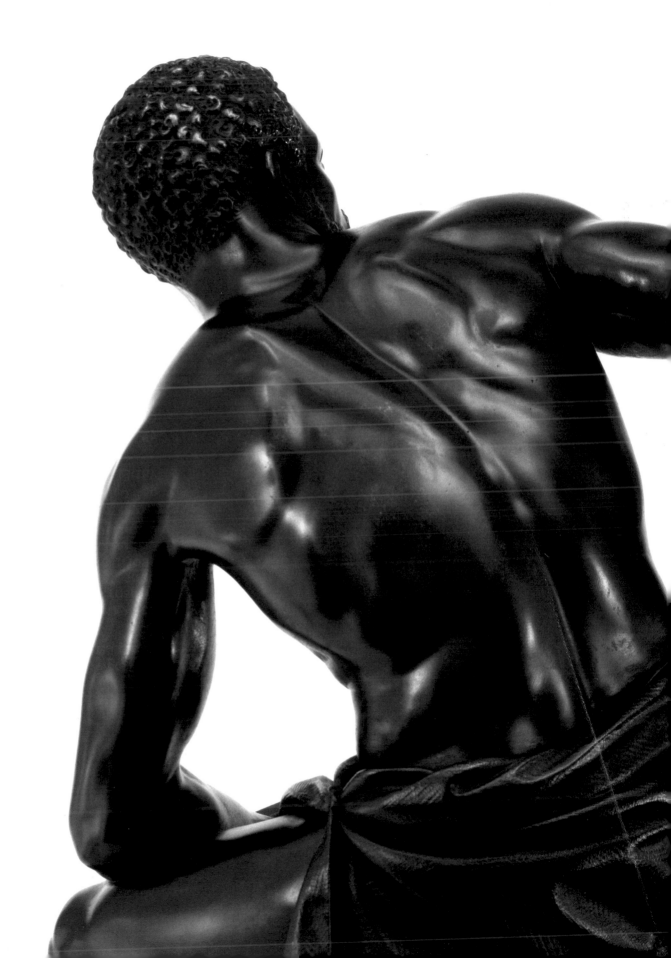

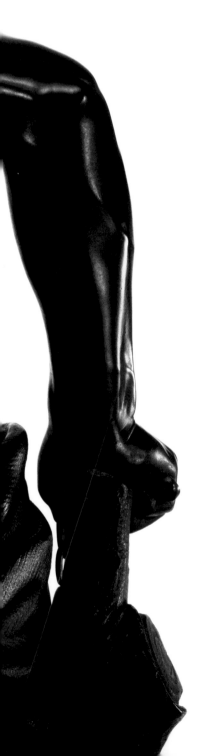

CONTENTS

To the memory of Zelma Watson George

DIRECTORS' ACKNOWLEDGMENTS

The Amon Carter Museum of American Art and the Williams College Museum of Art (WCMA) have the great privilege of enlivening the stories embedded in historical art objects through juxtaposition with the work of artists practicing today. *Emancipation: The Unfinished Project of Liberation* centers responses of living artists to a historical work and moment. The seven artists—Sadie Barnette, Alfred Conteh, Maya Freelon, Hugh Hayden, Letitia Huckaby, Jeffrey Meris, and Sable Elyse Smith—were selected to render visible a range of perspectives about freedom and imprisonment, identity and personhood, and emancipation as it is conceived by Black artists living and working nearly 160 years after the American Civil War. In keeping with the long and painful reach of the history of enslavement in the United States, this project emphasizes issues emanating out of the Civil War and the legacy of enslavement in our country that are yet to be resolved.

Maggie Adler, the Carter's curator of paintings, sculpture, and works on paper, and Maurita N. Poole, director of

the Newcomb Art Museum at Tulane University, have organized a timely exhibition and publication that commemorate the 160th anniversary of the Emancipation Proclamation. Following its presentation at the Carter, *Emancipation* will travel to WCMA and the Newcomb Art Museum.

One of the most important works in the Carter collection, *The Freedman* by John Quincy Adams Ward, was inspired by the Emancipation Proclamation and conceived from an aspirational idea of freedom as the outcome of the Civil War in 1863 was still uncertain. One of the first depictions of a Black person in bronze in the US, rather than show a Black figure in a position of subjugation or submission to White emancipators, as was common in contemporary artworks, *The Freedman* shows a figure in the process of achieving his own emancipation.

It was Ward's hope and vision that the sculpture would represent self-liberation, the strength of the formerly enslaved to be free and the achievement of that hope promised by the proclamation. And yet the presence of the shackles, though broken,

reminds twenty-first-century viewers there is still work to be done.

This fact is palpable in the work of the seven artists engaged for this project, whose works are in progress and will debut at the exhibition opening. Sadie Barnette's multimedia practice is rooted in her family's history of resistance and speaks to the collective issue of repression, particularly as it is embodied in governmental control and regulation of its citizens. Alfred Conteh is known for works that explore the detrimental effects of history, systemic racial oppression, and socioeconomic inequality. Maya Freelon is an installation artist who creates works from tissue paper, a delicate yet deceptively strong material that symbolically encourages questions about where strength lies. Hugh Hayden's fantastical sculptures metaphorically explore sociopolitical issues that make connectivity and relationship difficult and give visual form to the impact of systemic discrimination on African Americans. Letitia Huckaby's works revolve around her interest in the ideas of faith, family, and legacy, and in this regard she actively connects to the ways African Americans have woven the ideas of the Declaration of Independence and biblical precepts of Christianity into their understanding of emancipation and freedom. Jeffrey Meris employs mixed-media works composed of disparate materials to disrupt preconceived notions about identities and to help viewers transcend histories that hold humanity back from taking collective action. And Sable Elyse Smith explores themes of violence, trauma, and control in her work, using her site-specific installations and mixed-media works to illuminate the detrimental effects of violence, even when it is unseen, imperceptible, or unacknowledged. Collectively, these artists illuminate the continued power of Ward's sculpture, the elasticity of interpretations of the concept of emancipation, and the ways critical moments in American history continue to affect contemporary times.

This project would not have been possible without the collaboration of many. We would like to express our gratitude to early thought partner Horace Ballard while he was curator of American art at WCMA. We wish to recognize at WCMA Destinee Filmore, Mellon Curatorial Fellow, and Kevin Murphy, Eugenie Prendergast Curator of American and European Art, along with Joellen Adae, Lisa Dorin, Rebecca Dravis, Luis Granda, Alex Groff, Diane Hart, Brian Repetto, and Noah Smalls. At the Carter we wish to thank Amanda Blake, Selena Capraro, Heather Creamer, Marci Driggers, Will Gillham, Paul Leicht, Andi Severin, Tim Smith, Peggy Spier, Jodie Utter, Steve Watson, and most especially Alfred Walker. Our special thanks as well to artists Sadie Barnette, Alfred Conteh, Maya Freelon, Hugh Hayden, Letitia Huckaby, Jeffrey Meris, and Sable Elyse Smith, and to essayists Kirsten Pai Buick, Kelvin Parnell, and Thayer Tolles. Finally, we thank N. K. Jemisin for permission to reprint her story *Walking Awake*.

For their critical help across all facets of the project we thank Hawley Appleton, Massachusetts Historical Society; Julie Aronson, Cincinnati Art Museum; Andrea Belair, Albany Institute of History and Art; Sarah Cash, National Gallery of Art; Steven Day, American Academy of Arts and Letters; Ryan Dennis, Mississippi Museum of Art; Luisa Dispenzirie, Saint-Gaudens National Historical Park; Henry Duffy, Saint-Gaudens National Historical Park; Anne Evenhaugen, Smithsonian American Art and Portrait Gallery Library; Thomas Eykemans and the team at Lucia|Marquand; Kavi Gupta; Courtney Harris, Museum of Fine Arts, Boston; Eleanor Harvey, Smithsonian American Art Museum; Lauren Haynes, Nasher Art Gallery,

Duke University; Adam Jenkins; Haley Kane, American Academy of Arts and Letters; Rick Kendall, Saint-Gaudens National Historical Park; Steve Kersen, NVision; Molly Kodner, Missouri Historical Society; Brenda Lawson, Massachusetts Historical Society; Karen Lemmey, Smithsonian American Art Museum; Lisson Gallery; Annelise Madsen, Art Institute of Chicago; Anna Marley, Pennsylvania Academy of the Fine Arts; Diamond Mason, Clark Atlanta University; Christina Michelon, Boston Athenaeum; Ariel O'Connor, Smithsonian American Art Museum; Joel Rosenkranz; Amanda Shields, National Academy of Design; Jessica Silverman; Ann Sindelar, Cleveland History Center of the Western Reserve Historical Society; John Szlasa, American Academy of Arts and Letters; Diana Thompson, National Academy of Design; Hoang Tran, Pennsylvania Academy of the Fine Arts; Kathryn Wade; and Benjamin Ward.

Emancipation calls to mind the much-cited aphorism attributed to Spanish philosopher George Santayana: "Those who cannot remember the past are condemned to repeat it." It is our duty and privilege as museum directors to encourage a closer examination of history and the present toward building pathways to a brighter future for all.

Pamela Franks, Director
 Williams College Museum of Art

Andrew J. Walker, Executive Director
 Amon Carter Museum of American Art

"I CONTAIN MULTITUDES":

THE VARIED LIVES OF A CAST OF J. Q. A. WARD'S *THE FREEDMAN*

MARGARET C. ADLER

When we speak about art, we often move beyond the objecthood of a work into anthropomorphic embodiment.[1] We talk about the lives a sculpture has lived—life casts, posthumous casts, the life and career of the sculptor. That word "life" has come to encompass a host of meanings—how long a sculpture will last outdoors, for instance. Will it live out a natural life, or will it be toppled in feats of iconoclasm?[2]

What about the lives of an individual cast of John Quincy Adams Ward's *The Freedman* (fig. 1.1)? If this sculpture could speak, would it call upon the words of its contemporary Walt Whitman?

> *Do I contradict myself?*
> *Very well then I contradict myself,*
> *(I am large, I contain multitudes.)*[3]

Ward's sculpture in its multiple cast forms was an innovation. In its early life, when it was first conceived, the ink was barely dry on Lincoln's Emancipation Proclamation—the sculpture forming a bold statement of the aspirational outcome of a Civil War not yet concluded. Scholars believe *The Freedman* to be one of the first American depictions of a Black figure cast in bronze.[4] To my mind, it is a singularly evocative representation in American sculpture of a Black person liberating himself from enslavement by sheer force of will, breaking the chains that bind him and rising from a position of subjugation.[5] In Ward's words, "I intended it to express not one set free by any proclamation so much as by his own love of freedom and a conscious *power* to brake [*sic*] things. The struggle is not over with him (as it never is in this life), yet I have tried to express a degree of hope in his undertaking."[6]

Compare the work to Thomas Ball's *Freedmen's Memorial* (fig. 1.2) with Lincoln as towering liberator over a cowed Black figure, or with any number of representations based on Josiah Wedgwood's abolitionist medallions that helped inspire Ward (fig. 1.3), and it is clear that *The Freedman* is something truly apart in its revolutionary conception.

The Carter's particular cast of Ward's *The Freedman* is singular. Research indicates it is the only one with an operable shackle (fig. 1.4); the only one that has a brass key suited for a grandfather clock that releases the figure by springing his bonds; and the only one with a minute inscription carved into the openable manacle dedicating it to the Fifty-Fourth Massachusetts Volunteers, the first all-Black Union regiment (fig. 1.5).[7]

Unlocking or challenging the predicated assumptions that accumulate over the lifetime of an individual artwork, such as one cast of *The Freedman*, is the curator's task, as well as that of the artists and staff members and anyone else who encounters the piece. The context of sympathy, aspiration, strength, and innovation is the way the cast has lived its interpreted life as an object in the Carter's collection. Even so, the process of engagement and encounter with an entity that has lived many lives before us and will live long after us is complex.[8]

Questions we might ask ourselves: Is the sculpture as self-liberatory as Ward intended if a White railroad magnate of the Gilded Age holds the only key? Is it self-congratulatory or a reminder to continue to work harder if possessed by White abolitionists? If the shackles remain fixed in tempered metal forever, might we consider that enslavement is a ubiquitous, lasting evil humankind will never cease to perpetuate? In these contexts of ownership of a sculpture, the message seems akin to that expressed by cultural historian Saidiya Hartman in a discussion of the lives of Black women at the turn of the century:

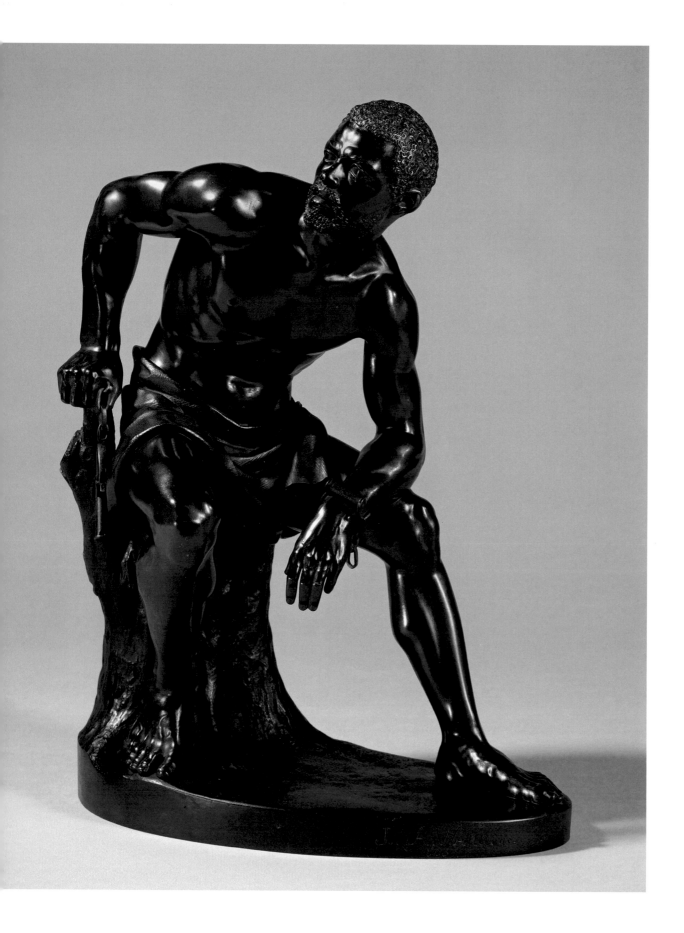

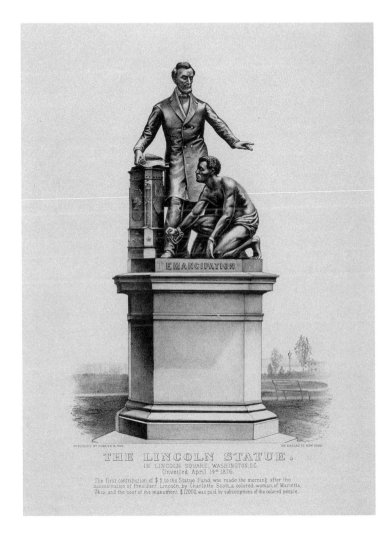

1.2 After Thomas Ball (1819–1911), Currier & Ives, *The Lincoln Statue in Lincoln Square, Washington, D.C.*, 1876, lithograph, 17¾ × 13½ in., Amon Carter Museum of American Art, Fort Worth, Texas, 2019.3

1.3 Anti-slavery medallion, 1786–87, stoneware (jasperware), gold, Museum of Fine Arts, Boston, Bequest of Mrs. Richard Baker, 96.779, Photograph © 2023 Museum of Fine Arts, Boston

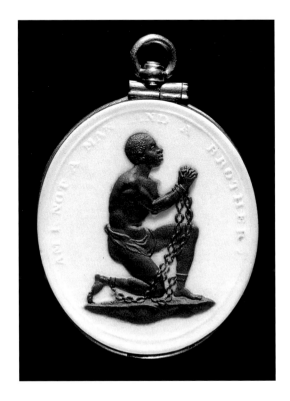

1.1 John Quincy Adams Ward (1830–1910), *The Freedman*, 1863, bronze, 19¾ × 14¼ × 10½ in., Amon Carter Museum of American Art, Fort Worth, Texas, 2000.15

1.4 John Quincy Adams Ward
(1830–1910), *The Freedman* (detail),
1863, bronze, 19¾ × 14¼ × 10½ in.,
Amon Carter Museum of American
Art, Fort Worth, Texas, 2000.15

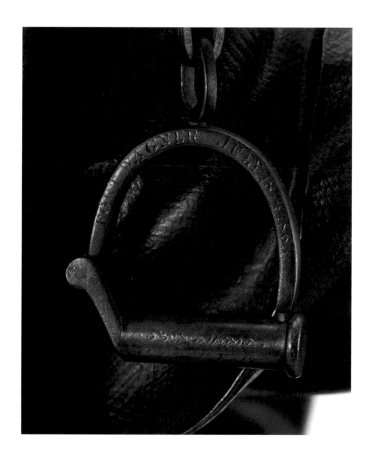

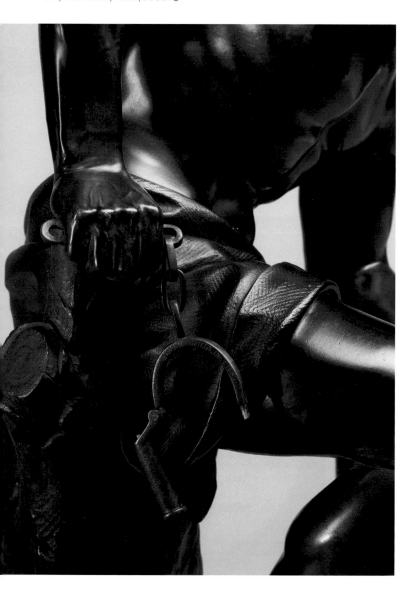

1.5 John Quincy Adams Ward
(1830–1910), *The Freedman* (detail),
1863, bronze, 19¾ × 14¼ × 10½ in.,
Amon Carter Museum of American
Art, Fort Worth, Texas, 2000.15

Inscribed (across arch of shackle):
FORT WAGNER JULY 18TH 1863;
(across barrel of shackle): 54th
Mass. / Colored Vols

Each new deprivation raises doubts about when freedom is going to come, if the question pounding inside her head—*Can I live?*—is one to which she could ever give a certain answer, or only repeat in anticipation of something better than this, bear the pain of it and the hope of it, the beauty and the promise.[9]

Certainly, the sculpture has a different life and resonance for me as a suburban, East Coast White woman than it has for Alfred Walker, the former head of facilities for more than forty years at the Amon Carter Museum of American Art. When asked to contribute his own label for *The Freedman*, this is what he submitted:

> I first saw *The Freedman* while walking through the galleries at the Carter. I was instantly captivated. My eyes could not get past the shackles on his wrists. Why can't they be removed? My belief is that it's because the shackles are so well hidden in a system that benefits White people who sometimes turn the other way because they are unaffected. I grew up in Stop Six, an all-Black neighborhood on Fort Worth's East Side, so I didn't encounter racial issues until I started working.
>
> When I was a young twenty-year-old housekeeper at the Museum, a White coworker said the N-word while telling me a story. He immediately saw the expression on my face and apologized. We never talked about what was said, but from that day on until his death, he treated me with dignity and respect. So, I know that people can change. I loved this man like a father, and he is the reason I was still working at the Museum forty-one years later. America, I am not asking for you to go back 400 years to make those years right. I am asking that going forward you treat every human being equally.[10]

What if, instead of the aforementioned railroad magnate, our cast had belonged to Dr. Zelma Watson George, a Texas-born diplomat, social-program and university administrator, musicologist, and opera singer whose childhood home frequently hosted Black luminaries such as W. E. B. Du Bois and Booker T. Washington (fig. 1.6)?[11] What if we discovered that she kept the sculpture on her piano, where she played and sang some of the 12,000 musical compositions written by African-American artists that were the subject of her doctoral dissertation, performing her music for houseguests like Malcolm X and her frequent visitor Martin Luther King Jr. (fig. 1.7)? Perhaps the social and political dignitaries and everyday citizens she met through her service in the Eisenhower administration, her role as a United Nations delegate, her advocacy for the Cleveland Job Corps Center, her leadership of the League of Women Voters and the NAACP looked on while our cast of *The Freedman* looked back at them? What does it mean that our sculpture found a home surrounded by African art; Gullah baskets; Christmas cards, prints, and letters from the leading Black artists of a half a century who called themselves friends of Zelma; a collection of rare volumes of slave narratives; photographs of the hands of Black luminaries; and signed copies of the poems of Langston Hughes? I wish our sculpture could speak—literally rather than only symbolically.

Quite simply, the rationale for this exhibition is that one sculpture contains multitudes. Something particular is embodied by Ward's *The Freedman* that gives it its numinism, that conjures uncertainty, that mourns hardship, that celebrates potential, that signals perpetual systems of subjugation.

While scholars can certainly help elucidate this phenomenon of multiple valences,

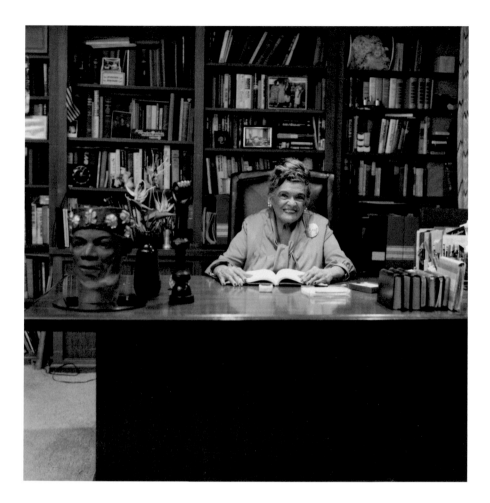

1.6 Zelma Watson George in an undated photograph, MS 5415 Dr. Zelma Watson George Papers and Photographs, Western Reserve Historical Society, Cleveland, Ohio [Container 44, Folder 17]

1.7 Zelma Watson George with Dr. Martin Luther King Jr. in an undated photograph, MS 5415 Dr. Zelma Watson George Papers and Photographs, Western Reserve Historical Society, Cleveland, Ohio [Container 44, Folder 3]

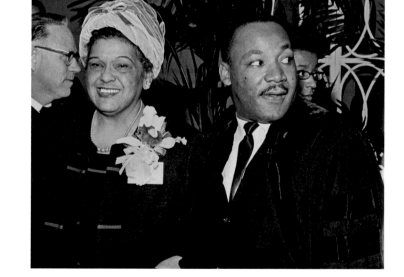

as a curator, I hold the firm belief that a work's best afterlife in an exhibition often comes from putting it in the hands of artists to unlock additional resonance—in this case, artists attuned to Black embodiment and the lasting legacies of enslavement and systems of oppression. To this end, we worked together as a group of twenty-first-century artists and twenty-first-century scholars to take the investigation and instigation this sculpture evokes and demands to create an exhibition and this book. Each contributor was invited to explore *The Freedman* through the lenses of their own lives and professions, and to consider the multiplicity of meanings those contexts create for the investigation of emancipation in literature, art, and human existence—in short, to lend a hand in addressing "the unfinished project of liberation."

Margaret (Maggie) C. Adler is curator of paintings, sculpture, and works on paper at the Amon Carter Museum of American Art.

NOTES

1 Arjun Appadurai, ed., *The Social Life of Things: Commodities in Cultural Perspective* (Cambridge, MA: Cambridge University Press, 1986).

2 For instance, see Sarah Beetham, "Confederate Monuments and the Inevitable Forces of Change," *Panorama: Journal of the Association of Historians of American Art* 4, 1 (Spring 2018); and "From Spray Cans to Minivans: Contesting the Legacy of Confederate Soldier Monuments in the Era of 'Black Lives Matter,'" *Public Art Dialogue* 6, 1 (2016): 9–33.

3 Walt Whitman, *Leaves of Grass* (United Kingdom: Wilson & McCormick, 1884), 78.

4 Kirk Savage, "Molding Emancipation: John Quincy Adams Ward's *The Freedman* and the Meaning of the Civil War," *Art Institute of Chicago Museum Studies* 27, 1 (2001): 27.

5 For more about Ward's innovation, see Kirk Savage, *Standing Soldiers, Kneeling Slaves: Race, War, and Monument in Nineteenth-Century America* (Princeton: Princeton University Press, 1999), 52–88.

6 Ward to J. R. Lambdin, April 2, 1863, in Savage, *Standing Soldiers*, 56.

7 See Thayer Tolles's essay in this volume for a list of casts and variations.

8 Georges Didi-Huberman, *Confronting Images: Questioning the Ends of a Certain History of Art* (University Park: Penn State University Press, 2009).

9 Saidiya Hartman, *Wayward Lives, Beautiful Experiments: Intimate Histories of Riotous Black Girls, Troublesome Women, and Queer Radicals* (London: Serpent's Tail, 2021), 10.

10 Reprinted with permission from Alfred Walker.

11 Zelma Watson George's papers reside at Western Reserve Historical Society in Cleveland, Ohio. Ann Sindelar, reference supervisor, was an invaluable help to my research. Though we reviewed all of Dr. Watson George's papers, we could not discern how Dr. George came upon owning the sculpture—through purchase or inheritance—the history remains unclear.

THE FREEDMAN AS AN EMERGENT BEING AND EMBLEM OF BLACK YEARNING

MAURITA N. POOLE

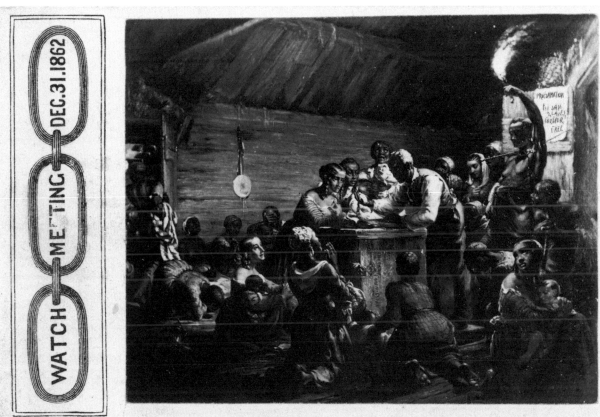
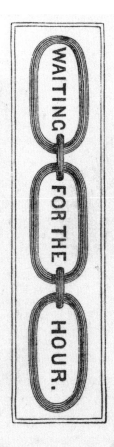

Ent'd according to Act of Congress, A. D. 1863, by W. T. Carlton, in the Clerk's Office of
the District Court of the District of Mass.

1.8 Heard & Moseley, *Watch Meeting, Dec. 31. 1862—Waiting for the Hour*, 1863, albumen and silver nitrate on carte-de-visite mount, 4¼ × 2½ in., Collection of the Smithsonian National Museum of African American History and Culture, 2010.77.7

In 2021, President Joseph Biden made Juneteenth a federal holiday with the tireless advocacy of Fort Worth dignitary Opal Lee. Alternatively called Emancipation Day, Freedom Day, and Jubilee Day, the occasion annually commemorates the moment when enslaved African Americans in Texas learned that they had been freed. Although Abraham Lincoln issued the Emancipation Proclamation in 1863, it would take the 13th Amendment and federal enforcements to completely bring slavery to its end (fig. 1.8).

A time for African-American communities to gather, Juneteenth celebrations often include sports, pageants, readings of the Emancipation Proclamation, political discussions, and singing traditional songs such as "Lift Every Voice and Sing," the hymn promoted beginning in 1917 by the National Association for the Advancement of Colored People as the Negro National Anthem (fig. 1.9). The development of the festivities and patriotic songs specific to Black experiences in the United States reveal how tenuous and complicated African Americans' relationship is to their nation-state. It also is an indication of how essential oppositional ways of thinking in tandem with the active pursuit of freedom and full citizenship continues to be for African-American survival. This duality that structures how Black people engage with American society and exist in

the world is captured in John Quincy Adams Ward's statuette *The Freedman*, which is the inspiration for *Emancipation: The Unfinished Project of Liberation*.

Despite Ward's inability to have the statuette enlarged into a monumental public sculpture or for *The Freedman* to become a broadly recognized work related to emancipation and Civil War history, the work remains critical to reflection on the visualization of the concept of freedom in both its narrowest and broadest senses. Though Ward named his sculpture *The Freedman*, in reality he depicted a fugitive. The starting point for engaging the work is thus a cogent commentary about the institution of slavery and emancipation, defined as freedom from the legal, social, and political restrictions imposed upon people during enslavement.

What is especially striking about the work is the figure's pose, which conveys the sense that he is in a state of contemplation, and which resonates with contemporary African-American yearnings for self-fashioning and re-envisioning Black subjectivities not restricted by social conventions and traditional ideas (fig. 1.10). While the sociopolitical context of the nineteenth and twenty-first centuries is markedly different, the contours that form inquiries about how Black people can be liberated despite structures of domination are rendered visible in *The Freedman*—a work that has the potential to become one

1.9 Grace Murray Stephenson (dates unknown), *[Emancipation Day Celebration Band, June 19, 1900]*, 1900, Austin History Center, Austin Public Library, PICA-05481

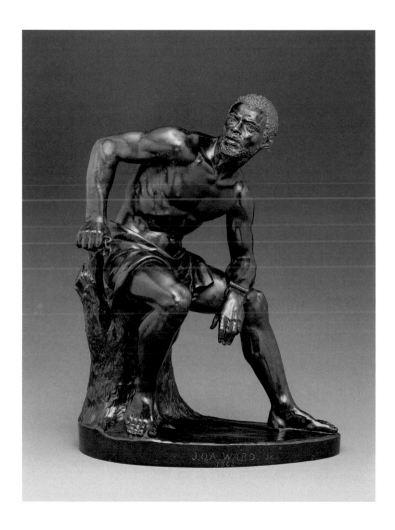

1.10 John Quincy Adams Ward (1830–1910), *The Freedman*, 1863, cast 1891, bronze, 19½ × 14¾ × 9¾ in., The Metropolitan Museum of Art, Gift of Charles Anthony Lamb and Barea Lamb Seeley, in memory of their grandfather, Charles Rollinson Lamb, 1979, 1979.394

of the most important emblems of American liberty. Ward presented us with a figure who seems to be grappling with the idea that freedom will demand a new way of being. This constantly evolving, emergent being requires society to relate to him, and so to all Black people, as "subjects" rather than "objects."

For this exhibition, seven artists were selected to respond to Ward's historical work and provide insight into how "freedom" and "liberation" are conceived from the viewpoint of a Black artist practicing in the twenty-first century. Collectively, these artists illuminate the continued power of Ward's sculpture, the elasticity of interpretations of the concept of emancipation, and the ways this critical moment in American history continues to carry impact in contemporary times.

While the promotion of Black liberation and radical imagination has shifted over time and transformed perspectives about freedom, we still are evolving. The "unfinished project of liberation" is deeply interconnected with what bell hooks identified as the cultivation of a "critical consciousness, as one invents new, alternative habits of being, and resists from the marginal space of difference inwardly defined."[1] Ward's historic work, and the commissioned works that augment it, ideally give us a sense of this as we reinterpret emancipation and envision new ways of being.

Maurita N. Poole is director of the Newcomb Art Museum of Tulane University.

NOTE

1 bell hooks, *Yearning: Race, Gender, and Cultural Politics* (Boston: South End Press, 1990), 15.

WHAT TO AMERICA IS
THE FREEDMAN?

KELVIN PARNELL

When we look at a work of art, especially when "we" look at one in which Black Folk appear—or do not appear when they should,— we should ask: What does it mean? What does it suggest? What impression is it likely to make on those who view it? What will be the effect on present-day problems, of its obvious and also of its insidious teachings?[1]

— FREEMAN H. M. MURRAY

On July 5, 1852, in Rochester, New York's Corinthian Hall, America's greatest orator, Frederick Douglass, delivered to the Rochester Ladies' Anti-Slavery Society a speech commemorating the most celebratory of days in the United States' short history— its Independence Day. Douglass's oration— empathetic yet admonishing, careful while radical—was an attempt to illuminate America's hypocrisy to his audience. Just as the crowd grew comfortable from the praise and adoration Douglass bestowed on America, its founders, and its founding principles, the self-emancipated statesman levied a question to his audience: "What, to the American slave, is your Fourth of July?"[2] The remainder of his speech denounces the United States and its heralded annual celebration of freedom, but in doing so it offers a productive, powerful polemic on the nature of freedom itself. How could a country whose founding principles espouse freedom remain faithful to those principles while millions within its borders are held in perpetual, abject servitude by the condition of their birth, skin color, and regional location?

The power of Douglass's speech lay in his ability to speak not just for his time but for all times. His words reverberate through the annals of history as he challenges us to reevaluate this nation's relationship to freedom and ask: What does it mean to be free, and what does that look like if so many

among us are not yet free? Let us remember what the eighteenth-century firebrand abolitionist preacher, David Walker, told the enslaved of his era: "Freedom is your natural right," as it is all of ours.[3] Yet, while that is a self-evident truth, our history demonstrates that freedom is not, nor has it ever been, a universal or all-encompassing ideology. It is a mediated and conditional status most often wielded by those in power. Through centuries of struggle and sacrifice, freedom has been distributed onto the public like a scarce commodity with no certainty as to how long it will last. In America, perhaps more than any other nation, one must be attuned, as historian Tyler Stovall suggests, to the *racial* dimension and characteristics of freedom as well as the insidious elements that contribute to defining its characteristics.[4]

Ten years after Douglass delivered his speech to that Rochester crowd, one can observe a clear example of the racial dimensions of freedom and how a tool of liberation can have insidious implications. On September 22, 1862, President Abraham Lincoln issued a preliminary Emancipation Proclamation in the midst of the American Civil War. This edict instructed that if Southern states continued to engage in open rebellion against the United States, if they did not cease hostilities and rejoin the Union:

That on the first day of January, in the year of our Lord one thousand eight hundred and sixty-three, all persons held as slaves within any State or designated part of a State, the people whereof shall then be in rebellion against the United States, shall be then, thenceforward, and forever free; and the Executive Government of the United States . . . will recognize and maintain the freedom of such persons, and will do no act or acts to repress such persons, or any of them, in any efforts they may make for their actual freedom.[5]

Despite Lincoln's warning, no Southern states put down their arms, so, on January 1, 1863, he made good on his promise (fig. 2.1). At the behest of one man and his pen, millions were set free. Because of Lincoln's proclamation, the priorities of the war shifted from one hell-bent on securing the unity of the Union to a morally righteous war of liberation wherein the former depended on the assurance of the latter. Many in his party as well as abolitionists across the political spectrum applauded his efforts. But leading up to the proclamation, Lincoln had exercised extreme caution and questioned whether he had the power to issue the order. More importantly, he concerned himself with whether the country was ready for such a proclamation. Of course, it can be said with certainty that the millions held in captivity as chattel property were prepared for the proclamation—for freedom. But they were not wholly where Lincoln's concerns rested; he worried if the White population, particularly those in Northern and border states, would accept a proclamation that freed millions whom many White citizens believed to be inferior in comparison to themselves. It would take more than a proclamation to prepare Americans for the new reality the president ushered in.

Three months after Lincoln issued the proclamation, an up-and-coming sculptor from Urbana, Ohio, John Quincy Adams Ward, began working on a statuette that attempted to lay bare the intersections of race, emancipation, and freedom in America. In April 1863, at the annual exhibition for the National Academy of Design in New York City, Ward exhibited for the first time a plaster model for his statuette entitled *Freedman* (fig. 2.2). This model was his attempt to give material form to the promise of the Emancipation Proclamation: Tucked away in a dimly lit corner of the gallery, sitting atop a pedestal, a Black figure looks outward as he sits on a tree stump. Save for a small wrap that covers his midsection, he is nude—his body laid bare for all to observe. We find him in either a moment of respite or in the midst of departure as the work embodies a sense of kinetic energy expressed through his musculature.

The sculpture elicits a number of questions: Where is he from, the rice plantations of Georgia; the tobacco fields of Virginia; the indigo plantations of South Carolina; the cotton fields of Alabama? Where is he going? The safety of a nearby Union encampment, or further beyond the Mason-Dixon line? Most importantly, who is he? Despite these and other questions, what we do know, and what is most important to know, is that he has been set free, or is at least in a state of being freed.

In his anonymity, there exists universality. He is not one but many, as Ward attempted to place on full display the racialized, complicated, and contentious idea of freedom in America. The figure clasps in his right hand the broken remains of his shackles, and yet a manacle remains secured around his left wrist, holding his freedom and thus his humanity in limbo. Even so, there is hope imbued within the work.

2.1 Abraham Lincoln (1809–1865), *Emancipation Proclamation*, January 1, 1863 (National Archives Identifier: 299998); Presidential Proclamations, 1791–2016; Record Group 11; General Records of the United States Government, 1778–2016; National Archives Building, Washington, DC

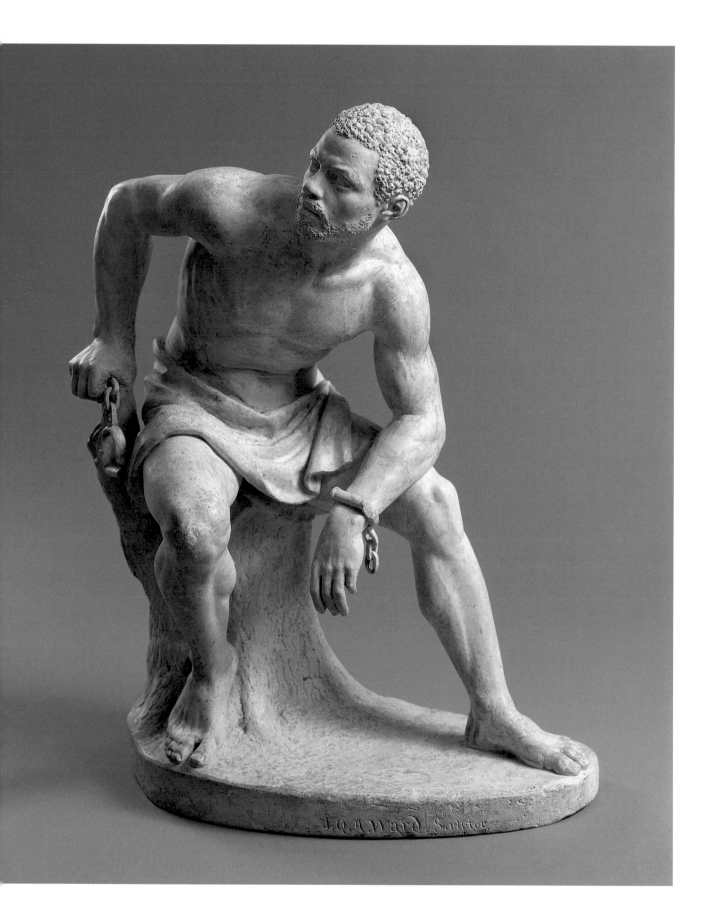

Writing to his friend James Reid Lambdin, Ward expressed his motivations behind creating *The Freedman*: "I intended it to express not one set free by any proclamation so much as by his own hour of freedom and a conscious power . . . the struggle is not over with him as it never is in this life!, yet I have tried to express a degree of hope in this undertaking."[6] Within this work's small twenty-inch frame exists a cacophony of large, complex ideas, some intended by the artist and some not.

In the stringent medium of sculpture, this example opens up a realm of possibilities for envisioning and interpreting the Black subject in three dimensions. While Ward titled his statuette *The Freedman*, he admittedly did so "for want of a better name."[7] Over the past 160 years, the work has garnered different names, many within the months after its unveiling and in the early years of its display. So throughout this essay I will refer to *The Freedman* by a few of these names to demonstrate its mixed reception over time and to question the state of his freedom and the limitations placed upon that freedom by the politics of the era, contemporary audiences, and the artistic medium of sculpture.

CONTRABAND

On June 24, 1863, two months after Ward displayed *The Freedman* for the first time at the National Academy of Design, the *New York Times* reported on the event and bestowed a peculiar yet particular name upon the statuette: "The 'Contraband' is, however, an encouraging effort, especially as it has elicited very hearty appreciation."[8] In a matter of weeks, Ward's sculpture went from a freedman to contraband—a common good or commodity whose possession or exchange is forbidden and illegal. The term

became popularized in the American lexicon with the passage of the 1861 and 1862 Confiscation Acts, both of which were Congress's attempts to free enslaved Africans as a military measure. President Lincoln later used these two pieces of legislation as the legal basis for his Emancipation Proclamation, authorizing him to seize rebel property in the form of their enslaved laborers and to free those individuals as "captives of war."[9] The Confiscation Acts and the Emancipation Proclamation thread a relatively narrow legal needle.

On one hand, both acts maintained enslaved Blacks' status as chattel property—legally allowed to be seized as Southern secessionists renounced their citizenship and thus their property rights. On the other hand, the acts recognized Blacks' humanity, paving the way for them to engage in self-determined labor and later serve in the Union Army.[10] Thus, the given name of "Contraband" by the *Times* demonstrates the complexities and paradoxical nature of Ward's sculpture. It speaks to the duality of both the object and the millions of individuals freed by the proclamation.

The balance between property and humanity lay at the heart of the Confiscation Acts and the Emancipation Proclamation. In Ward's *Freedman*, that paradox is made material. *Contraband* is both object and person; the sculpture is a piece of property to be admired, purchased, and circulated. The subject represents a vast swath of the American populace deserving of having their humanity recognized, and while it is imperative for viewers and interpreters of this work not to disregard the work's personhood, one cannot discount the work's objecthood as the two are one.

In the fall of 1864, at Goupil's gallery in New York City, Ward unveiled a bronze version of the sculpture, forever changing

2.2 John Quincy Adams Ward (1830–1910), *Freedman*, 1863, plaster, tinted yellow ochre, 20¼ × 15 × 7 in., Courtesy of the Pennsylvania Academy of the Fine Arts, Philadelphia. Gift of the artist, 1866.2

its interpretation (see fig. 1.1). The inherent properties of bronze should not be diminished when interpreting this work's reception in its contemporary moment, or when understanding in our current time for that matter. Reporting on the gallery opening, the *Times* wrote:

> We welcome with great interest the appearance of Ward's statuette of the "Freedman" in bronze. . . . For more than a year we have patiently awaited its reproduction in some permanent material; and if so much time was necessary to produce it in its present form, we do not regret it, for certainly it is a triumph mechanically as well as artistically—the casting and chasing being as fine as could have been done even in Europe. To those who have had an opportunity of seeing the model, the perfect fitness of the material to the subject will be apparent—the very color seeming to add to its sentiment and reality.[11]

Ward's shift from ephemeral plaster to the permanence of bronze was significant both then and now, having resulted in manifold implications for Ward, his statuette, and the depiction of Black figures in American sculpture. First, the sculptor's material deployment demonstrates his technical ability and artistic skill to work in a medium that eluded many American sculptors due to a lack of training and requisite infrastructure.[12] The work's quality contributed to its widespread appeal and valuation. Second, bronze affords *The Freedman* a heightened degree of authenticity. It allowed Ward to remain faithful to his subject while delivering to his viewers what they believed to be a more accurate reflection of a Black body. In this case, the properties of the sculptural materials contribute to how audiences read, understood, and contrasted themselves against Ward's Black subject. In either instance, the move to bronze from plaster increased the work's monetary value and its cultural desirability by art viewers and potential patrons.

At first glance, the allure of *The Freedman* appears to have only been known and available to a small portion of New York's art market. Months before it was produced in bronze, however, and roughly a year following its debut in plaster, a reproduction of the work appeared in *Frank Leslie's Illustrated Newspaper* (fig. 2.3). Although unable to capture some of the material and sculptural properties of the work, the reproduction was able to convey the exquisite detail and artistry of the piece that would be later admired in the bronze version. To the point, Leslie's paper distributed the image of *The Freedman* far beyond the boundaries of Goupil's gallery space, introducing the statuette to its sixty thousand readers. The dissemination of this image contributed to the sculpture's popularity and expanded the demographics of potential viewers. In either the National Academy of Design or Goupil's gallery, attendees would have almost certainly been all White as Blacks in New York would have been prohibited entry.[13]

Although American sculptors had produced few bronze statuettes by the 1860s, the appetite for their collection and display by wealthy patrons and collectors was not diminished. Typically, European sculptors, studios, and galleries satisfied the desire for these objects. However, due to high import tariffs, the collection of small bronzes from Europe became financially untenable for many households. Figures like Ward and his teacher, sculptor Henry Kirke Brown, helped pioneer American bronze infrastructure and production, providing consumers of fine arts a more financially stable means to feed their collecting needs. In December 1864, a month after *The Freedman*'s debut in bronze, the bronze foundry L. A. Amouroux

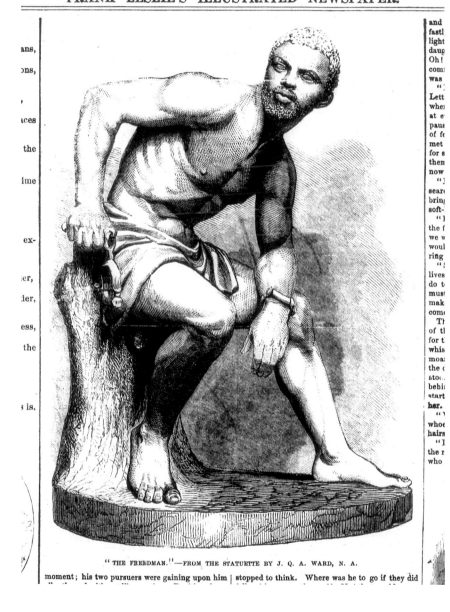

FRANK LESLIE'S ILLUSTRATED NEWSPAPER.

"THE FREEDMAN."—FROM THE STATUETTE BY J. Q. A. WARD, N. A.

2.3 *The Freedman*, in "The Freedman, by Ward," *Frank Leslie's Illustrated Newspaper* XVIL, no. 441 (March 12, 1864): 389. Courtesy of Accessible Archives Inc.

began casting Ward's statuette for $150 retail, which amounts to roughly $2,600 today. The exposure the work received, along with the collection habits of wealthy, White audiences for non-White statuettes, were critical to Ward's career advancement. Similar to how the artist leveraged the success of his *Indian Hunter* statuette (fig. 2.4) to gain a monumental public commission for New York City's Central Park, the display of his design skill and technical execution in *The Freedman* would have been equally lucrative for Ward's career. Apart from the monetary or professional value for Ward, his statuette also had immense social value.

As contraband *The Freedman* was conscripted, but for what intended purpose? When Ward exhibited the statue's plaster model, in a somewhat unusual convention for the time, he insisted that the plaster be painted before its debut. The use of color, in this instance, demonstrates that early on, Ward considered how the austere whiteness of plaster might detract from reading the racial character of his subject—a critical aspect of his self-emancipation narrative for the work. This decision shows how Ward understood his audience's viewing practices and how they believed or internalized the degree to which race was immutable and inseparable from skin color in the mid-nineteenth century.[14] As he sits alone, *The Freedman* is tasked with being the archetype of his race. While no one knows who he is, his pronounced physical traits are used to deliver a universalized vision of the Black male body in America.

Moreover, one can see in *The Freedman* how nudity functions on multiple registers. In one instance, the nudity, combined with the shackles and the subject's bare feet, communicate signifiers of his enslavement to the viewer. In another, the nudity allowed Ward to more effectively demonstrate his

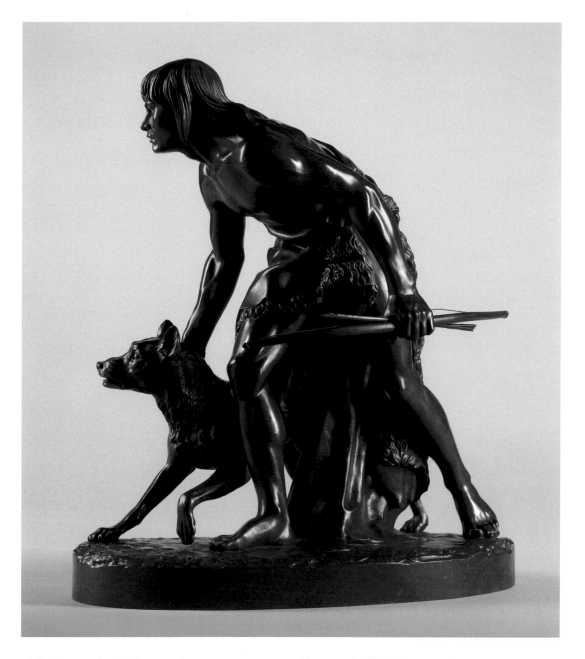

2.4 John Quincy Adams Ward (1830–1910), *The Indian Hunter*, 1857–59, bronze, 16 × 14¹⁵⁄₁₆ × 8½ in., Amon Carter Museum of American Art, Fort Worth, Texas, Purchase with funds provided by the Council, 2000.16

ability to render the human form on par with his European counterparts and display his "naturalistic" sculpting style, which he could only do with a non-White subject in the American context. These characteristics allowed the work to perform a didactic function. Shortly after its unveiling, the *New York Times* expressed dismay that bronze's expense prohibited the statuette from being made into multiples so that it might be "seen and possessed by the great mass of people . . . [and] fill a great want in our available sculpture—something to educate the people."[15] In bronze, then, one can see how color functions as an agent to speak to the truth of the material. Thus, for Ward and his audience, the material implied an authentic racial imagining of *The Freedman* wherein bronze's natural patina and its resemblance to darker skin tones enhanced the "realism" of the figure.

Color is not the only property of bronze that contributes to the racialization of Ward's *Freedman*. The material's ability to draw attention to the stark contrast of surface texture leads the viewer to take

stock of the physical characteristics that helped Ward construct his Black body. As we move through the work, the monochrome patina remains consistent, with no variations in hue between the different formal elements. However, differences in surface texture between those elements are highlighted to separate the subject's flesh from the tree stump and the manacles and clothing (or lack thereof) that frame his social condition. Manipulating the surface is potentially what led critic Henry Tuckerman to suggest that "there is no departure from the negro type."[16] Ward takes advantage of surface texture to make apparent the "type" to which Tuckerman refers as he leads viewers to observe the different physical traits that constituted the conception of racial difference and biological determinism based on race in the minds of nineteenth-century audiences. When further describing the work, the *Times* wrote that Ward's Black figure was true to his type, "not only in feature, but in pose and anatomical structure."[17] The coarseness of the subject's hair, his musculature, the contours of his face, the fullness of his lips, and his wide nose all become contributing factors that position him as a racial other. Absent color, these elements have been deployed in other sculptural materials, such as marble, to help make clear the perceived differences between White and Black bodies.[18]

THE FREEDMAN

"The *Freedman*," according to art historian Kirk Savage, "pose[s] a series of questions about the fate of the black body, in sculpture and society."[19] Chiefly among them, I argue, is: What does freedom look like? How does one give visual form to emancipation, raise the moral issues of slavery, and allude to the racial dimensions of freedom? When we

consider these questions, it becomes clear that Ward tasked himself with a difficult charge. In one object, he attempts to represent an enslaved man who has been emancipated and now teeters on the threshold of freedom. The viewer is made to understand this tension wherein this Black figure occupies a liminal space, similar to emancipated slaves; he is in the process of liberation, though that liberation has not yet been fully realized, nor guaranteed.

Although Ward claimed that his figure had emancipated himself, one should not ignore the degree to which the sculptor plays a pivotal role in his *visual* emancipation. One should question how Ward's aesthetic criteria for constructing a freed Black body influenced his audience's perceptions of Blackness and Black people in America. For him to set the Black subject free in this case, Ward had to rely on a set of conventions communicating *The Freedman*'s enslavement—or at least past enslavement—is legible to assure viewers that his act of self-emancipation was profound and deliberate. Three works may have strongly influenced Ward while he constructed his statuette: Hiram Powers's *Greek Slave* (1841), and Brown's *DeWitt Clinton* monument (1852) and model for the pediment for the US Capitol (1855).

In *The Freedman*, Ward offers mediation between these various depictions of enslavement, alleviating his statuette from allegory and imbuing it with wavering degrees of "intense realism and idealizing classicism."[20] Brown exposed Ward early on in his training to representations of Blackness in sculpture. This is evident most clearly on a panel for the base of the *DeWitt Clinton* monument in Greenwood Cemetery in Brooklyn, New York (fig. 2.5). Perhaps even more paradigm-shifting than Ward's statuette, Brown's Black subject occupies

2.5 Henry Kirke Brown (1814–1886), *DeWitt Clinton Monument* (detail), bronze, 1852, Green-Wood Cemetery, Brooklyn, NY, Photo by Kelvin Parnell

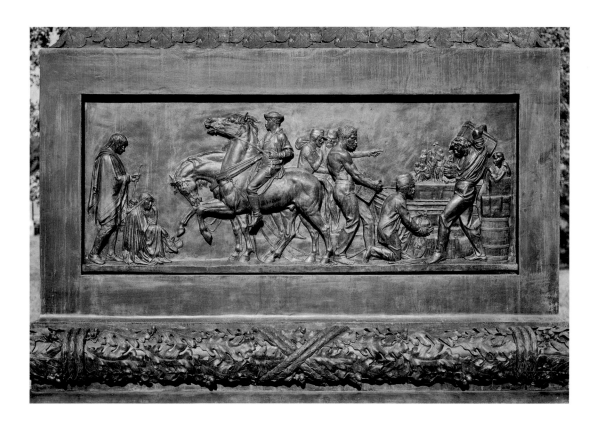

2.6 Henry Kirke Brown (1814–1886), *US Capitol Pediment Design*, plaster, 1855, Photo credit: Dr. Karen Lemmey

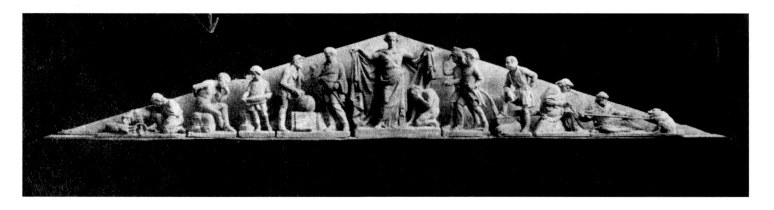

a central location in this composition and is standing rather than kneeling. This stark contrast is made evident by the figure stooping below him on the right side of the panel. Unlike Ward's Black figure, Brown's exhibits no classical signifiers. What the two figures do share are racializing physical features such as coarse hair and beard, seminudity, and bare feet, all complemented by the bronze's brown patina. Further, one can see the degree to which the emphasis on the figure's musculature highlights the realism both sculptors attempt to impart in their works.

While one cannot say for certain if Brown's Black figure is enslaved or freed, the similarities in physiognomic characteristics suggest Ward came to understand myopic sculptural constructions of Blackness primarily through Brown. When we examine Brown's model for a pediment for the US Capitol, we gain insight into where Ward may have adopted the resting-slave motif (fig. 2.6). Seated on a bale of cotton near the left end of the model, Brown's Black figure is connected directly with the institution of slavery and the economic foundation upon which the institution relied. Similar to the Black figure on the *Clinton* monument, Brown in this piece has "pared away classical signifiers and substituted instead a range of recognizably contemporary types who staked their claim to national existence by engaging in productive work."[21] Outside of Ward's emphasis on the strong musculature of his Black figure, the sculptor does not rely on associations of slave labor for his subject. Yet the hunched, seated position and cloth draped around his waist locate *The Freedman* within Brown's contemporary visual discourse of enslavement. What is unclear in Brown's constructions of Blackness in these two examples is whether they evoke abolitionist sentiments. Contrastingly,

Ward's statuette suggests that he does not want to render the topic of slavery inert and commonplace but instead establish it as a status from which to be freed. To do so, he attempted to infuse his sculpture with a moral dimension.

Ward has freed, at least partially, the Black subject from the visual semiotics of enslavement that condemned the Black body in American visual culture to cartoonish, dim-witted, and subservient representations. He does not adopt the abolitionist visual strategy either, wherein the Black figure poses as a supplicant and pleads to have his humanity recognized, as with the antislavery Wedgwood medallion (fig. 2.7). He also does not attempt to illicit a visceral emotional response from his audience by displaying the harsh realities of enslavement often conveyed through deformation or disfiguration of the body as a result of abuse, as seen in this *Harper's Weekly* illustration of an enslaved man with his whipped back exposed (fig. 2.8). While such models certainly exist in abolitionist literature, popular prints, and even some paintings of the era, representations of enslavement in American sculpture functioned quite differently— which prompts the question of whether nineteenth-century sculptural conventions allowed for such degrading aesthetics, even for enslavement.[22] Regardless, that type of imagery does not seem to be critical to Ward's artistic enterprise in this work; his *Freedman* manifests the moralizing aspects of sculpture typically reserved for White subjects in the medium. To do so, I posit Ward turned to Powers's *Greek Slave* (fig. 2.9), where one can see the moral and racial dimensions of slavery and freedom put on full display.[23]

Ward first encountered *The Greek Slave* as a teenager in Cincinnati, prior to his training as a sculptor.[24] Although the work

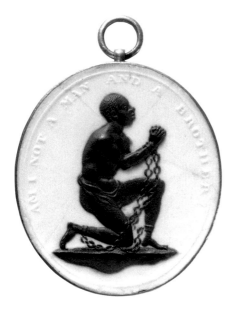

2.7 William Hackwood (ca. 1753–1836), *Medallion of the Society for the Abolition of the Slave Trade*, ca. 1787, jasper and metal, 1⅙ × 1³⁄₁₆ in., Victoria and Albert Museum, London, Photo: © Victoria and Albert Museum, London

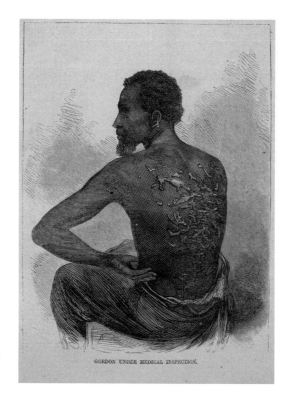

GORDON UNDER MEDICAL INSPECTION.

2.8 *Gordon under Medical Inspection*, in "A Typical Negro," *Harper's Weekly: A Journal of Civilization* VII, no. 340 (July 4, 1863): 429. Courtesy of the Amon Carter Museum of American Art, Fort Worth, Texas

is not a commentary on African slavery in America, it still provided Ward a method by which he could juxtapose the beauty and ideality of his *Freedman* against the immorality of his social condition. Like Ward's subject, Powers's figure is elegant in its form and modest in its pose. As the viewer traverses her unblemished flesh, our gaze is disrupted by the presence of two sets of chains connected to the shackles that bind her wrists. Powers laid bare here the politics of aesthetics and articulated to viewers a paradoxical identity: the balance between beauty and slavery. But as scholar Marcus Wood reminds us: "Art which describes or responds to trauma and mass murder always embodies paradox."[25] A similar logic follows in Ward's statuette. When observing this sculpture's beauty, the viewer is met with the figure's chains, but they do not bind him. Ward has implied that the figure has broken free of his bondage. Thus, the paradox evident in the *The Greek Slave* is absent in *The Freedman*. The foundation of his beauty lies not solely in Ward's sculpting brilliance but also in consequence of his figure's actions—his self-liberation.

The efficacy of Ward's approach, however, should be called into question. At the time, critics writing for the *New Path* signaled the inadequacy of Ward as a sculptor, and the inability of American artists in general, to address seriously the plight of the American slave and the morally bankrupt institution of slavery.[26] Regarding *The Freedman* specifically, they explained:

> Mr. Ward is by far the best sculptor in America . . . who could have made that figure of the negro. As a blow levelled [*sic*] against slavery, however, it was most ineffectual. . . . As for any moral impression, it could never have been produced by Mr. Ward's admirable scientific performance. It requires

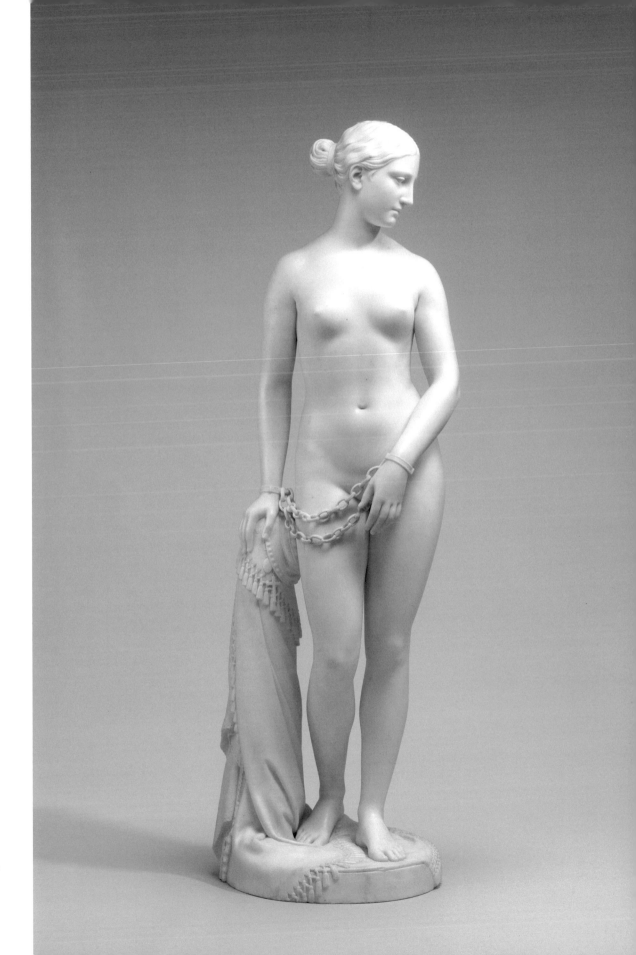

2.9 Hiram Powers (1805–1873), *The Greek Slave*, 1846, Seravezza marble, 65¹⁵⁄₁₆ × 20¼ × 18½ in., National Gallery of Art, Washington, Corcoran Collection (Gift of William Wilson Corcoran), 2014.79.37

different work from any that we have been considering, to stir the hearts, convince the minds or rouse the consciences of men.[27]

In his efforts to strike a balance between the "real" and the "ideal," Ward may have inadvertently collapsed the two onto one another, causing the true realities of slavery to be misrepresented, concealed, and pacified for viewers. In the 1863 account of Ward's statuette by the *New York Times*, there is little indication that *The Freedman* was understood as a mediated and constructed body with no real-world referent: "It shows the black man as he runs to-day," the *Times* reported. "It is no abstraction, or bit of metaphysics that needs to be labeled or explained. It is a fact, and not a fancy . . . Mr. Ward has gone among the race, and from the best specimens, with wonderful patience and perseverance, has selected and combined, and from this race alone erected a noble figure—a form that might challenge the admiration of an ancient Greek."[28] This reporting, alongside the criticism levied against Ward and his statuette by the *New Path*, suggests the work was illustrative of a passive approach to abolition, conveying a sense of resolution instead of communicating a small victory in a series of impending struggles that still plague this figure. While his beauty and ideality in comparison to ancient Grecian sculpture may be the sole contributing factors to audiences recognizing his humanity, those factors distract from the reality of those he represents.

The Freedman represents an undoubtedly remarkable shift from contemporary practices and conventions depicting Black subjects in American visual culture. However, Ward remained in ways loyal to the representational strategies deployed to articulate Blackness and convey racial difference. It is therefore incumbent upon us when interpreting this work to understand the ways in which Ward aligned with and departed from these strategies. Moreover, we should be attuned to how Ward's *Freedman* both simultaneously challenges his audiences and confirms their biases toward the Black subject in American art.

CONCLUSION: *EMANCIPATION*

Although *The Freedman* has maintained an everlasting and significant presence in American visual culture, the fervor for its consumption somewhat diminished after the war. Critics like James Jackson Jarves alluded to the potential power of its reconstitution as a monument, but neither Ward nor the public made significant efforts to erect his statuette on a monumental scale, nor were there any substantial campaigns to erect sculptures dedicated to the self-liberation of the enslaved.[29] The heroics and sacrifices of America's deadliest conflict were credited to primarily White men, whether statesmen, abolitionists, or common soldiers. The war that Lincoln transformed into a moral fight for the nation's soul dependent upon the abolition of slavery was transposed onto the American landscape with the rise of public monuments in the postwar era. Lincoln was constituted as the Great Emancipator and great White savior, while the White men and boys who wore the Union blue were enshrined as the "citizen-soldier."[30] Except for Augustus Saint-Gaudens's *Robert Gould Shaw and the Massachusetts 54th Memorial* (1884), Black men were not visually and socially accepted as heroes of the war, even as Ward's statuettes tell us they were responsible for their own liberation.

One may ask, was Ward an abolitionist? I am not so sure. No one can be certain; the historical record does not bring us such

clarity. Ultimately, interpretations of his acclaimed *Freedman* do not necessitate that question be answered definitively. The preeminent Civil War historian Eric Foner details a spectrum of abolition that encompassed many ideologies, including those who sought the immediate and absolute end of slavery and full enfranchisement of all Black people in the US, those who wished to prevent slavery's expansion into the western territories, those who advocated for gradual emancipation and slave owner compensation, and those in favor of colonizing the formerly enslaved outside the US.[31] Regarding Lincoln's abolitionism, Foner writes, "At various times, Lincoln occupied different places on this spectrum."[32] I suspect we can locate Ward along the same spectrum and view *The Freedman* in a similar light. While the artist may have subverted expectations for a Black body in American sculpture, one could argue that he did not entirely free the Black subject in American visual culture. "It is not difficult," Murray writes:

> to see prophecy as well as history in [*The Freedman*'s] form, pose, and accessories; and even more, perhaps, in its lack of accessories. Indeed, if Mr. Ward were living now, fifty years after the Emancipation, he could scarcely state the case more truly. The Freedman's shackles are broken it is true, but still he is partially fettered; still unclothed with the rights and prerogatives which freedom is supposed to connote—a "Freedman" but not a freeman.[33]

Even so, I offer that Ward set the Black body in American sculpture on a pathway toward freedom—to be understood and appreciated on its own terms.

In 1899, the Henry-Bonnard Bronze Company published a catalogue of their works, and in it Ward's statuette was given one of its last and perhaps most-fitting

names—*Emancipation*. Although a somewhat ambiguous title, it strikes true to the essence of the sculpture as it contains within it the many contradictions, intricacies, and beauty that have defined one of Ward's as well as America's crowning achievements over the past 160 years. Like many of his contemporaries, Ward would have known, as Lincoln did when he delivered his proclamation, that emancipation did not equal true freedom in the form of equality, citizenship, or enfranchisement. But just as the Civil War president slow-walked emancipation and abolition efforts to prepare the country for its new reality, perhaps Ward wanted his statuette to perform a similar task.[34] *The Freedman* exists at a nexus point, one which he was destined to occupy in a state of permanence that exposes the tensions of this nation at one of its most contentious moments. His is the story of emancipation.

Kelvin Parnell is a PhD candidate at the University of Virginia and a recent recipient of the Wyeth Predoctoral Fellowship at the Center for Advanced Study in the Visual Arts.

NOTES

1 Freeman H. M. Murray, *Emancipation and the Freed in American Sculpture* (Washington, DC: Murray Brothers, 1916), xix.

2 Frederick Douglass, "What to the Slave Is the Fourth of July" (speech, Rochester, NY, July 5, 1852).

3 David Walker, *Walker's Appeal, in Four Articles: Together with a Preamble, to the Coloured Citizens of the World, but in Particular, and Very Expressly, to Those of the United States of America, Written in Boston, State of Massachusetts, September 28, 1829*, 3rd ed. (Mansfield Centre: Martino Publishing, 2015), 71.

4 See Tyler Edward Stovall, *White Freedom: The Racial History of an Idea* (Princeton: Princeton University Press, 2021).

5 Abraham Lincoln, "Preliminary Emancipation Proclamation," September 22, 1862.

6 John Quincy Adams Ward, "J. Q. A. Ward to James Reid Lambdin," April 2, 1863, Albert Rosenthal Papers, Archives of American Art, Smithsonian Institution, reel D34, frame 1302.

7 Ward, "J. Q. A. Ward to James Reid Lambdin."

8 "The National Academy of Design," *New York Times*, June 24, 1863, 3.

9 James M. McPherson, *Battle Cry of Freedom: The Civil War Era* (New York: Oxford University Press, 2003), 500.

10 McPherson, *Battle Cry of Freedom*, 355.

11 "Ward's Statuette of the 'Freedman,'" *New York Times*, November 19, 1864, 2.

12 See Michael Edward Shapiro, *Bronze Casting and American Sculpture, 1850–1900* (Newark: University of Delaware Press, 1985), 32–33.

13 See Kirk Savage, *Standing Soldiers, Kneeling Slaves: Race, War, and Monument in Nineteenth-Century America*, 2nd ed. (Princeton: Princeton University Press, 2018).

14 See Anne Lafont, "How Skin Color Became a Racial Marker: Art Historical Perspectives on Race," *Eighteenth-Century Studies* 51, no. 1 (2017): 89–113.

15 "Ward's Statuette of the 'Freedman,'" *New York Times*, November 19, 1864, 2.

16 Henry T. Tuckerman, *Book of the Artists: American Artist Life, Comprising Biographical and Critical Sketches of American Artists: Preceded by an Historical Account of the Rise and Progress of Art in America*, 2nd ed. (New York: G. P. Putnam's Sons, Sampson Low, Son, 1867), 581.

17 "Ward's Statuette of the 'Freedman,'" *New York Times*, November 19, 1864, 2. Also see "Fine Arts: National Academy of Design," *Albion, a Journal of News, Politics, and Literature (1822–1876)* 41, no. 19 (May 9, 1863): 225–26.

18 See Charmaine Nelson, *The Color of Stone Sculpting the Black Female Subject in Nineteenth-Century America* (Minneapolis: University of Minnesota Press, 2007).

19 Savage, *Standing Soldiers, Kneeling Slaves*, 64.

20 Kirk Savage, "Molding Emancipation: John Quincy Adams Ward's 'The Freedman' and the Meaning of the Civil War," *Art Institute of Chicago Museum Studies* 27, no. 1 (2001): 33.

21 Savage, *Standing Soldiers, Kneeling Slaves*, 34.

22 For more on the history of visually representing slavery and emancipation in a broader transatlantic and American context, see Marcus Wood, *Blind Memory: Visual Representations of Slavery in England and America, 1780–1865* (Manchester: Manchester University Press, 2000), and Kirk Savage, "Molding Emancipation: John Quincy Adams Ward's 'The Freedman' and the Meaning of the Civil War," *Art Institute of Chicago Museum Studies* 27, no. 1 (2001): 26–101.

23 For more sculpture and morality, see "Introduction," in Savage, *Standing Soldiers, Kneeling Slaves*. See also David Bindman, *Ape to Apollo: Aesthetics and the Idea of Race in the 18th Century* (Ithaca: Cornell University Press, 2002).

24 Theodore Dreiser, "The Foremost American Sculptors," in *Selected Magazine Articles of Theodore Dreiser: Life and Art in the American 1890s*, ed. Yoshinobu Hakutani (London: Fairleigh Dickinson University Press, 1985), 257.

25 Marcus Wood, *Blind Memory: Visual Representations of Slavery in England and America, 1780–1865* (Manchester: Manchester University Press, 2000), 7.

26 "A Letter to a Subscriber," *New Path* 1, no. 9 (1864): 218.

27 "A Letter to a Subscriber," *New Path* 1, no. 9 (1864), 218.

28 "Mr. Ward's Statue of the Fugitive Negro, at the Academy of Design," *New York Times*, May 3, 1863, 5.

29 See James Jackson Jarves, *The Art-Idea: Sculpture, Painting, and Architecture in America* (New York: Hurd and Houghton, 1865).

30 See Savage, *Standing Soldiers, Kneeling Slaves*. Also see Kirk Savage, *Monument Wars: Washington, DC, the National Mall, and the Transformation of the Memorial Landscape* (Berkeley: University of California Press, 2011).

31 See Foner, *The Fiery Trial: Abraham Lincoln and American Slavery* (New York: W. W. Norton, 2011), 27–28.

32 See Foner, *The Fiery Trial*, 28.

33 Freeman H. M. Murray, *Emancipation and the Freed in American Sculpture* (Washington, DC: Murray Brothers, 1916), 16.

34 McPherson, *Battle Cry of Freedom*, 509.

Q & A

HUGH HAYDEN

Is there a particular definition or concept of emancipation that holds true to you or your work?

I associate the idea of emancipation with having agency to do whatever you want unhindered by anyone or anything.

This exhibition is landing in a moment when a global pandemic, systemic inequities of race and class, and climate precarity are front and center as we think about new futures. In what ways have current events transformed or shifted your work, if at all?

I do not think my work has changed during the current crises. It has always situated the experience of marginalized communities as being equal and just the same as anyone seeking the American Dream. Likewise, my use of natural materials has equally been in dialogue with our relationship to the environment. These current crises have only highlighted and exposed the disparities in the world that were already preexisting, affecting some communities and environments more than others. I altruistically hope that the current "shedding of light" on these matters will demonstrate they are not relegated to a single group but to everyone and can ultimately bring humanity closer together.

At what point in your artistic practice did the histories of American and African art, music, and food become assiduous investigations?

These histories have been present in every waking moment of my life. As I shifted to working as an artist, my practice became a natural outlet for sharing my perspective on the world, which is an amalgamation of my life experiences. I am no expert in any of these things; I have only always enjoyed them. I love to cook, eat, and share meals as a way to bring people together. I enjoy music, though I can't sing or play an instrument. Throughout my work, I'm interested in exploring and remixing the inseparable African origins of the creation of America in all aspects of culture, society, food, music, entertainment, and industry.

Your practice has been discussed as one of balance: between materials, historical context, and the physical process of endurance. Could you speak to this tripartite communion of embodied meaning?

As an artist I am not an expert, a historian, a scientist, or a writer. I remix and rethink our shared understanding of history, society, and materials to create a new way of looking at the world around us.

There seems to be a precarious edge to your work brought on by a dynamic between expected object functionality and adventitious intervention. To what extent does this intentionally charge the viewing experience?

Working in sculpture and in the round, I hope to use this physical medium to create a visceral experience to challenge viewers' comfort levels and their understanding of the world, and to consider the perspectives of others. I strive to create experiences they can situate themselves in and open up and confront their expectations.

Q & A

LETITIA HUCKABY

Is there a particular definition or concept of emancipation that holds true to you or your work?

The definition of emancipation that strikes me the most is "the fact or process of being set free from legal, social or political restrictions." Oftentimes when we think of the word "emancipation," we use it as a definitive, but it's not. It's a process, something ongoing.

This exhibition is landing in a moment when a global pandemic, systemic inequities of race and class, and climate precarity are front and center as we think about new futures. In what ways have current events transformed or shifted your work, if at all?

Current events have had a huge impact on my work. I find myself moving more and more back to my documentary roots. I want to talk about the issues we are facing today but do it in a way that draws the viewer in and softens the blow. My hope is to educate and spark conversation.

We are interested in your transition from photojournalist to artist. Was there a certain moment that you felt the transition was necessary?

The transition from photojournalist to artist came after the loss of my father. I was searching for ways to add history and family lineage to my work, so I turned to vintage and heirloom fabrics to use with my photographs (see below). That has allowed me to layer in not only history and comfort but also to bridge gaps with other cultures.

How does your background in photojournalism remain a vital aspect of your work?

I still shoot like a documentary photographer. I like to immerse myself in a story and try to tell it with truth and poetry. The truth part is paramount to me. I don't want to alter what I find but [point out] the subtle things that are often overlooked.

In what ways do you see the ideals and concepts, the promises and challenges, of emancipation and Black liberation within your artwork, which is often so deeply evocative of personal memory?

My work is a celebration of my African-American heritage, but it is also a comparison between the hardships of the past and our present realities. I am always trying to shine a spotlight on the fact that emancipation is not over; we are still in it, and although we have come a long way, the battle is not yet won.

Letitia Huckaby, Photo by Rambo

Letitia Huckaby, *1 week old/Haskell Place*, 2021, pigment print on cotton fabric with embroidery hoop, 27¾ × 34¾ in., Courtesy of the artist, © Letitia Huckaby

FROM EMANCIPATION TO TRANSCENDENCE:

MEDITATIONS ON FREEDOM IN AMERICAN ART

MAURITA N. POOLE

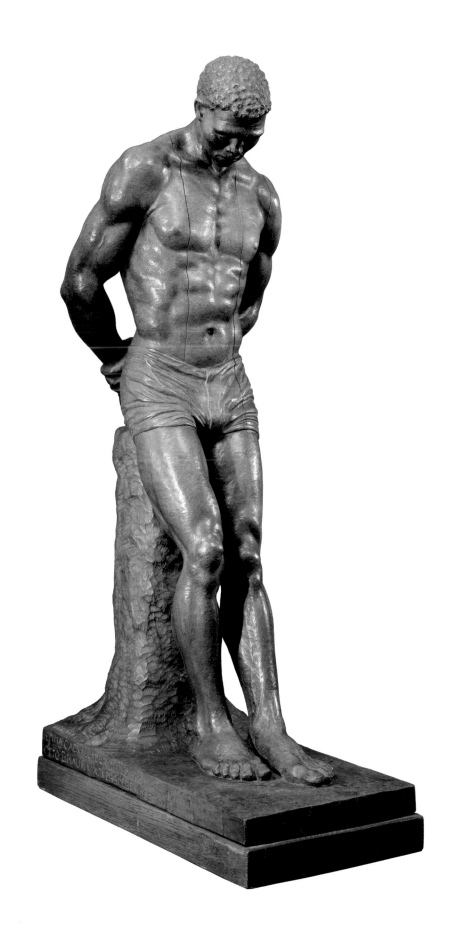

3.1 Otto Braun, after Emma Marie Cadwalader-Guild, *Free*, modeled 1876, carved after 1876, basswood, 30½ × 8¼ × 15⅜ in., Courtesy Crystal Bridges Museum of American Art, Bentonville, Arkansas

In 1876, Emma Cadwalader-Guild cast a bronze sculpture titled *Free*. Lost to history, the original work's structure and composition can be appreciated by examining a basswood replica by Otto Braun (fig. 3.1). The sculpture depicts a seminude Black man leaning against the stump of a tree. Gazing downward with one hand clasping his opposing arm behind his back, the figure calls to mind the ambiguities surrounding the emancipation of African Americans during the Reconstruction era. Resembling a person in bondage rather than a newly freed American citizen, the sculpture highlights an issue that African Americans would continually contemplate as it became evident that neither the Emancipation Proclamation nor the Reconstruction Amendments provided them with access to the basic tenets of American democracy. Furthermore, the composition of the piece implies that Cadwalader-Guild, and later Braun, sensed that the idea of freedom in the United States was intricately and intimately bound with the institution of slavery.

According to an article in *Pearson's Magazine*, Cadwalader-Guild conceived of *Free* when she saw a dark-skinned Black man looking dejected in a market in Boston. Arrested by the lone figure that she saw, the artist allegedly exclaimed to a friend, "I can model that man! He is my idea of a slave!"[1] This insight into her motivation for the work's creation, which would have been understood by the readers when the article was written in 1904, engenders a few basic questions. Why would a depressed Black man in a market conjure up the image of a slave for her? What about his behavior, bearing, or attire suggested a person in bondage rather than a freed man of African descent? More significantly, in what ways do her words and rendering of this unknown Black man capture the ambivalence and tension surrounding the social status of African Americans post-emancipation?

Cadwalader-Guild's understanding of the status of African Americans was surely influenced by the innumerable photographs and print materials that circulated by antislavery activists at the time to convey the iniquity and brutality that informed the lives of the enslaved. The artist's exclamation suggests that the visual record and material culture intended to sway Northerners to help eradicate the institution of slavery also conditioned the way Black people were seen, regardless of the context and long after their emancipation. The sculptor's exposure to artist studios in Boston and close examination of public monuments influenced the work's conception. Commissioned to create portrait busts for President William McKinley and industrialist Andrew Carnegie, as well as a tribute to Abraham Lincoln, she played a critical role in the design and development of art that shaped perspectives about the nation's development and its leaders.

Cast in Italy and placed in her London studio, *Free* earned praise from European critics, though the work, which was rarely exhibited, was primarily seen by those who had a relationship with the artist. The artist's unguarded, spontaneous remark points to a struggle that many Americans would have with the idea of a Black man and, by extension, the entire community of newly freed Black people, being equal to Whites. His body is aestheticized, though not as a reprehensible or stereotypical figure. Though idealized and beautiful, the free yet impoverished man is portrayed not as an empowered being but as a dejected figure who embodies the contradictions of the Emancipation Proclamation itself. The man seems unable to realize the objective of being fully liberated and treated like a citizen. Cadwalader-Guild's sense that the

sufferer in the marketplace was akin to an enslaved person rather than a free citizen may be what allowed her to construct a sculpture that translates, through its visual cues and allusions, the challenges facing African Americans following the war.

Despite the work's title and the artist's success at creating a nuanced sculpture, the piece still supports, if it does not fully reinforce, the idea that Black Americans had not yet transcended their position within the nation's racial economy. By describing the man as the ideal representation of "a slave," and by using his vulnerability to fulfill her fancy as well as her desire to realize the work of art that she had envisioned, the artist makes it evident that African Americans at the time rarely had real control or power over their destinies. They were often dependent upon paternalistic bonds with Whites who could control their economic, sociopolitical, and even sexual circumstances.[2] The sculpture, like the man who served as its model, was to be looked at, consumed, and to serve those in power who were fascinated by his condition. Neither he nor the work of art disrupted the social order or truly countered the idea that Black men were inferior and, by virtue of their constitutions, unable to survive without the benevolence of Whites. The work of art is thus a sobering reminder that the United States government had not carefully considered what to do, or how social relations and legal structures would proceed once this population transitioned from chattel to free people.

The scantily clad figure also highlights the economic instability and near-complete vulnerability of African Americans post-emancipation. Subject to Black Codes, or restrictive laws that limited their movement and access to sociopolitical rights, they were often compelled to work for low wages. In the South, men without jobs were more at risk of being criminalized and arrested as vagrants for being unemployed. Cadwalader-Guild's perspective about the dispirited and struggling Black male in a Boston market, however, indicates that the conditions under which African Americans lived in Northern states after the demise of slavery were also harrowing. The precariousness of life could be disheartening, particularly if they were hoping to have the opportunity to achieve political and social equality. In competition with European immigrants for jobs, African Americans such as the man who inspired Cadwalader-Guild's sculpture struggled to find employment and a permanent residence, which are vital in any age for achieving stability for individuals, families, and communities.

Because Cadwalader-Guild's preferred media were bronze, granite, and marble, it is likely that she was in dialogue with others who were attempting to develop a distinctly American sculptural style.[3] Her awareness may have incited her desire to develop a work that could illustrate her perspective about the growing number of sculpted representations of "the Negro" that emerged beginning in the 1860s. The title of Cadwalader-Guild's sculpture and her remarks about her model suggest that she was familiar with the 1867 sculpture *Morning of Liberty* (known as *Forever Free*) by the acclaimed mixed-race sculptor Mary Edmonia Lewis.[4] The neoclassical sculpture depicts a standing male figure with one hand holding his broken chains and manacle in the air while his other hand rests on the shoulder of a formerly enslaved woman who is still fettered. From her kneeling position, the woman clasps her hands together in prayer and thanksgiving (fig. 3.2).

Forever Free centers on the reaction of slaves to the 1863 Emancipation

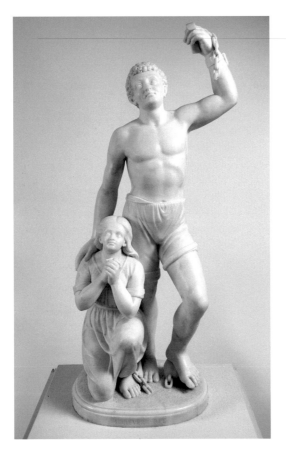

3.2 Edmonia Lewis (1843/5–ca. 1911), *Forever Free*, 1867, Carrara marble, 41¾ × 22½ × 12⅜ in., Howard University Gallery of Art, Washington, DC / Licensed by Art Resource, NY

Proclamation, or the decree that assured them that they would never be in bondage again. The broken chains are to be understood not only in a sociopolitical way but also in a religious or spiritual sense. The figures' upward gaze and the woman's prayerful hands draw attention to African American belief in the living presence and aid of a higher power. Though her figures' facial expressions are subdued and passive, they are depicted at a moment when they have begun to envision a future when they are completely emancipated. The work portrays and centralizes one of the most studied biblical ideas by African Americans: namely, the moment when their deliverance,

like that of the children of Israel from the Egyptian pharoah, would arrive.

Not only did the Exodus story provide the enslaved with a semblance of hope when they encountered immense suffering, it connected them to a historical community that had experienced, and been liberated from, enslavement.[5] While the enslaved were not certain how or when their deliverance would take place, their familiarity with the Exodus story, along with their reverence for Moses as a central figure for the liberation of the children of Israel, helped to console them in their despair. On the Day of Jubilee, when Lincoln signed the Emancipation Proclamation, for many of the formerly enslaved the biblical Exodus narrative cemented their identity as a "chosen people" akin to the Jews. The Exodus provided a framework for understanding past suffering and disappointment that would continue for decades to come. Is it surprising that this narrative and Moses would become fused with Harriet Tubman, the historic figure who helped Black people escape from bondage prior to the end of slavery?

African-American artists in the twentieth and twenty-first centuries, cognizant of their liminal status and position in relation to ideologies about race and gender, created and continue to create art about freedom informed by values from within their own communities. My discussion includes selected works where emancipation is presented as freedom from bondage and gaining access to full citizenship and equal treatment under the law. These works, which largely come from Clark Atlanta University's art collection, have mostly been exhibited in galleries and museums that primarily serve African Americans.[6] My primary contribution, and emphasis, is the examination of contemporary African-American art that uses Christian tropes or

African-derived spiritual frameworks to encourage reinterpretation of emancipation and post-emancipation liberation. The works subtly imply that recalling Black history and meditating on African-American relationships to the divine and spiritual realm has the potential to lessen, if not fully alleviate, the distress and hardship faced post-emancipation.

Born in 1884, about two decades after the demise of slavery, William Edouard Scott had a remarkable career as a draftsman, painter, and muralist. Trained at the School of the Art Institute in Chicago and mentored by Henry Ossawa Tanner, Scott depicted Black people and subject matter without directly dealing with the more traumatic issues of Black life. His painting *Woman at Rest by Candlelight* depicts a woman who

appears to seek relief from a troubling circumstance (fig. 3.3). Sitting at a table in a darkened kitchen, the woman leans forward with her hands clasped together in a prayer of supplication. It is beautifully rendered yet restrained, only hinting at the broader context, or individualized story, that would compel this woman to seek aid from the divine. But it also illuminates how countless numbers of African Americans found solace in the face of hardship. Realizing that suffering and racial violence would be part and parcel of their experience in the United States, successive generations of Black people would resort to prayer and revisit stories in the Bible to shore them up to contend with adversity, privation, and oppression. Works that overtly explore the after-effects of slavery and the continued impact of discrimination on African Americans became more prevalent from the 1930s to the 1950s, when a new generation affected by the Great Depression encountered new barriers and forms of racial and economic discrimination.

In *The Mourners*, artist Frederick C. Flemister utilized the trope of the crucified Christ to convey the horror of African Americans victimized by racial violence (fig. 3.4). Composed in a manner suggesting that the artist was inspired by Anthony van Dyck's *Lamentation over the Dead Christ*, the artist depicts a mother holding her dead son who has been taken down from a lynching tree. A grieving woman behind her throws her hands up in the air, while a frightened and stunned child rushes into the arms of his mother as he looks back at the corpse. The story of Christ's crucifixion on Mount Calvary resonated deeply with African Americans intimately acquainted with mutilated, disfigured, or lynched Black people, both prior to the Civil War and for decades following the Emancipation Proclamation. Although Flemister's painting doesn't provide an

3.3 William Edouard Scott (1884–1964), *Woman at Rest by Candlelight*, 1912, oil on canvas, 17½ × 21 in., Clark Atlanta University Art Museum, 1985.001, © William Edouard Scott Estate

3.4 Frederick C. Flemister (1916–1976), *The Mourners*, 1942, oil on canvas, 39¾ × 31¼ in., Clark Atlanta University Art Museum, 1942.002, © Frederick C. Flemister Estate

image of transcendence, wherein the evil of the lynching tree is transformed into triumphant beauty of the divine, the work profoundly questions the nature and character of Black freedom as well as its implications for citizenship and social justice during the era of segregation.

In Norma Morgan's engraving *Harriet Tubman*, the Black Moses is depicted as an individual having an encounter with a supernatural presence (fig. 3.5). The artist visually translates a section of the Book of Exodus into a metaphorical composition easily recognizable to African Americans because of its assurance that God would deliver them from enslavement and future suffering. In contrast to Lewis's *Forever Free*, the focus here is not on a time when the formerly enslaved emancipate themselves or reach a promised land. Instead, Morgan's Tubman appears to be in dialogue with God, or an angel, possibly about the role she will play in helping African Americans escape bondage.

A parallel to Moses's experience with the burning bush, Morgan's Harriet Tubman stands on hallowed ground immersed in supernatural light. In contrast to engravings Morgan created during the 1950s and 1960s, like *David in the Wilderness* (fig. 3.6), this figure is more prominent in the composition and not overwhelmed by the environment. David is almost lost in the rocky wilderness outcropping on which he sits. A visual metaphor for what Morgan labeled "social erosion" as much as a meditation on the biblical figure hiding from his pursuers while seeking support from God, it is uncertain what inspired the artist to create this work. Made the same year as the Montgomery bus boycott, *David in the Wilderness* perhaps can be understood as one of the utmost acts of freedom for Morgan, an artist who actively refused to "expend her

3.5 Norma Morgan (1928–2017), *Harriet Tubman*, 2002, hand-colored engraving, 30 × 22 in., Clark Atlanta University Art Museum, 2015.006, © Norma Morgan Estate

3.6 Norma Morgan (1928–2017), *David in the Wilderness*, 1955–56, engraving, 34⅝ × 17⅝ in., The Museum of Modern Art/New York, NY/U.S.A., Abby Aldrich Rockefeller Fund, © Norma Morgan Estate, digital image © The Museum of Modern Art/ Licensed by SCALA/Art Resource, NY

energies in physical protests and parades" during the civil rights era.[7]

Morgan's depiction of Tubman mirrors the ways enslaved African Americans often related to the sacred realm. In determining how to adapt Christianity to their lives, and to interpret scripture that was deployed to promote docility, subservience, and obedience, Black people often gave primacy to their own experiences with the divine. Prayer meetings held in woods, thickets, or other secluded places—like the cavernous environment this Harriet Tubman occupies— gave them the chance to commune with God. In these private places of worship, they cultivated a relationship with a higher power, which helped them independently determine their personal perspectives about the world they inhabited. More significantly, they could receive guidance about managing the strictures associated with bondage as they waited in anticipation for their future day of deliverance.

As one of the engravings created by Morgan three years before she passed, this meditation on Tubman may not have been

intended to be a reflection on freedom and liberation. The subject of the work is rare for Morgan, an artist who actively sought to expand discussions of her work beyond Black experiences and feminist movements.[8] Her landscapes often subordinate humans to promote a more fantastical, dramatic, or brooding natural environment. In such works, inspired by her study of Scottish moors, the artist was able to explore ideas of upheaval and to give visual form to demons and prophets in the Bible. Although acutely aware of problems facing African Americans in the real world, Morgan was more interested in using her art to extend her reach beyond the sociopolitical and secular realm.

In the era of the civil rights and Black Power movements, artists such as John T. Riddle revisited heroic figures like Tubman and incorporated archival imagery in their work to make cogent statements about pathways out of suffering and oppression for African Americans. Riddle emerged as one of the most significant artists shaping art in Georgia after he moved from California in 1974 to teach at Spelman College. In 1982,

he was exhibited at the High Museum of Art in Atlanta in a show titled *Making Plans: Five Silkscreens by John Riddle*. The significance of this work, and Riddle's standing in the Black arts community, was bolstered by the reviews he received in the *Atlanta Journal-Constitution*.[9] The journalist, along with Peter Morrin, the High's curator of twentieth-century art, emphasized the formal qualities of the series and the influence of Jacob Lawrence, who was one of the few nationally known African-American artists at the time. Riddle, by contrast, stressed inspiration by non-Black canonical artists on his practice, as well as his desire to use his art to raise social consciousness.[10] The Making Plans series was a part of other artistic ventures that Riddle undertook during his tenure in Atlanta. A champion for the incorporation of Black art into the city's urban planning, the artist played a central role in partnerships between local Black

artists, universities, and city officials as the director of Atlanta's Neighborhood Arts Center (NAC). His public sculpture, support of murals focused on African-American history and culture, and oversight of one of the city's most important Black arts community centers contributed to what Pearl Cleage defined as the "Atlanta Black Renaissance" of the eighties.[11] This art movement was defined by its interest in the political use of art as well as its role in ensuring that African-American history and culture would be transmitted to a new generation. Atlanta was one of the most successful centers of the national Black Arts Movement, and this period can be credited for creating the contours of Atlanta's arts ecosystem in the twenty-first century.[12]

Riddle's Making Plans series can be interpreted as an extension of other works on paper that deal with racial uplift and economic development created by the artist during the same period. In a print titled *Fairbanks or Garvey* (fig. 3.7), his interest in Pan-Africanism and Black internationalism is clearly evident in the juxtaposition of the twentieth-century Black nationalist leader Marcus Garvey with an image of an advertisement for "Fairbank's Gold Dust" washing powder. One of the first cost-effective, all-purpose cleaning agents sold in the United States, Fairbank's Gold Dust bore the trademarked logo of the Gold Dust Twins, who were bald, Black children—caricatures and embodiments of racist imagery that drew upon ideologies about the primitiveness and inferiority of people of African descent. The Gold Dust Twins were iconic, popular, and deeply intertwined with American consumer culture until the mid-1950s. Riddle's radical view of liberation is striking in this print, which features Garvey and thus his well-known advocacy for the Black diaspora's return to Africa. Garveyism—like

3.7 John T. Riddle (1933–2002), *Fairbanks or Garvey*, 1979, screenprint on paper, 23 15/16 × 34 in., Brooklyn Museum, Gift of R. M. Atwater, Anna Wolfrom Dove, Alice Fiebiger, Joseph Fiebiger, Belle Campbell Harriss, and Emma L. Hyde, by exchange, Designated Purchase Fund, Mary Smith Dorward Fund, Dick S. Ramsay Fund, and Carll H. de Silver Fund, 2012.80.37, © John T. Riddle Estate

3.8 John T. Riddle (1933–2002), Making Plans series: *Change the Plan*, 1982, serigraph, 41 × 31½ in., Clark Atlanta University Art Museum, 2005.003.001, © John T. Riddle Estate

earlier forms of Black nationalism—posited that Africa and its descendants could be redeemed by creating separate and independently controlled societies. The choice for African Americans in Riddle's print can be interpreted as a decision to remain subservient, ridiculed, and second-class citizens, or to be independent in a way that seemed improbable to the majority of African Americans in the twentieth century.

In 1974, Riddle helped to organize the creation of Atlanta's *Wall of Respect* mural on Auburn Avenue, which was unceremoniously whitewashed in 2007.[13] The mural paid tribute to civil rights leaders and historical Black figures and explicitly sought to connect African-American and African cultures through the incorporation of depictions of sub-Saharan African masks and the most

popular Egyptian pharoah, Tutankhamun. As with Hale Woodruff's 1952 Art of the Negro mural series in Trevor Arnett Hall at Clark Atlanta University, the *Wall of Respect* artists utilized easily recognizable symbols and iconography to convey that African history included great civilizations and traditions that African Americans retained despite slavery. Equally important was the mural's implicit message that Africans and African Americans should see their histories and cultures as intertwined in the contemporary moment.

The Making Plans series also promoted the idea of African and African-American interconnection. Likely influenced by his experiences at NAC, where altercations and discord about the best way to approach community uplift occurred, the series begins with *Change the Plan*, a print showing two Black men fighting with each other on top of a globe that associates one with the United States and the other with the African continent (fig. 3.8). A complex image that references African Americans with different standpoints in relation to Africans—one rooted in perspectives that emphasize Black people's Americanness, and the other grounded in Afrocentric viewpoints that stress the connection to Africa—the two subjects are in battle with each other instead of working together in a spirit of equal partnership, which is signified by a handshake beneath them. The print can also be seen as a commentary on the tension between African Americans descended from enslaved Africans and American Africans, a designation popularized by writers like Nigerian-born Chimamanda Ngozi Adichie to refer to Black Africans who recently immigrated to the United States.[14] Though bound together by discrimination based upon their skin color, these two groups' desire to differentiate and distance themselves

from one another is also a part of how they relate to one another. Riddle was acutely aware of this dynamic as an individual with a Pan-African sensibility and desire to connect African Americans to Africans. Therefore, the work implies that Riddle believed that liberation and full independence for Black people, on both the continent and in the diaspora in the postcolonial era, would not be possible without cooperation.

The artist's vision of emancipation is more evident in *Harriet Tubman—Carrying Out the Plan*, the third print in the series (fig. 3.9). Grounded in archival and documentary material connected to known and unknown historic figures who liberated themselves, the print emphasizes Black people's agency in their liberation. Images of Black fugitives are intertwined with Adinkra symbols with meanings like hope and faith to draw attention, in part, to attributes that would have been essential for an enslaved person seeking to escape. Planning the journey and developing a sense of the terrain are indicated by the incorporation of details, such as blueprints that include the day of the week, the endeavor would have required. From the archetypal image of a fugitive with a knapsack over his shoulder to the image of Henry "Box" Brown, who became famous for shipping himself in a wooden box from Virginia to Philadelphia, this work highlights the ingenuity of Black people who sought a way out of enslavement. Using history to guide contemporary perspectives, this print suggests that strategic planning and collective action within Black communities are still relevant for community development and sociopolitical uplift—essential components of Black liberation today.

Documentary and archival impulses in this print connect Riddle's practice to the photographic tradition that was used to promote the abolition of slavery to advocacy for rights during the civil rights movements of the twentieth and twenty-first centuries. The deployment of photography for demonstrating the horrors of the institution of slavery was acutely understood by African-American leaders such as Frederick Douglass and Sojourner Truth.[15] Their goal was to reveal the position of African Americans in the United States and the specific challenges for those residing in the South. The trajectory set by these early abolitionists has continued into the present in the work of contemporary photographers who documented the civil rights and Black Lives Matters movements like Danny Lyon, James Karales, Robert Sengstacke, and Sheila Pree Bright. Such work clarifies the issues with the treatment of Black subjects who have been abused, harmed, or killed without culpability. Riddle's Making Plans series veers away from non-Black audiences to provide a pathway to overcome challenges faced in daily life.

Riddle's fourth silkscreen in the series, *God's Plan—Only God*, extends beyond Christianity to search for ideas rooted in African traditional religions and philosophies about life and death, as well as the human journey in relation to the divine (fig. 3.10). Although the silkscreen comprises symbols from diverse ethnic groups and traditions, the artist's focus is commonality. The similar features of such spiritual traditions are a belief in a supreme creator, veneration of ancestors and the dead, and the sense that the human journey is a cyclical one where people are encouraged to seek harmony with nature and the supernatural. These concepts are embodied in this print's overall composition, which resembles a cosmogram or ideographic symbol from Kongo culture; the work reflects a broad range of ideas and metaphors that together maintain that the meaning of life cannot be determined, or

3.9 John T. Riddle (1933–2002), Making Plans series: *Harriet Tubman–Carrying Out the Plan*, 1982, serigraph, 33 × 22½ in., Clark Atlanta University Art Museum, 2005.003.003, © John T. Riddle Estate

3.10 John T. Riddle (1933–2002), Making Plans series: *God's Plan–Only God*, 1982, serigraph, 31 × 22½ in., Clark Atlanta University Art Museum, 2005.003.004, © John T. Riddle Estate

understood at all, without seeking connection with God.

Cosmograms focus on humanity's relationship to the cosmos and are "coded as a cross, a quartered circle or diamond, a seashell spiral, or special cross with solar emblems at each ending" to illustrate rebirth and the continuity between the living and the dead.[16] The cosmogram designates a vision of a circular movement of human souls around the circumference of its intersecting lines, which Riddle emphasizes by interspersing images of people of the twentieth century with historic sites and figures in archival prints, African masks such as the Kota reliquary that connects the living with deceased ancestors who have power in the afterlife, and the Akan culture's Adinkra symbol for the "supremacy of God." Inspired by the traditional Kongo cosmogram, the artist's version is blended, revealing how the ancient cruciform evolved in the diaspora by incorporating iconography from different ethnic groups as well as Catholicism. Considering this print in relation to the entire series, we can surmise that the artist understands emancipation as a multilevel process that evolves over time. People

should strategically plan and proceed with it as ancestors like Harriet Tubman and Henry "Box" Brown did; yet none of it is feasible if it is not a part of God's overarching plan for them. Emancipation in John Riddle's series evolves as a concept, comprising definitions that range from literal freedom from bondage to liberation through access to sociopolitical rights and economic independence to transcendence, which requires making a connection with the divine, or a supreme being, and the cosmos.

Georgia-born, Atlanta-based artist Alfred Conteh further complicates the notion of emancipation as either freedom from bondage, liberation, or transcendence. Though most of his works do not have a religious overtone, they are inspired by sociohistorical, political, and economic forces that affect the lives of African Americans. His Tetanus series in particular renders visible the detrimental effects of a history of enslavement and Jim Crow segregation, systemic racial oppression, and socioeconomic inequality. The works in the series comprise drawings, paintings, and sculpture with individuals and landscapes coated with a rust-like residue to metaphorically connect

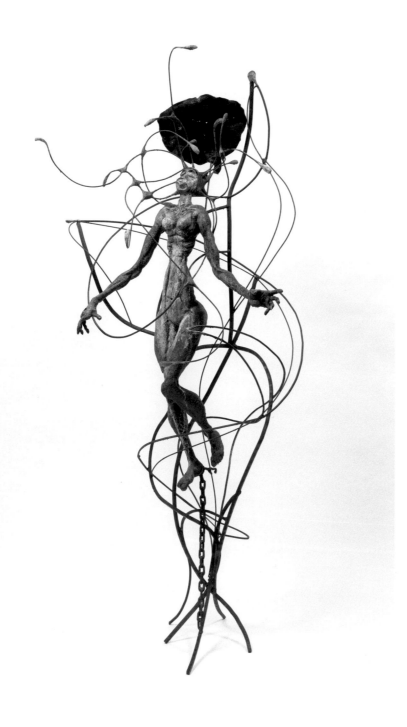

the way tetanus insidiously alters what it touches to the effect of interlocking systems of Black oppression.

Conteh's 2014 sculpture *Float* is arresting because of its layered meanings, and implications, as a work intended to translate the continued struggle that African Americans have as independent subjects and citizens in the United States (fig. 3.11). While the current generation has access to more opportunities and freedom of movement than any generation before, the inequities and racially motivated violence and injustice remain. Unlike Black artists in previous generations, in *Float* Conteh presents this dynamic in a Black female Christ figure who bears the stigmata of the crucifixion. Her shackle removed, she rises in a whirlwind, her arms spread out from her emaciated body as her church hat flies off revealing the potency of the experience.

A visualization of the ecstasy of freedom, *Float* engenders as many questions as Emma Cadwalader-Guild's *Free*. What does freedom mean to a Black woman covered and tainted by a social system as poisonous and injurious as tetanus? Can she be revived, or resurrected, like Christ? Will the cycle of discrimination and systemic oppression, engendered by the history of slavery, ever come to an end? Conteh's sculpture captures the ambivalence and tension surrounding emancipation, or freedom, and later Black liberation in the twenty-first century. There has been progress, but the issue remains unresolved. The image of suffering Christ as a parallel for Black people unjustly treated, and killed, remains deeply compelling. Yet Conteh in this work provides a new perspective that represents a generation of African Americans who may be more skeptical about the power of Christianity, a supreme deity, or spirituality to help them transcend oppression.

3.11 Alfred Conteh (b. 1978), *Float*, 2014, mixed media, 67½ × 76¼ × 32 in., Clark Atlanta University Art Museum, 2021.001, © Alfred Conteh

The vexing, and unsettled, questions about Black people's reliance on religion to attain liberation and transcendence that Conteh's work inspires is equally significant in reflecting on emancipation. Because injustices continued to be a part of life for African Americans after slavery's demise, many distrusted religions or any form of spirituality that allowed Black suffering to abound. The art discussed here focuses on those who not only found solace in religion and spiritual practice but also utilized the tenets to counter dehumanizing forces that encouraged them to devalue themselves and doubt their humanity. The range of religious beliefs and practices, in that regard, allowed African Americans post-emancipation to expand beyond the reality of freedom to contemplate Black liberation and the possibility of transcendence.

Maurita N. Poole is director of the Newcomb Art Museum of Tulane University.

NOTES

1 Abby G. Baker, "An American Woman Sculptor: Mrs. Emma Cadwalader-Guild Whose Portrait Bust of President McKinley to Be Placed in the National Capital," *Pearson's Magazine* 11, no. 2 (February 1904), 171–74.

2 Charmaine Nelson provides an in-depth and provocative analysis of the representations of Black men on the eve of and following emancipation as castrated individuals. She highlights the significance of depictions of emasculated men in neoclassical sculptures. Michael Hatt's research about Black masculinity in mid-nineteenth-century sculpture is a great complement to her analysis. Charmaine A. Nelson, "Male or Man?: The Politics of Emancipation in the Neoclassical Imaginary," in *A Companion to American Art*, ed. John Davis et al. (Hoboken, NJ: Wiley-Blackwell, 2015).

3 Michael Hatt, "'Making a Man of Him': Masculinity and the Black Body in Mid-Nineteeth-Century American Sculpture," *Oxford Art Journal* 15, no. 1 (1992), 21–34.

4 Kirsten P. Buick, "The Ideal Works of Edmonia Lewis: Invoking and Inverting Autobiography," in *Reading American Art*, eds. Marianne Doezema and Elizabeth Milroy (New Haven: Yale University Press, 1998); Bonnie Claudia Harrison, "Diasporadas: Black Women

and the Fine Art of Activism," in *Meridians: Feminism, Race, Transnationalism* 2, no. 2 (2002): 171–72.

5 Albert Raboteau, *Slave Religion: The "Invisible Institution" in Antebellum South* (New York and Oxford: Oxford University Press, 2004), 311.

6 Tina Maria Dunkley and Jerry Callum, *In the Eye of the Muses: Selections from the Clark Atlanta University Art Collection* (Atlanta, GA: Clark Atlanta University, 2012).

7 Robert Henkes, *The Art of Black American Women: Works of Twenty-Four Artists of the Twentieth Century* (Jefferson, NC: McFarland, 1993), 64.

8 Henkes, *The Art of Black American Women*, 64–74.

9 Rachanice Candy Patrice Tate, "'Our Art Itself Was Our Activism': Atlanta's Neighborhood Art Center, 1975–1990" (2012), ETD Collection for AUC Robert W. Woodruff Library, Paper 296, 214.

10 Kellie Jones et al., *Now Dig This!: Art and Black Los Angeles, 1960–1980* (Los Angeles: Hammer Museum in association with DelMonico Books/Prestel, 2011), 86; Tate, "'Our Art Itself Was Our Activism,'" 214.

11 Pearl Cleage, "Atlanta Is Hub of a New Black Renaissance in the Arts," *Atlanta Constitution* (June 19, 1984), 11-A.

12 Mike Peed, "Realities of Race," review of *Americanah* by Chimamanda Ngozi Adichie, Sunday Book Review, *New York Times*, June 7, 2013, 12.

13 Tate, "'Our Art Itself Was Our Activism,'" 211.

14 Peed, "Realities of Race."

15 See Matthew Fox-Amato, *Exposing Slavery: Photography, Human Bondage, and the Birth of Modern Visual Politics in America* (New York: Oxford University Press, 2019); Aston Gonzalez, *Visualizing Equality: African American Rights and Visual Culture in the Nineteenth Century* (Chapel Hill: University of North Carolina Press, 2020); Maurice O. Wallace and Shawn Michelle Smith, eds., *Pictures and Progress: Early Photography and the Making of African American Identity* (Durham: Duke University Press, 2012); Deborah Willis and Barbara Krauthamer, *Envisioning Emancipation: Black Americans and the End of Slavery* (Philadelphia: Temple University Press, 2013).

16 Robert Farris Thompson and Joseph Cornet, *The Four Moments of the Sun: Kongo Art in Two Worlds* (Washington, DC: National Gallery of Art, 1981), 26.

Q & A

ALFRED CONTEH

Is there a particular definition or concept of emancipation that holds true to you or your work?

I see emancipation as a leveling of the playing field here in the West. When I think about slaves being emancipated from chattel slavery, that wasn't true emancipation. What we still haven't come to realize is that emancipation wasn't just the destruction of the institution but the destruction of Whiteness as a construct when it comes to power and access to resources and equal protection under the law. Emancipation is everyone who lives in the society having access to such things, to institutions, to resources, to wealth. That parity is what I see as true emancipation, true freedom, not for just one group but for all.

This exhibition is landing in a moment when a global pandemic, systemic inequities of race and class, and climate precarity are front and center as we think about new futures. In what ways have current events transformed or shifted your work, if at all?

Over the last two years in regard to the pandemic, the Buffalo shooting, the Charlottesville riots, and the insurrection at the Capitol, those incidents have indicated to me that I am on the right track with what I'm speaking to in my work. There's been a war waged on Black folks since we've been here, whether we are aware of it or not. I think these and similar incidents have made a lot of Black and White folks alike understand that, despite the fact that we haven't given any credence to it and to a large degree still don't, racism is the largest problem that this country has yet to face and address. Police violence, the current issue in schools with critical race theory, the Buffalo shooter's

Alfred Conteh, Photo by Melissa Alexander

motive based on his belief that White people are being marginalized in this nation, being pushed out—all these things are symptoms of the root disease, which is White supremacy and racism in this country. I hope my work is in lockstep with helping Black folks recognize how vigilant we should be in protecting ourselves from these things and making ourselves more aware of where we stand in this social experiment called America.

What is the role of rust and decay in your work?

They are reminiscent or emblematic of two different things. One is that I am trying to remind the viewer about the reality of Black life, unfortunately, as a people. Since emancipation, Black folks have been left to their own devices in regard to how to live life, surviving in an American landscape. When your people are left unprotected and without a means to take care of themselves, they've got to do whatever they can. They're left out to weather. They're left exposed to the elements, and anything that you leave exposed to the elements, what happens? It decays, erodes. It rusts. Anytime I drive to see sharecroppers' shacks in the South and cross bridges in the cities throughout the Midwest, the Rust Belt so to speak, I see objects and places and spaces that have been left to decay, to rot, much like us. On the other side of that, atomized steel dust at one time was used as a lubricant for machines, which is kind of how Black labor and blood and bodies were used to build this nation. It was a lubricant to help this machine work, for this machine to operate. But as with most things that become antiquated, Black people were cast aside.

Do you think there is something unique stylistically and thematically about work emerging from the American South?

What makes southern artists unique, especially if you're Black growing up there, is that you're surrounded by all the southern traditions, all of the institutions that have been there so long and that create these environments that are more often than not anti-you, Black man, Black woman. You have grown up where most of the Black folks in this country matriculated from. So when it comes to that Black southern tradition, to music, food, fashion, and language, I think Black artists who grow up in the South, including myself, have a unique perspective about how they practice and about their outlook on the world.

Alfred Conteh (b. 1978), *Build*, 2015, steel and mixed media, 56 × 36½ × 21 in., © Alfred Conteh

A CONTROLLED BURN:

DISCURSIVE EMANCIPATION, ABOLITIONISM, AND THE CONSOLIDATION OF "RACE" IN VISUAL CULTURE

KIRSTEN PAI BUICK

His life had not agreed with my phantasy at any point.

— ZORA NEALE HURSTON

In Zora Neale Hurston's autobiography *Dust Tracks on a Road*, she recounts an event from her childhood in which a man, Mr. Pendir, whom she found quite magical, turned out to be anything but and to have, in fact, died a very ordinary death. Indeed, he was not part alligator nor was he able to put on and slough off his skin as part of his resurrection ritual. Writing as an adult in hindsight, she spells "phantasy" as it is used archaically or in the fields of psychology and psychiatry.[1] However, I begin my essay with that epigraph not to promise a deep dive into the psychopathy of "emancipation" nor to question the agency of those most directly affected (enslaved people, those who had relatives who were enslaved, and those who profited from the slavocracy), but instead to reach for the broad view of what I call "discursive emancipation," which is to acknowledge that abolitionism was not one thing; for some, freedom for the enslaved meant negotiating the survival of White supremacy, for example. Or in the case of the Society for Effecting the Abolition of the Slave Trade (SEAST), founded in 1787 in England, they settled on a limited strategy to end the slave trade but not to fight for

general emancipation.[2] And those with the power to invent and control mass media were the primary force that set the terms of the discourse. Thus, it is unsurprising that "discursive emancipation" often centered on the concerns of White people who occupied separate and different sides of the issue of liberty and with varying degrees of intensity and desired outcomes. The "phantasy" of emancipation enveloped them as well.

Rather than "to free" or "not to free," the central question posed by abolitionism was the following: How do you grant freedom to a group whose oppression is instrumental in the construction of empire? How do you grant freedom to a group whose racialization as "Black" invents and reinvents "Whiteness" as a legitimate category of being? The acquittal of Kyle Rittenhouse for the 2020 murders of two White men (Joseph Rosenbaum and Anthony Huber) who were part of a Black Lives Matter protest exposed the illusion of White as a stable racial category and revealed Whiteness as coercive and performed and profoundly unstable.[3] Whiteness is the process of negotiation, ongoing, that grants White its appearance of fixity, realism, and purpose. Whiteness is the process that facilitates and consolidates White. Racial killing (murderous Whiteness—in this instance of White men) becomes just action; and furthermore, racial killing functions *as* negotiation (through the trial and acquittal of Rittenhouse for murder) when rhetorics of Whiteness fail. Like Karen Sánchez-Eppler, "I am concerned precisely with the ways in which rhetoric effaces and contains the real, not only with the physical and juridical violence directed against women and slaves"—and in the case of Rittenhouse, physical and juridical violence against White men—"but also with the violence of representation and the anxieties about difference inherent in the

appropriation of their flesh for the purposes of political and literary discourse."[4]

As Rosenbaum's and Huber's deaths demonstrate, all flesh can be appropriated and conscripted to Whiteness; furthermore, those who perform their Whiteness contrarily (here in the interests of BLM) invoke anxieties about differences within Whiteness that expose the threat to it as ideologically sound. Within rhetorics of Whiteness, the potential for class conflict can be ameliorated and can bring together historically marginalized immigrants in a consolidation of "race" (in quotation marks to acknowledge it as abstraction) and racial belonging.

Within rhetorics of Whiteness, Black suffering has always been visible and necessary. However, the terms of its visibility are subject to negotiation and interpretation—this is the true violence of representation. If, as Calvin Warren argues, Black suffering is the necessary precondition for the democracy yet to come, then Black people must remain the human boundaries that demarcate relative states of belonging and citizenship.[5] Nevertheless, and outside the scope of this essay, I would also argue that the partial freedom granted to enslaved people was and is possible because of the permanent status of First Nations people as outsiders, racialized and simplified as Indian, on whose land the empire was built and is sustained. The very question of freedom takes upon itself the conundrum raised by abolitionism: How is emancipation procured while simultaneously causing limited damage to White supremacy, understanding that White supremacy is not the goal but the product of economic exploitation? White supremacy masks economic exploitation even as it reinvents and reinstantiates itself as the very purpose of Whiteness. Such nuance is only possible within discourse, helpfully and contextually defined by Sánchez-Eppler:

By *discourse* I mean any historically specific structure of assertions, vocabularies, categories, and beliefs; thus, though I rely predominantly on the linguistic manifestations of such structures, *discourse* can refer to a variety of institutional or social practices. For example, there exists both slavery (the fact of bondage) and the discourse of slavery (the pattern of statements, definitions, and beliefs that both enables the fact of bondage and mediates subsequent accounts of it).[6]

To extend her argument, there is the embodied experience of enslavement and the discourse of embodiment that mediate the meaning and impact of slavery as well as emancipation.

Consequently, this essay is about the violence of representation within discursive emancipation, a phantasy that takes as its mission "a controlled burn," which involves intentionally setting fires to maintain the health of a forest, though always with the goal not to allow the fire to spread out of control. At various times in the nation's history, we have these metaphorical prescribed burns that are negotiated at the expense of the oppressed. We are forced to live a collective phantasy that says we are all welcome at the table of equality and freedom and that any evidence to the contrary is the fault of the subjugated. In the time leading up to the Civil War, abolitionism and Slave Power alike worked toward such a burn to maintain the health of the nation and of Whiteness. The Civil War was the fire out of control but contained by the failure of Reconstruction, the implementation of Jim Crow, and the additional violence of an onslaught of monuments to the Confederacy with quite a few located in the United States Capitol. As a nation, we are forced to continue learning these lessons; as January 6, 2021,

reinforced, insurrection and the phantasy of violent performative Whiteness (which appropriated and conscripted the flesh of the Capitol police officers whose deaths were a direct result of the violence) enters the public realm not as insurrection but as "legitimate political discourse."[7] Within visual culture, discursive emancipation functioned as a form of negotiated Whiteness over and against the fact of enslavement as embodied experience.

PART 1: DECEPTIVE EMBODIMENT: NUMERACY AND THE EVIDENCE OF ENSLAVEMENT, 1787–1838

The form that antislavery visual culture took demonstrates the difficulties around the fact of enslavement as embodied experience and unleashes an unpleasant phantasy—that the bodies of the enslaved make up the center of deceitfulness so that the body itself *is* the lie. The equivocation around embodied experiences of enslavement is exposed in the most popular images of abolitionism. Phillip Lapsansky identifies the three most effective and affective images that were developed in the eighteenth century and refined throughout the nineteenth: the cross section of the slave ship; prints of "whippings and other punishments of slaves, slave auctions, separation of slave families, and other atrocities"; and variations of the Wedgwood medallion that was created in 1787 and depicts a kneeling man around whom cycle the words "Am I Not a Man and a Brother?"[8] The audience for these images, primarily understood to be White and free, were meant to be inspired to act on behalf of some form of abolition, whether it was stopping the slave trade, advocating for the emancipation of the enslaved, or championing emancipation with the intention to send free Black people to Africa. Recycled continuously,

DESCRIPTION OF A SLAVE SHIP.

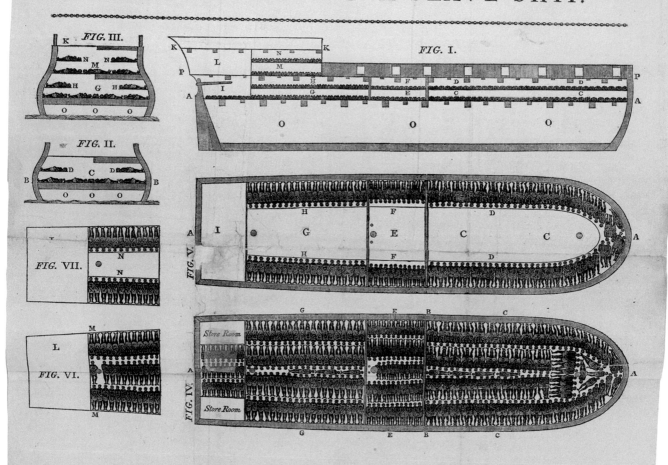

FIG. III. FIG. I. FIG. II. FIG. V. FIG. VII. FIG. IV. FIG. VI.

The Plan and Sections annexed exhibits a slave ship with the slaves stowed. In order to give a representation of the trade against which no complaint of exaggeration could be brought by those concerned in it, the *Brookes* is here described, a ship well known in the trade, and the first mentioned in the report delivered to the House of Commons last year by Captain Parrey, who was sent to Liverpool by Government to take the dimensions of the ships employed in the African slave trade from that port. These plans and sections are on a scale of the 8th of an inch to a foot.

DIMENSIONS OF THE SHIP.

	Feet	Inches
Length of the *Lower Deck*, gratings, bulk-heads, included at AA	100	0
Breadth of *Beam* on the Lower Deck inside, BB	25	4
Depth of *Hold*, OOO from cieling to cieling	10	0
Height between decks from deck to deck	5	8
Length of the *Mens Room*, CC on the lower deck	46	0
Breadth of the *Mens Room*, CC on the lower deck	25	4
Length of the *Platforms*, DD in the mens room	46	0
Breadth of the *Platforms* in mens rooms on each side	6	0
Length of the *Boys Room*, EE	13	9
Breadth of the *Boys Room*	25	0
Breadth of *Platforms*, FF in boys room	6	0
Length of *Womens Room*, GG	28	6
Breadth of *Womens Room*, GG	23	6
Length of *Platforms*, HH in womens room	28	6
Breadth of *Platforms* in womens room	6	0
Length of the *Gun Room*, II on the lower deck	10	6
Breadth of the *Gun Room* on the lower deck	12	0
Length of the *Quarter Deck*, KK	33	6
Breadth of *Quarter Deck*	19	6
Length of the *Cabin*, LL	14	0
Height of the *Cabin*	6	2
Length of the *Half Deck*, MM	16	6
Height of the *Half Deck*	6	2
Length of the *Platforms*, NN on the half deck	16	6
Breadth of the *Platforms* on the half deck	6	0

Nominal tonnage — 297
Supposed tonnage by measurement 320
Number of seamen — 45

The number of slaves which this vessel actually carried appears from the accounts given to Capt. Parrey by the slave-merchants themselves as follows:

Men	—	351
Women	—	127
Boys	—	90
Girls	—	41

Total 609

The room allowed to each description of slaves in this plan is;
To the Men 6 feet by 1 foot 4 inches.
Women 5 feet 10 in. by 1 foot 4 in.
Boys 5 feet by 1 foot 2 in.
Girls 4 feet 6 in. by 1 foot.

With this allowance of room the utmost number that can be stowed in a vessel of the dimension of the *Brooks*, is as follow, (being the number exhibited in the plan) and is less than 1½ to a ton, viz:

	On the Plan.	Actually carried.
Men—on the lower deck, at CC	126 }	
Ditto on the platforms of ditto, CC DD	66 }	192 351
Boys—lower deck EE	40 }	
Ditto—platform FF	24 }	70 90
Women—lower deck, GG	83 }	
Ditto—platform, HH	40 }	
Women Half deck, MM	36 }	183 127
Platform ditto, NN	24 }	
Girls Gun room, II		27 41
General total	470	609

It may be expected, from this mode of packing a number of our fellow-creatures, used in their own country to a life of ease, and from the anguish of mind their situation must necessarily create, that many of them fall sick and die. Instances sometimes occur of horrible mortality.

London: Printed by James Phillips, George-Yard, Lombard-Street. M,DCC,LXXXIX.

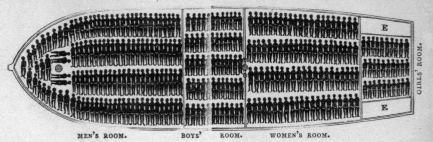

Plan of an African Ship's lower Deck, with Negroes in the proportion of not quite one to a Ton.

GIRLS' ROOM.

MEN'S ROOM. BOYS' ROOM. WOMEN'S ROOM.

REMARKS ON THE SLAVE-TRADE.

IT must afford great pleasure to every true friend to liberty, to find that the case of the unhappy Africans engrosses the general attention of the humane, in many parts of Europe; but we do not recollect to have met with a more striking illustration of the barbarity of the slave-trade, than in a small pamphlet lately published by a society at Plymouth, in Great-Britain; from which, the Philadelphia Society for Promoting the Abolition of Slavery have taken the following extracts, and have added a copy of the plate, which accompanied it. Perhaps a more powerful mode of conviction could not have been adopted, than is displayed in this small piece. Here is presented to our view, one of the most horrid spectacles—a number of human creatures, packed, side by side, almost like herrings in a barrel, and reduced nearly to the state of being buried alive, with just air enough to preserve a degree of life sufficient to make them sensible of all the horrors of their situation. To every person, who has ever been at sea, it must present a scene of wretchedness in the extreme; for, with every comfort, which room, air, variety of nourishment, and careful cleanliness can yield, it is still a wearisome and irksome state. What then must it be to those, who are not only deprived of the necessaries of life, but confined down, the greater part of the voyage, to the same posture, with scarcely the privilege of turning from one painful side to the other, and subjected to all the nauseous consequences arising from sea-sickness, and other disorders, unavoidable amongst such a number of forlorn wretches? Where is the human being that can picture to himself this scene of wo, without, at the same time, execrating a trade, which spreads misery and desolation wherever it appears? Where is the man of real benevolence, who will not join heart and hand, in opposing this barbarous, this iniquitous traffic?

"THE above plate represents the lower deck of an African ship, of two hundred and ninety-seven tons burden, with the slaves stowed in it, in the proportion of not quite one to a ton.

"In the men's apartment, the space allowed to each is six feet in length, by sixteen inches in breadth. The boys are each allowed five feet by fourteen inches; the women five feet ten inches, by sixteen inches; and the girls four feet by twelve inches. The perpendicular height between the decks is five feet eight inches.

"The men are fastened together, two and two, by handcuffs on their wrists, and by irons rivetted on their legs. They are brought up on the main deck every day, about eight o'clock; and, as each pair ascends, a strong chain, fastened by ring-bolts to the deck, is passed through their shackles; a precaution absolutely necessary to prevent insurrection. In this state, if the weather is favourable, they are permitted to remain about one third part of the twenty-four hours, and, during this interval, they are fed, and their apartment below is cleaned; but when the weather is bad, even these indulgences cannot be granted them, and they are only permitted to come up in small companies, of about ten at a time, to be fed, where, after remaining a quarter of an hour, each mess is obliged to give place to the next, in rotation.

"It may perhaps be conceived, from the crowded state in which the slaves appear in this plate, that an unusual and exaggerated instance has been produced; this, however, is so far from being the case, that no ship, if her intended cargo can be procured, ever carries a less number than one to a ton, and the usual practice has been to carry nearly double that number. The bill which has passed this last session of parliament (1789), only restricts the carriage to five slaves to three tons: and the Brooks, of Liverpool, a capital ship, from which the above sketch was proportioned, did, in one voyage, actually carry six hundred and nine slaves, which is more than double the number that appear in the plate. The mode of stowing them was as fol-

lows: platforms, or wide shelves, were erected between the decks, extending so far from the sides towards the middle of the vessel, as to be capable of containing four additional rows of slaves, by which means, the perpendicular height above each tier, after allowing for the beams and platforms, was reduced to two feet six inches, so that they could not even sit in an erect posture; besides which, in the men's apartment, instead of four rows, five were stowed, by placing the head of one between the thighs of another. All the horrors of this situation are still multiplied in the smaller vessels. The Kitty, of one hundred and thirty-seven tons, had only one foot ten inches; and the Venus, of one hundred and forty-six tons, only one foot nine inches perpendicular height, above each layer.

"The above mode of carrying the slaves, however, is only one, among a thousand other miseries which those unhappy and devoted creatures suffer, from this disgraceful traffic of the human species, which, in every part of its progress, exhibits scenes that strike us with horror and indignation. If we regard the first stage of it, on the continent of Africa, we find, that a hundred thousand slaves are annually produced there for exportation, the greatest part of whom consist of innocent persons, torn from their dearest friends and connexions, sometimes by force, and sometimes by treachery. Of these, experience has shewn, that forty-five thousand perish, either in the dreadful mode of conveyance before described, or within two years after their arrival at the plantations, before they are seasoned to the climate. Those who unhappily survive these hardships, are destined, like beasts of burden, to exhaust their lives in the unremitting labours of slavery, without recompense, and without hope.

"It is said by the well-wishers to this trade, that the suppression of it will destroy a great nursery for seamen, and annihilate a very considerable source of commercial profit. In answer to these objections, Mr. Clarkson, in his admirable treatise on the impolicy of the trade, lays down two positions, which he has proved from the most incontestible authority—First, that so far from being a nursery, it has been constantly and regularly a grave for our seamen; for, that in this traffic only, more men perish in one year, than in all the other trades of Great-Britain in two years:

"And, Secondly, that the balance of the trade, from its extreme precariousness and uncertainty, is so notoriously against the merchants, that if all the vessels employed in it, were the property of one man, he would infallibly, at the end of their voyages, find himself a loser.

"As then the cruelty and inhumanity of this trade must be universally admitted and lamented, and as the policy or impolicy of its abolition is a question, which the wisdom of the legislatures must ultimately decide upon, and which it can only be enabled to form a just estimate of, by the most thorough investigation of all its relations and dependencies; it becomes the indispensable duty of every friend to humanity, however his speculations may have led him to conclude on the political tendency of the measure, to stand forward, and assist the committees, either by producing such facts as he may himself be acquainted with, or by subscribing, to enable them to procure and transmit to the legislature, such evidence as will tend to throw the necessary lights on the subject. And people would do well to consider, that it does not often fall to the lot of individuals, to have an opportunity of performing so important a moral and religious duty, as that of endeavouring to put an end to a practice, which may, without exaggeration, be styled one of the greatest evils at this day existing upon the earth.

"*By the Plymouth Committee,*

"W. ELFORD, chairman."

E E.—*Store Rooms.*

PRINTED AND SOLD BY SAMUEL WOOD, NO. 362, PEARL-STREET.

4.2 *Description of a Slave Ship,* 1787, engraving, British Library

4.3 "Remarks on the Slave-Trade," Printed and sold by Samuel Wood, No. 362 Pearl-Street, 1807, Library of Congress, Rare Book and Special Collections Division, Printed Ephemera Collection

such imagery could also cross media.[9] The three-dimensional model of the slave ship *Brookes* (fig. 4.1), for example, is based on a copper engraving from 1787 produced by SEAST titled *Description of a Slave Ship* (fig. 4.2).[10] Marcus Wood addresses the problematic representation of African people within the print versions of the cross section: "In purely aesthetic terms the slaves have no human presence at all; in terms of compositional balance the white spaces where the slaves are not are as important as the black spaces of ink which represent their bodies. It is possible that it was precisely this formality, which appears to deny the flesh and blood presence of the slaves," that necessitated the creation of the three-dimensional model.[11] Furthermore, Wood notes, "the slave is a cultural void," and this void allowed White European observers to cast themselves in place of the Africans who are crammed together on the surface of the paper and on the copper pasted on top of the model's surface. The model was to humanize the "Description" of the engraving's title and was a moral and intellectual test, writes Wood, "for imagining suffering through the subjective projection onto the site of the slave bodies, but the rules for the test are ultimately laid out by the *Description*. They are rules which allow the black body no voice which is not the creation of a white observer."[12] The model fails in its own ways and on its own terms: as the model of the *Brookes* was passed from hand to hand in Parliament, it created a sensory hierarchy so that the body of the ship became more substantial, tactile, and therefore real than the bodies of the Africans. The space within the model is also divided according to gender with signage that demarcates the "Men's Room" and "Women's Room" and, in the stern, the "Childs' Room."

Like the image of the kneeling slave in the Wedgwood medallion, the broadside of the slave ship's cross section also crossed the Atlantic. In "Remarks on the Slave-Trade" published in Philadelphia in 1807, the nod to decorum is revealed as the practicalities of packaging (fig. 4.3). The picture of the ship was accompanied by a narrative that overwhelms an image already abstracted. In fact, the text seems to compete with the cross section and reveals the investment in accounting and numeracy as the truly valid evidence of the horrors of enslavement. The remarks offer the origin of the illustration: "We do not recollect to have met with a more striking illustration of the barbarity of the slave-trade, than in a small pamphlet lately published by a society at Plymouth, in Great-Britain; from which, the Philadelphia Society for Promoting the Abolition of Slavery have taken the following extracts, and have added a copy of the plate, which accompanied it." With the provenance of the image established, the author exposes the effectiveness of the abolitionists with their reliance on pamphlets and the cheapness of prints, which made their propaganda widely available. By the mid-to-late 1830s, the American Anti-Slavery Society had standardized its publications, created a system for distribution and sales, transformed anti-slavery beliefs into household knowledge through domestic material objects such as pincushions and coin boxes, and, in effect, invented mass media.[13]

Unsurprisingly, the remarks then ask the reader to picture themselves in the hold of the ship, tunneling down into packing logistics:

> The plate represents the lower deck of an African ship, of two hundred and ninety-seven tons burden, with the slaves

SPECIMEN OF THE COLLECTOR'S CARD. (Gould in May, Daniel Harris in July, &c.)	1838.			1	2	3	4	5	6	7	8	9	10	11	12	
	Susan Gould,	95	Mercer-st.													
	Wm. Gould,	"	"													
	Sarah Gould,	"	"													
	Harriet Gould,	"	"													
	Wm. Gould, jr.	"	"													
	Arad Kent,	97	"													
	John Kent,	"	"													
	Mrs. Kent,	"	"													
	Mr. A. Kent,	"	"													
	Ann Harris,	93	"													
	Julia Harris,	"	"													
	Stephen Kent,	97	"													
	Chloe Spear,	93	"													
	David Gould,	95	"													
	Daniel Harris,	93	"													
	Mrs. Harris,	93	"													

N. B. Abolitionists will confer on us a *great favor* by recommending suitable persons to act as agents for carrying out this system. We wish to have an agency in cities and large towns, and if possible, one in each county, who will receive and circulate tracts, cards, &c. for collectors, and do all in his power to promote the success of these societies.

N. SOUTHARD, Agent for Cent a-Week Societies.

4.4 "Specimen of the Collector's Card," *Emancipator*, 1838, Courtesy of the Library Company

stowed in it, in the proportion of not quite one to a ton.

In the men's apartment, the space allowed to each is six feet in length, by sixteen inches in breadth. The boys are each allowed five feet by fourteen inches; the women five feet ten inches, by sixteen inches; and the girls four feet by twelve inches. The perpendicular height between the decks is five feet eight inches.

The men are fastened together, two and two, by handcuffs on their wrists, and by irons rivetted on their legs.[14]

Such an emphasis on numeracy was to create what Teresa A. Goddu describes as a "White envelope" of knowledge that pitted White empiricism against Black embodiment.[15] The "Specimen of the Collector's Card" performs a parallel feat of abstraction (fig. 4.4). Published in the *Emancipator* in March 1838, the table provides the names and addresses of donors toward the cause of emancipation, with a column for each month and a dot recording each cent received. The dots signify the triumph of numeracy over the embodied experiences of enslavement. "In constructing the collector as a bookkeeper, the card transformed her from

an unregulated organizer into the manager of a small business," Goddu contends.[16] The business of antislavery enforced the idea that only White people could produce facts and that White denial and skepticism could invalidate the material culture produced by the enslaved, whether it was a narrative or a panorama. Antislavery invented consumerism as freedom and the consumer as White, which reinforced "the production of white identity through the purchase of black freedom."[17] Such practices helped to forge a middle class sustained by structures of racial discrimination that made enslaved Black people "evidence" rather than "witness" to their embodied oppressions. Goddu compellingly argues, "By investing in ever-greater forms of social inequality as it moved toward the moment of emancipation and beyond, institutional antislavery foreclosed other forms of freedom."[18]

But it was the Wedgwood medallion that would become the source material for the abolitionists' most effective piece of propaganda (see fig. 1.3). Much has been written about the ceramic medallion first developed in 1786 by Josiah Wedgwood to support the cause of abolitionism. Initially designed by an anonymous craftsman, Wedgwood charged William Hackwood, his chief modeler, to create the cameo. Both members of the Committee to Abolish the Slave Trade, Wedgwood and Hackwood retained "the gender, nudity, and chains of the earlier figure, they posed the slave as a supplicant; blackening his skin, they made him race specific; and they added a motto": the legend and legendary "Am I Not a Man and a Brother?"[19] Mass-produced in Wedgwood's English factory, the cameo synthesized "advanced technological skills and radical political ideas" as Wedgwood innovated a clay body that could heighten the contrast between ground and figure to

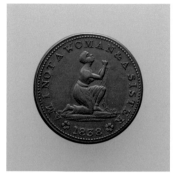

4.5 "Am I Not a Woman and a Sister" anti-slavery hard times token, 1838, copper, 1⅛ in., Yale University Art Gallery, Transfer from the Yale University Library, Numismatic Collection, 2001, Gift of Irving Dillaye-Vann, B.A. 1897, 2001.87.3459

best convey the skin tone of an "African." Abolitionist leader Thomas Clarkson noted, "The ground was a most delicate white, but the Negro, who was seen imploring compassion in the middle of it, was his own native color."[20] The radical political ideas that the cameo advanced were complex: In an Enlightenment context that peddled freedom as a natural right, the message here was that for the African, freedom could only be granted as a gift from the very institutions that enslaved him;[21] the design further emphasized the unequal nature of the petitioner and the petitioned as the African performs as an eternal supplicant. When the cameo was adapted by American women of the various US antislavery societies, the gender of the figure was changed to female and the motto to "Am I Not a Woman and a Sister?" It was reproduced on pincushions, coin boxes, the frontispieces of antislavery books, almanacs, as the masthead to abolitionist newspapers, et cetera. The transformation from cameo to coin (from jewelry to money) is a telling one that reinforces the abstraction of the enslaved's body under the perquisites of numeracy (fig. 4.5). Just as the enslaved's body was traded for money, this coin was supposed to both represent and indict that trade as it was sold at abolitionist fairs. Numeracy is the ultimate abstraction, and in the cumulative instances of this section, abstraction meant the opposite of freedom.

INTERLUDE: REMAINS OF THE DAY, 1850–1863

Despite the overexposure of a handful of period photographs depicting slavery and the enslaved, it is surprising what scarce use of photographic imagery was employed toward the cause of abolitionism or even anti-abolitionism. Given the importance of

engraved and printed images of "whippings and other punishments of slaves, slave auctions, separation of slave families, and other atrocities" that Lapsansky identified, along with the function of nineteenth-century anthropology (physiognomy, phrenology, craniology) and its commitment to demonstrating African inferiority, photography could have lent its reputation for realism and objectivity much more widely to either cause. Such was not the case. My "Interlude" centers around photography, image scarcity, and ambiguity; and I speculate on the later overexposure in contemporary culture of the few examples that we do have, specifically the Agassiz daguerreotypes (1850) and *The Scourged Back* (1863) by McAllister & Brothers—Agassiz's set created to reinforce scientific racism, and the image of the runaway slave Gordon/"Whipped Peter" and his scarred back to work on behalf of emancipation. (There are no accompanying illustrations for this section, and there are two reasons for my refusal to include them: Their ubiquity in contemporary visual culture makes their reproduction here unnecessary, and leaving them solely as evocations is a way to acknowledge the harm that they continue to do to contemporary viewers of trauma and abuse.)

There are always confluences in life, but it is extraordinary to me that I would arrive at this point of refusal concurrent with a wellspring of gratitude toward the scholars who conceptualized this project. The slave daguerreotypes commissioned by the anthropologist Louis Agassiz were rediscovered in 1975 in the archives of Harvard's Peabody Museum; and thirty years ago, as I write this, the Amon Carter Museum held the influential and celebrated exhibition *Photography in Nineteenth-Century America* that featured all fifteen of the images—seven men and women who were enslaved, forced

to strip naked, and pose before the camera. The daguerreotypes have seldom been out of sight since 1992 as Harvard continues to license their reproduction for an array of projects, some of them, tellingly, switching out the anthropological labels that describe the sitters as specimens for labels more in keeping with art museums and how those institutions hierarchize information.[22]

It doesn't matter what scientific theory Agassiz was trying to prove. What matters is that other "men of science" did not take up photography to convey their hypotheses, finding instead the printed table of comparative profiles by Josiah C. Nott more useful in conveying their theories. The nature of daguerreotypes is perhaps one reason why. Their singularity worked against Agassiz's attempts to use his forced models as types or as objective representations. Three years after the Carter's exhibition, Brian Wallis injected a note of caution around their use and mislabeling that went largely ignored. "The very literalness of photographs produces an uncontrollable multiplication of meanings in even the most banal images," he contended.[23] And these Agassiz daguerreotypes are hardly that. Indeed, the compulsion in contemporary engagement with them is to want to read defiance or pain or sadness in their direct stares into the camera. While this may be true and provide another clue as to why photography was essentially useless to the causes of scientific racism and anti-abolitionism, we nevertheless seem unprepared to deal with our own reactions as viewers. The need to witness a discernable emotion as an assertion of the subjects' triumph (despite enslavement) over their circumstances is what *we* require to feel better about what we are witnessing. Our discomfort is now the burden of the enslaved. Such projections inspired Molly Rogers and David W. Blight to use the image

of Delia on the cover of their book *Delia's Tears: Race, Science, and Photography in Nineteenth-Century America*, the self-described first "narrative history" of these images.[24] Independently of how we feel or need to feel in the presence of these objects, I argue that these daguerreotypes be treated as remains and repatriated to their descendants. Even the descendants of Louis Agassiz argue this point.[25] Thus, the question for Harvard is this: Are they specimens or are they ancestors?

The Scourged Back photograph depicting the runaway Gordon/Peter, which was distributed around the country in the form of cartes de visite during the critical year of 1863, has sparked confusion among the curators in whose collections the image is housed and among scholars who have written about it.[26] For example, the Metropolitan Museum of Art attributes their copy of *The Scourged Back* to McPherson & Oliver, but the resemblance is not to Gordon but to Peter, and Peter is given Gordon's story. Or are they the same men? Unless we map the scars on their backs and create an overlay, like fingerprinting, we remain unsure. But perhaps the confusion is the point. When *The Scourged Back* was first reproduced for mass consumption, it was not as a carte de visite sold at antislavery fairs but as part of the story of Gordon as told in *Harper's Weekly* in 1863 with the engraved image of his back sandwiched between a rendering of "Gordon as he entered our lines" and "Gordon in his uniform as a U.S. soldier." The containment of the photographic information's brutal detail of the figure's back happens on three levels: the translation of his scars from the photograph to the engraving, which lessens the impact and makes the scars "visible" because they are less immediate to an equivocating public; the creation of a narrative arc that counters

the information of the scars—a triumphal *accounting* (a call back to numeracy) of slave to soldier with the images used as illustration; and finally, a story told not by Gordon but by a White interlocuter.[27] Identity is not as important as the imagined intensity of the pain that Gordon/Peter suffers. The confusion helps to restage who gets to own and authenticate pain. The enslaved is once again a cultural void.

Ironically, the rarity of the Agassiz daguerreotypes and of Gordon/Whipped Peter (given the availability of the medium, why don't we have photographs either before or after 1863?), together with the overexposure of the Agassiz daguerreotypes and Gordon/Whipped Peter in the present, means that the images inhabit a phantasy archive of all the possible missing images that provide similar evidence. For the present, intensity (either through the gaze of Agassiz's specimens or the empathetic appropriation of Gordon's pain) is configured as the power to witness, transferred from the enslaved to the viewer, who assumes for themselves the fact of enslavement as embodied experience. We are hungry for the evidence of their degradation. Search the internet for "the scourged back." See how often Gordon/Whipped Peter is not only reproduced but reenacted. Provocations of empathy have remained consistent from then until now. Despite the images' scarcity and the ambiguity of their original messaging, they set today's conditions for viewing lynching photographs and our recent addiction to public executions. Remember, the appropriation by activists of George Floyd's cry of "I can't breathe" (no matter how well-intentioned) was answered by law-enforcement apologists who produced a Valentine's Day card with a picture of Floyd and the words "You Take My Breath Away." In the absence of institutional reform, the ability to leverage Floyd's breath, either for or against him, becomes our "prescribed burn." Undeniably, the ambiguity is the violence.[28]

PART 2: SEEING DOUBLE: WHITE SUPREMACY AND THE EMANCIPATION LIE, 1863–1916

The ambiguity is the violence. Fifty years after the Emancipation Proclamation, Freeman Henry Morris Murray presented and later published *Emancipation and the Freed in American Sculpture: A Study in Interpretation*. The chapters from Murray's book were initially offered as a series of lectures for the Chautauqua and later published by Murray in 1916.[29] Murray's history is told from the perspective of a Black man on the anniversary of what he saw as a series of broken promises and the duplicity that resided at the very heart of emancipation. Murray unpacks the equivocations of discursive emancipation through close reads of sculpture. When I first agreed to write this essay for the Carter, I planned to focus on the following works: John Quincy Adams Ward's *The Freedman* (1863; see fig. 1.1); Mary Edmonia Lewis's *Forever Free* (1867; fig. 4.6); and Thomas Ball's *Emancipation Memorial* (1876; see fig. 5.3). For decades, these works have helped me think through the differences between the embodied experience of enslavement and the discourse of embodiment that mediates the meaning and impact of slavery as well as emancipation. But time, if we are fortunate, expands our perspective, and what I offer here is yet another layer of the onion, in this instance from Murray's standpoint.

Each sculpture carries with it a significant year in African-American history: Ward's sculpture was timed to follow President Abraham Lincoln's momentous

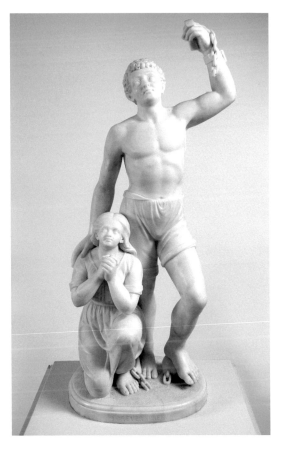

4.6 Edmonia Lewis (1843/5– ca. 1911), *Forever Free*, 1867, Carrara marble, 41¾ × 22½ × 12⅜ in., Howard University Gallery of Art, Washington, DC / Licensed by Art Resource, NY

announcement of the Emancipation Proclamation, an edict that granted only limited emancipation to those enslaved in breakaway states and in some cases districts of the Confederacy. Lewis's *Forever Free*, though created and named for the Emancipation Proclamation, was debuted four years later in 1867, which is the year that African-American men were granted the right to vote in the District of Columbia. Ball's sculpture, which bears the likeness of Lincoln and, on the column beside him, George Washington, was funded by a group of formerly enslaved people, erected during the nation's centennial, and spoke to the tests that the United States had undergone to create and preserve the union both because of and despite the presence of Black people.

Murray had something to say about each of these works. He describes the period following the Civil War as one committed to the "re-enslavement" of African Americans. Almost ninety-four years later, Marcus Wood describes the period variously as "the Emancipation Lie" and "the Horrible Gift

of Freedom." Wood is incandescent in his reasoning:

> If freedom as nature's gift has been violently removed from certain people, it can only be returned to those who have been robbed of it. Such a process of restoring stolen property is not the same as the process of bestowing a gift. And yet, again and again across the Atlantic slave diaspora the ex-slave powers, turned liberators, decided to fictionalize freedom as a pristine gift that was in their power, or the power of their allegorical figures, to bestow upon the victims of their abuse in a successive series of emancipation moments.[30]

For Murray, and later Wood, "emancipation" exists almost solely as mediated discourse and barely as fact. Consequently, Murray viewed Ward's *Freedman* as both history and prophecy:

> It is not difficult to see prophecy as well as history in its form, pose, and accessories: and even more, perhaps, in its lack of accessories. Indeed, if Mr. Ward were living now, fifty years after Emancipation, he could scarcely state the case more truly. The freedman's shackles are broken it is true, but still he is partially fettered; still un-clothed with the rights and prerogatives which freedom is supposed to connote—a "Freedman" but not a free-man.[31]

In each sculpture, Murray points out the ambiguity, the doubleness, and the duplicity relative to the "gift" of freedom that each work exposes. Although Murray never saw Lewis's two emancipation images at the time of his presentation and later publication, he did have access to nineteenth-century descriptions of the works. Although he confuses Lewis's *Freedwoman* with *Forever Free*, when he was later shown a photograph of *Forever Free* he claimed that seeing

it did not change his interpretation of it.[32] What is important is the weight that Murray gives to Lewis's rendering over Ward's by benefit of her experience.

> This cultured young artist, though descended from the two races mentioned [Lewis was Ojibwe and Black], was yet by American custom identified wholly with the Negro. Hence, she must needs see and feel her "Freedwoman" what it was almost or quite impossible that Ward should feel when modeling his "Freedman," admirable though it was.[33]

Granted, the embodied experience that Murray allows Lewis is one of "proximity" to enslavement, but what is astounding is that he privileges her perspective as "witness" rather than "evidence." Murray then notes the differences in the times in which the two works were created and what a difference only four years could make. "When Miss Lewis was modeling her 'Freedwoman,' in 1867, reaction—reenslavement, I had almost said—had set in. If, perchance, Mr. Ward and other sincere and absorbed souls had not observed it, Miss Lewis and 'her people' had felt it."[34] The "sincere and absorbed souls" that Murray invokes reminds us that as I wrote previously, within rhetorics of Whiteness, Black suffering has always been visible and necessary though the terms of its visibility continue to be subject to negotiation and interpretation. By privileging Lewis's perspective, Murray attempts to undo some of the harm inherent in the violence of representation.

The decision to turn Thomas Ball's sculpture into a stereograph card (literally "seeing double") puts a solid period to this section of my essay. Murray reminds us that Ball had not originally modeled an emancipation group; instead, he had conceived of the work as "Lincoln and the Kneeling Slave."[35] It is the nature of freedom, conceptualized to protect and preserve White supremacy, that allows the sculpture of a slave to suddenly become a representation of emancipation. And the fiction is complete, as Lincoln—here an allegory of "freedom"—waves a beneficent hand over the kneeling man as if to gift to him something that it was not Lincoln's to give. Murray writes, "The sculptor has given to the figures in this group attitudes and expressions which are too strongly suggestive of the conventional representations of Jesus and the Magdalene. In fact, Ball has come perilously near making Mr. Lincoln appear to be saying: 'Go, and sin no more,' or 'Thy sins be forgiven thee.'"[36] Despite the humor in the observation, Murray touches on another important aspect within discursive emancipation, which is the idea that the fault of enslavement rests with the character of the enslaved and thus the act of emancipation is actually one of forgiveness.

CONCLUSION: MANY UNHAPPY RETURNS: HOWARDENA PINDELL'S HAUNTINGS OF THE MIDDLE PASSAGE, 1988

For over fifty years, Howardena Pindell has made lasting change as an artist, activist, scholar, professor, and cultural critic. In her many guises, she moves fluidly between art academies, universities, museums, galleries, and the street because she must. Through rigorous process, Pindell is a diarist of the eternal and interminable present, holding herself and us accountable, beautifully rolling out the obligation to witness in the time that it takes to make her work and subsequently to behold it. Her autobiographies are about journeys and the right to act as witness to one's own journey. "Being a woman of color, I have experienced directly

the omission and under representation of works by women of color," she offers. "I have also noted how people of color, and their history and culture are being appropriated, distorted, and used as images and points of focus by white artists while artists of color are excluded from 'speaking' visually, interpreting themselves on the same platform." As a result, Pindell planned an exhibition of artists of color tasked with "interpreting themselves in the context of their choice, which may not be particularly pleasing to the dominant culture."[37] This was the context in which she began her Autobiography series.

Pindell indicts the use of her and other artists of color as evidence in the work of White artists. With the exhibition and subsequent Autobiography series, Pindell claims her right to bear witness to her life and her history. Four years after painting *Autobiography: Water / Ancestors / Middle Passage / Family Ghosts* (fig. 4.7), Pindell put pen to paper and described not only what she saw but also what she had learned of slavery in the intervening years. The torture, the institutionalized rape and victimization, all that she had learned caused her to approach her own work with fresh eyes. As for me, every time I see this work—whether in person or as a reproduction—I am moved by the sight of the heavily worked canvas that signifies the cold waters of the Atlantic

4.7 Howardena Pindell (b. 1943), *Autobiography: Water / Ancestors / Middle Passage / Family Ghosts*, 1988, acrylic and mixed media on canvas, 118 × 71 in., Wadsworth Atheneum Museum of Art, Hartford, CT, The Ella Gallup Sumner and Mary Catlin Sumner Collection Fund, 1989.17, © Howardena Pindell, Courtesy the artist and Garth Greenan Gallery, New York

Ocean, which serves as a grave for millions of Africans; I am stirred by the outline of the artist's body that seems to both float and drown in that same ocean, while the eyes and the faces that surround her bear witness. Pindell traced her own body onto the canvas, and so it powerfully indexes and reasserts the authority of her embodied experiences. Nevertheless, an abundance of presence is balanced by the representation and representational absence of the slave ship. In 1992, Pindell wrote, "An image of a ship with enslaved Africans during the Middle Passage is located on the lower left,"[38] but they are not there. The memory of her own work does the powerful job of filling in the black hatch marks, which represent African people. However, she sees what we all do in an act of automatic completion. The outline of the ship has come to truly represent the powerful work of abstraction, harnessed to enslavement. It is perhaps one of the most famous and evocative profiles in history, even as it is impossible to represent.

Kirsten Pai Buick is professor of art history and director of the Africana Studies program at the University of New Mexico and was named the 2022 Distinguished Scholar by the College Art Association.

NOTES

I would like to thank Horace Ballard for the initial invitation to join this project. I also extend my sincere gratitude to Maggie Adler and Will Gillham. Finally, I thank Eva S. Hayward, my friend and my most trusted editor and my most dependable companion in laughter and joy.

1 Zora Neale Hurston, *Dust Tracks on a Road: An Autobiography* (New York: J. B. Lippincott, 1942), 61.
2 Marcus Wood, *Blind Memory: Visual Representations of Slavery in England and America, 1780–1865* (New York: Routledge, 2000), 14–15.
3 "These Are the Victims Killed in the Kyle Rittenhouse Shooting in Kenosha," 5Chicago, November 19, 2021, https://www.nbcchicago.com/news/local/these-are -the-victims-killed-in-the-kyle-rittenhouse-shooting -in-kenosha/2689489/.
4 Karen Sánchez-Eppler, *Touching Liberty: Abolition, Feminism, and the Politics of the Body* (Berkeley: University of California Press, 1993), 8–9.
5 Calvin L. Warren, "Black Nihilism and the Politics of Hope," *CR: The New Centennial Review* 15, no. 1 (Spring 2015): 17: "The American dream, then, is realized through black suffering. It is the humiliated, incarcerated, mutilated, and terrorized black body that serves as the vestibule for the Democracy that is to come. In fact, it almost becomes impossible to think the Political without black suffering. According to this logic, corporeal fracture engenders ontological coherence, in a political arithmetic saturated with violence. Thus, nonviolence is a misnomer, or somewhat of a ruse. Black-sacrifice [sic] is necessary to achieve the American dream and its promise of coherence, progress, and equality."
6 Sánchez-Eppler, *Touching Liberty*, 9.
7 Jonathan Weisman and Reid J. Epstein, "G.O.P. Declares Jan. 6 Attack 'Legitimate Political Discourse,'" *New York Times*, February 4, 2022, https:// www.nytimes.com/2022/02/04/us/politics /republicans-jan-6-cheney-censure.html.
8 Phillip Lapsansky, "Graphic Discord: Abolitionist and Antiabolitionist Images," in Jean Fagan Yellin and John C. Van Horne, eds., *The Abolitionist Sisterhood: Women's Political Culture in Antebellum America* (Ithaca: Cornell University Press, 1994), 203.
9 Marcus Wood's chapter on the imagery of the Middle Passage is worth reading in its entirety. See Wood, *Blind Memory*, 14–75.
10 The model illustrated here is the first of two known models created during the eighteenth century. Commissioned by William Wilberforce in 1790, this model was based on the engraving of the *Brookes* and was made of wood and pasted copper (https://www.bl.uk /collection-items/diagram-of-the-brookes-slave -ship) [accessed May 25, 2022]. The second model was created by Gabriel Honoré de Riqueti, Comte de Mirabeau, and was to accompany his own demand

for the immediate abolition of the slave trade during the March 1790 meeting of the National Assembly in Paris. See also Wood, *Blind Memory*, 27–28.

11 Wood, *Blind Memory*, 29.

12 Wood, *Blind Memory*, 29.

13 Teresa A. Goddu, *Selling Antislavery: Abolition and Mass Media in Antebellum America* (Philadelphia: University of Pennsylvania Press, 2020), 6–23, 88–107.

14 For an in-depth examination of ship crowding during the Atlantic slave trade, see Nicholas Radburn and David Eltis, "Visualizing the Middle Passage: The *Brooks* and the Reality of Ship Crowding in the Transatlantic Slave Trade," *Journal of Interdisciplinary History* 49, no. 4 (Spring 2019): 533–565, https://doi .org/10.1162/jinh_a_01337.

15 Goddu, *Selling Antislavery*, 55–57.

16 Goddu, *Selling Antislavery*, 17.

17 Goddu, *Selling Antislavery*, 93.

18 Goddu, *Selling Antislavery*, 138.

19 Jean Fagan Yellin, *Women & Sisters: The Antislavery Feminists in American Culture* (New Haven: Yale University Press, 1989), 5–7.

20 Yellin, *Women & Sisters*, 5–7.

21 This was deemed the "emancipation lie" by Marcus Wood, who has written compellingly about the true cost of freedom in *The Horrible Gift of Freedom: Atlantic Slavery and the Representation of Emancipation* (Athens, GA: University of Georgia Press).

22 I was inadvertently part of such a project that moved Agassiz's subjects from anthropological specimens to art objects privileging maker, sitter, medium, etc. See Colin L. Westerbeck, "Frederick Douglass Chooses His Moment," *Art Institute of Chicago Museum Studies* 24, no. 2 (1999); 144–262.

23 Brian Wallis, "Black Bodies, White Science: Louis Agassiz's Slave Daguerreotypes," *American Art* 9, no. 2 (Summer 1995): 48.

24 Molly Rogers and David W. Blight, *Delia's Tears: Race, Science, and Photography in Nineteenth-Century America* (New Haven: Yale University Press, 2010).

25 Anemona Hartocollis, "Who Should Own Photos of Slaves? The Descendants, not Harvard, a Lawsuit Says," *New York Times*, March 20, 2019, https://www .nytimes.com/2019/03/20/us/slave-photographs -harvard.html; and Juliet E. Isselbacher and Molly C. McCafferty, "Agassiz's Descendants Urge Harvard to Turn Over Slave Photos," *Harvard Crimson*, June 21, 2019, https://www.thecrimson.com/article/2019 /6/21/agassiz-family-says-give-up-photos/.

26 Articles like Erin Blakemore's feed the notion that what was at stake with cartes de visite like Gordon/ "Whipped Peter" was the conversion of White Northerners to abolitionism. Her essay misrepresents Northerners' involvement in the slave trade as well as what was at stake for abolitionists (Northern or Southern, national or international), which was often not whether enslavement was wrong but instead how

do we untangle the nation from its necessity. See Erin Blakemore, "The Shocking Photo of 'Whipped Peter' That Made Slavery's Brutality Impossible to Deny," History.com, February 7, 2019; updated May 11, 2021, https://www.history.com/news/whipped-peter -slavery-photo-scourged-back-real-story-civil-war. The Metropolitan Museum of Art attributes the carte de visite in their collection to McPherson & Oliver and name the man in the image "Gordon" (https://www .metmuseum.org/art/collection/search/302544; accessed May 25, 2022). There is another attribution on the back of a copy of the carte de visite that bears the testimony from a surgeon about the condition of the man's back along with the signature "McAllister & Brothers, Opticians, 728 Chestnut Street, Philada" (https://commons.wikimedia.org/wiki/File:Scourged _Back_cdv_by_McAllister_%26_Brothers,_c1863 .jpg; accessed May 25, 2022).

27 Wood, *Blind Memory*, 260–71.

28 While Eva Hayward helped enormously in the crafting of this essay during long discussions and kindly reading drafts, the noted statement is all hers, and I am grateful.

29 Freeman Henry Morris Murray, *Emancipation and the Freed in American Sculpture: A Study in Interpretation* (Freeport, NY: Books for Libraries Press, 1916; reprint 1972).

30 Marcus Wood, *The Horrible Gift of Freedom: Atlantic Slavery and the Representation of Emancipation* (Athens, GA: University of Georgia Press, 2010), 3.

31 Murray, *Emancipation and the Freed in American Sculpture*, 16.

32 Murray, *Emancipation and the Freed in American Sculpture*, 225.

33 Murray, *Emancipation and the Freed in American Sculpture*, 22.

34 Murray, *Emancipation and the Freed in American Sculpture*, 22.

35 Murray, *Emancipation and the Freed in American Sculpture*, 29.

36 Murray, *Emancipation and the Freed in American Sculpture*, 27–28.

37 Howardena Pindell, *The Heart of the Question: The Writings and Paintings of Howardena Pindell* (New York: Midmarch Arts Press, 1997), 76.

38 Pindell, *The Heart of the Question*, 76.

Q&A

IF WE ALL WORK TOGETHER, WE CAN

MAKE THE WORLD A BETTER PLACE.

SABLE ELYSE SMITH

Is there a particular definition or concept of emancipation that holds true to you or your work?

As a human I am invested in the project of liberation.

This exhibition is landing in a moment when a global pandemic, systemic inequities of race and class, and climate precarity are front and center as we think about new futures. In what ways have current events transformed or shifted your work, if at all?

This question is ubiquitous now, and what sticks out to me is the idea that this list of things is "front and center." I think the pandemic is front and center. I feel like I can say that confidently. As far as systemic inequities, I think the visibility is complicated and nuanced. It's true of course that even the phrase "systemic inequity" feels commonplace now, something you encounter in the news, print media, entertainment, social media, museum statements, political speeches, and so forth. But visibility is a complicated animal. And the visibility or utterance of issues does not equate to real work being done or change made. Not all the time but sometimes visibility is about pacification. This awareness of these distinctions is important to me. Race and class inequity do not feel like current events but conditions that have historical roots and that persist. Conditions that my work has always been engaged with and always will. Nothing has shifted in my work as a response to what might be named current. My work just accumulates and crafts a longer more intricate narrative over time.

What texts do you assign to your students to help them think through the possibilities of sculpture in our contemporary moment?

Sable Elyse Smith, Photo by John Edmonds

Actually my favorite thing to read together in class with my students is a press release for a Kara Walker exhibition. And we argue and debate what constitutes an artwork and discuss aesthetic, tone, materiality, and objecthood. It is always a wildly invigorating conversation and opens up students' minds about the possibility, or rather how various moves can impart information and content. The release is for Walker's 2017 show *Sikkema Jenkins and Co. is Compelled to present The most Astounding and Important Painting show of the fall Art Show viewing season!*. We also read "Sculpture: Not-Not-Not (or, Pretty Air)" by Johanna Burton from the book *The Uncertainty of Objects and Ideas: Recent Sculpture*.

A word that you have associated with your practice is "quotidian," which has both the meanings of the everyday commonplace as well as something shocking or malignant that raises the commonplace to critical attention. Could you say more about the significance of this word in your practice as it relates to emancipation and incarceration?

I am of course very intentional about the language I use. But I feel like here my emphasis is not so much the word but the idea of the everyday or the banal or the mundane or commonplace as a way to actually bring us outside of our narrow understandings of prison or unfreedom. To recognize and trace the reach, the impact . . . where the violence of these systems begins. Where the "path" to prison begins. To articulate that prison, for example, begins way before the brick-and-mortar architecture comes into view. I point to realities of our day-to-day that bring into focus what Christina Sharpe calls "the weather" in her book *In the Wake: On Blackness and Being*.

THE FRÉMONTS AND *THE FREEDMAN*

ANDREW J. WALKER

5.1 Tyler Hammel, "Fate of
Charlottesville Statues Still Awaits
Court Decisions," *Daily Progress*
(Charlottesville, VA), July 2, 2020

Monuments have been under siege as sites of political dispute over historical accuracy for most of our nation's history. In July 1776, American patriots toppled a monument to King George III in Manhattan; the statue was viewed as a symbol of British oppression.[1] But ever since the deadly Unite the Right White supremacist rally in 2017 in Charlottesville, Virginia, the urgency of claiming the historical narrative has risen to a fevered pitch. During that protest, groups of mostly White men descended upon Charlottesville in a show of force after the city proposed the removal of Confederate monuments, including a massive statue of Robert E. Lee on Monument Avenue. The rally turned violent, resulting in the death of a counter-protestor.

In 2020, following the murder of George Floyd by Minneapolis police, debates were still ongoing in Charlottesville's city government about how and when to dismantle the Lee monument. The site of the statue became a focus for protests in the name of social justice and the Black Lives Matter movement. Protesters repurposed the monument's Confederate past to engage contemporary issues, including by adding graffiti and light projections related to Floyd's murder (fig. 5.1).

In 2021, the statue of Lee was finally removed from its perch and donated to the local Jefferson School African American Heritage Center, which planned to melt it down and use its base metal to fashion a new

monument to celebrate "community values" relevant to contemporary social justice.[2] The transformation reflects the powerful agency of those previously excluded from the monument's narrative in determining a new, more historically accurate recounting. The Lost Cause story, which originated soon after the Civil War and still seeks to justify and honor the Confederacy's heritage, fueled the monument's original commission in 1917.

Community activists and artists in Franklin, Tennessee, wound up taking a different approach to the towering 1899 monument of a Confederate soldier standing in their town square: Rather than its removal, a new life-size monument of a Black Union soldier was positioned nearby (fig. 5.2). The new work, spearheaded by local residents and universally approved by the city, provides a missing part of the war's complicated narrative. As one participant at the unveiling observed, "Here is a Black man who was enslaved, who gave his life to go out to help free other people. . . . Because he

5.2 Sarahbeth Maney, "People Gather for the Unveiling and Dedication of a U.S. Colored Troop Soldier Statue in Franklin, Tennessee," *New York Times*, October 23, 2021, Sarahbeth Maney/New York Times/Redux

was willing to do that, we won—what a powerful message." And Joe Frank Howard, the sculptor of the monument, noted, "The first step toward true freedom for people of color in America was that war."[3]

Monuments commemorating aspects of the Civil War and its impact on civil society have tended to focus on individual leaders or the common soldier—and monuments to mark the eradication of slavery are few. The most notable among them is Thomas Ball's *Emancipation Memorial* in Lincoln Park in Washington, DC (fig. 5.3); funded by formerly enslaved people who had fought for the Union during the Civil War, the sculpture was dedicated in 1876. Ball developed the monument's design, in part, as a response to Lincoln's assassination, choosing as his subject the Emancipation Proclamation. The work depicts a Black man, shirtless and on his knees, in front of a fully clothed and standing Abraham Lincoln. In his right hand Lincoln holds a copy of his proclamation, while his left hand stretches out over the kneeling freedman. In recent times even this work, long considered a monument to the good intentions of well-meaning people, has come under scrutiny as supporting White supremacy.[4] In 2020, another version of the sculpture was removed from Boston's Park Square, where it had stood since 1879. In historical context, the sculpture lies along a paradoxical fault line, even though formerly enslaved people raised the funds to pay for it and supported its placement in the nation's capital. In her study of monuments and memorials, Erika Doss discusses these processes as a form of historical revisionism.[5]

This exhibition and publication take as their subject the artistic representation of emancipation as it relates to contemporary issues, including the removal, adaptation, or retention of historical monuments within the public sphere. The historical referent

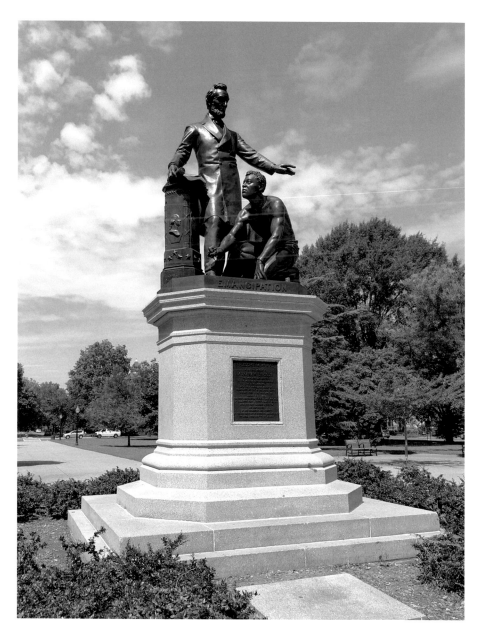

5.3 Thomas Ball (1819–1911), *Emancipation Memorial*, 1875, bronze, National Capitol Hill Parks-East, National Park Service

for this project, wherein seven living Black American artists take up the subject of emancipation—of freedom—is John Quincy Adams Ward's *The Freedman* (see fig. 1.1), a sculpture that was cast in 1863 to celebrate Lincoln's Emancipation Proclamation issued the same year. Modeled from life, *The Freedman* is generally considered one of the first representations of a Black American to be cast in bronze.[6] When a plaster cast of the statue was exhibited in New York shortly after the formal issuance of the Emancipation Proclamation, art critics applauded Ward's careful attention to the dignity and physical strength of his subject. "It is a mighty expression of stalwart manhood," one writer observed,[7] and the critic James Jackson Jarves wrote a glowing assessment of the work: "A naked slave has burst his shackles, and with uplifted face thanks God for freedom. . . . It tells in one word the whole sad story of slavery and the bright story of emancipation."[8]

Rarely depicted as agents of their own liberation, enslaved people who had been freed were commonly portrayed in the 1860s as the passive recipients of an emancipation initiated by Lincoln, as in Ball's memorial. Ward, however, offered an alternative that commentators of the day interpreted in specific terms: This Black American was understood to be a fugitive slave who had broken his own shackles, left his plantation, and fled northward to seek freedom within the ranks of the Union Army.

This intersection between individual agency and military opportunity is crucial to understanding how *The Freedman* attracted the attention of collectors, which were few despite the critical attention paid to the work. One prominent abolitionist, however, commissioned a copy of the sculpture from Ward in 1864: Jessie B. Frémont, wife of John, the great adventurer and military

officer best known for his exploration of the American West in the 1840s and for being nominated for the Republican presidential ticket in 1856, bolstered in part by his fierce antislavery stance.

With the campaign slogan "Free Soil, Free men, and Frémont," he ultimately lost the election, though his antislavery resolve only strengthened. What may be less well known is his controversial advocacy for emancipation while serving in the Union Army. Appointed in 1861 as major general heading up the army's Department of the West and headquartered in St. Louis, Frémont took an aggressive stance against rebel sympathizers whose numbers were strong in Missouri. In a bold act, he issued a proclamation on August 30, 1861, that declared martial law and transferred state power to the military. The proclamation also freed all the enslaved people owned by Confederate sympathizers in the area under his command. His actions, as many historians note, constituted the first emancipation of enslaved people, and earned him simultaneous adulation and disdain. What distinguished his act was that Frémont put military over civil authority and insisted that all property held by Confederate supporters be surrendered. He proclaimed without falter a military-backed emancipation.[9]

Frémont's martial law proclamation frustrated President Lincoln, who knew nothing of it before it was issued. The major general's act put in jeopardy the states, including Missouri, that had yet to choose a side in the war. Enslavers in Missouri advocated for Frémont's immediate removal, and Lincoln leaned in that direction; Frémont had, after all, proved an ineffective military commander. For the president, military emancipation threatened the delicate balance of the Union by antagonizing loyal enslaver states and undermining civil authority. It further exceeded Congress's newly initiated confiscation laws. Seeking to reverse Frémont's actions and maintain political balance, Lincoln ordered Frémont to rescind the edict on September 11, 1861. Frémont refused, and the president issued a public order annulling the act. By October, Frémont had been removed from his command.

Frémont's demotion was a devastating personal blow. He left St. Louis with Jessie and eventually settled in Sleepy Hollow, New York. Among the abolitionists, however, he became a hero celebrated by poet John Greenleaf Whittier and clergyman Henry Ward Beecher, who publicly proclaimed, "Your name will live and be remembered by a nation of *Freemen*."[10]

From their home in New York, both John and Jessie became ardent supporters of the moral cause of emancipation. On Valentine's Day in 1864, Jessie wrote in a letter to Whittier a description of a vignette that she had composed in her home above a stack of antislavery books: "I put a [sculpture by] [John] Rogers called the Slave Auction (fig. 5.4). Have you ever seen it? And to finish the idea I have added a piece of a rebel gun taken at Fort Wagner—one of the guns that mowed down the 54th Mass. Young Hallowell, a quaker of the war kind & now the head of the regiment, sent me the piece of the gun."[11]

This remarkable antislavery plaster likely led to Jessie's decision to order a version of *The Freedman* from Ward. The choice makes sense; the sculpture represented a fitting sign of the emancipation that John had initiated with his martial law order. The individuality of the Black man also underscored the couple's radical view that America should be a true social and economic democracy in which Blacks also merit civil rights. In an undated letter, but likely from 1865, Jessie wrote to Ward telling him that she was ready

to send the "Fort Wagner irons" for incorporation into the sculpture.[12] In a later letter to Eliza Ballard of St. Louis, Jessie again tells the story of their cast of *The Freedman*: "The bronze is from the gun of the young Shaw who raised and led his negro troops, the 54th Massachusetts, to their death—and his—at Fort Wagner, SC."[13]

There is much to unpack here, not the least of which is the irony of a rebel gun and Shaw's own weapon making up the "Fort Wagner irons" that Jessie and her husband possessed. Underneath the irony is the persistence of the Frémonts to see the sculpture as a work that made a moral, rather than a political, statement that defined their public life. Both fashioned their abolitionist

beliefs as core to their identities, and the importance of the statue's narrative—of Black American agency through the example of the Massachusetts Fifty-Fourth—they placed on the work cannot be overstated. Here, it is the agency of the formerly enslaved, fighting for their own freedom, that is deemed worthy of a public monument. In the same letter to Ballard, Jessie wrote about the advocacy of the Fifty-Fourth to embody public memory, encouraging her friend to visit Augustus Saint-Gaudens's *Shaw Memorial* (1897) in Boston Common: "You should see the bronze memorial . . . in Boston, it is notable."

The focus on the Fifty-Fourth may be manifested in the version of *The Freedman* that is at the Carter and that Jessie commissioned in a unique and remarkable way. The manacle in the figure's right hand is engraved with a tribute to the Fifty-Fourth, and the shackle can be opened and closed with a key, serving as a powerful reminder of the still-unresolved issue of slavery at the time (see fig. 1.5).

Both Jessie and John were aware of how to market an idea and to assert that their commissioning of *The Freedman* represented their antislavery stance: emancipation linked to military service. An important second commission reinforces this story line. In 1867, just two years after the sculpture entered their lives, the Frémonts engaged the Italian artist Giuseppe Fagnani to paint their portraits. The painting of Jessie is lost, but that of John currently resides in the collection of the Missouri Historical Society in St. Louis. In the portrait, Frémont is dressed in the military uniform he wore while in command of the Department of the West. He deliberately chose attire linked to his controversial service in which he freed enslaved people held by Confederate rebels and sympathizers. His act of military

5.4 John Rogers (1829–1904), *The Slave Auction*, 1859, painted plaster, 13⅜ × 8 × 8¾ in. Gift of Mr. Samuel V. Hoffman, New-York Historical Society, 1928.28

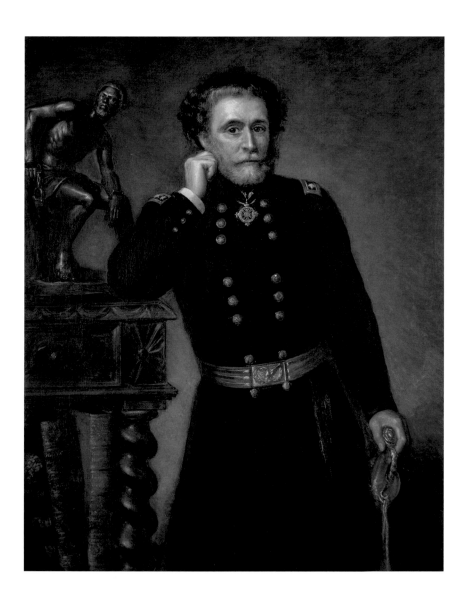

5.5 Giuseppe Fagnani (1819–1873), *General John Charles Fremont*, 1867, oil on canvas, 50½ × 40½ in., Missouri Historical Society, St. Louis

emancipation is further underscored by a cast of *The Freedman*, surely his and Jessie's, on a pedestal above his right shoulder (fig. 5.5).

The association of *The Freedman* commissioned by Jessie to the Fifty-Fourth Massachusetts connected the work to a specific narrative that during the Civil War proved to the Northern populace that Black Americans were heroic, strong, and worthy of citizenship. Given its prominent placement in John Frémont's portrait, the sculpture's status as a work of towering antislavery significance was further affirmed. To make this significance concrete, the Frémonts had two choices available to them regarding the work's execution. The first choice would have made the commission monumental in size as well as subject, scaling the original to a large size and setting it in public to celebrate emancipation. Jarves suggested this, stating the work must be cast in "heroic" size and placed on the US Capitol grounds alongside Horatio Greenough's statue of George Washington "to commemorate the crowning virtue of democratic institutions in the final liberty of the slave."[14] That distinction, however, would be manifest in Ball's sculpture for Washington, DC. The second choice, and the one chosen by the Frémonts, followed the practice popularized by John Rogers: the widespread manufacture of narrative sculptures for display in the family home or municipal buildings. They may have taken their lead from the observation of historian Henry Tuckerman, who in 1867 suggested the sculpture be replicated cheaply and in small scale so that the widest possible audience could display *The Freedman* in their homes.[15]

The transformation of Ward's design through an additive process of material directly connected to Fort Wagner and the Fifty-Fourth Massachusetts shows an

intentionality that closes in on a public statement. Unfortunately, the diminishing social and political influence of the Frémonts throughout the post-Reconstruction era limited their reach and lessened *The Freedman*'s impact. Ironically, their fall from grace was marked when in 1877 they were forced to auction off most of their possessions, including *The Freedman* and the portraits by Fagnani. As historian John Mack Faragher noted, "The auction marked the destruction of not only Frémont's fortune but his reputation as well."[16] Only in the years preceding her death did Jessie again revive the story of *The Freedman* and her husband's portrait in a letter to Eliza Ballard, who had purchased the Fagnani portrait of her husband.

Today, however, the story has been reconstituted and extended to the Black civil rights leader who eventually acquired what is likely to have been the Frémonts' copy of *The Freedman*, Zelma Watson George (see fig. 1.6). But the story also extends to the work highlighted in this exhibition and publication: an experience that underscores that history is never static, and that emancipation and expressions of freedom find relevance in the joys and struggles of the present day.

Andrew J. Walker is executive director of the Amon Carter Museum of American Art.

NOTES

1 Wendy Bellion, *Iconoclasm in New York: Revolution to Reenactment* (University Park: Penn State University Press, 2019), 17–58.
2 Caroline Goldstein, "Charlottesville's Divisive Robert E. Lee Statue Will Be Melted Down to Create New Public Artwork," *Artnet News* (December 8, 2021).
3 Jamie McGee, "Remove a Confederate Statue? A Tennessee City Did This Instead," *New York Times*, October 25, 2021, sec. A, 12.
4 See Renée Ater, "On the Removal of Statues: Freedman's Memorial to Abraham Lincoln," blog post, July 1, 2020, https://www.reneeater.com/on -monuments-blog/2020/7/1/on-the-removal-of -statues-freedmens-memorial-to-abraham-lincoln.
5 Erika Doss, *Memorial Mania: Public Feeling in America* (Chicago: University of Chicago Press, 2010), 340.
6 Kirk Savage, "Molding Emancipation: John Quincy Adams Ward's *The Freedman* and the Meaning of the Civil War," *Art Institute of Chicago Museum Studies* 27, no. 1 (2001): 27.
7 "Mr. Ward's Statue of the Fugitive Negro, at the Academy of Design," *New York Times*, May 3, 1863, https:// www.nytimes.com/1863/05/03/archives/mr-wards -statue-of-the-fugitive-negro-at-the-academy-of -design.html.
8 James Jackson Jarves, *The Art-Idea*, ed. B. Rowland Jr. (Cambridge, MA: Harvard University Press, 1960), 225.
9 Chandra Manning, *Troubled Refuge: Struggling for Freedom in the Civil War* (New York: Alfred A. Knopf, 2016), 182.
10 Henry Ward Beecher, in Sally Denton, *Passion and Principle: John and Jessie Frémont, the Couple Whose Power, Politics, and Love Shaped Nineteenth-Century America* (New York: Bloomsbury, 2007), 330.
11 Jesse Fremont to Eliza Ballard, June 26, 1902, Thomas H. Benton Collection, box 2, folder 3, Missouri Historical Society Archives.
12 Jesse Fremont to John Quincy Adams Ward, Dec. 23 [no year], John Quincy Adams Ward Papers, 1800–1933, CM 544, Albany Institute of History & Art Library, Albany, NY, Ward Papers, box 2, folder 3.
13 Jesse Fremont to Eliza Ballard, June 26, 1902, Thomas H. Benton Collection, box 2, folder 3, Missouri Historical Society Archives.
14 Jarves, *The Art-Idea*, 225.
15 Henry T. Tuckerman, *Book of the Artists: American Artist Life Comprising Biographical and Critical Sketches of American Artists, Preceded by an Historical Account of the Rise and Progress of Art in America* (New York: Garland Press, 1967), 581–82.
16 John Mack Faragher, "The Frémonts: Agents of Empire, Legends of Liberty," in *Empire and Liberty: The Civil War and the West*, ed. Virginia Scharff (Berkeley: University of California Press, 2015), 44.

Q & A

JEFFREY MERIS

Is there a particular definition or concept of emancipation that holds true to you or your work?

My worldview is informed by growing up in the Bahamas, a paradise to some and a harsh escalator of upward mobility to others. I fit in the latter part being an immigrant of Haitian ancestry. I immigrated to America, "the land of freedom and opportunity," in my midtwenties where, for the first time in my life, I had to deal with the conundrum of race. This is not to say the Bahamas was paradise when it came to race either—more that being in the cultural majority provided a political mirage. When I think about emancipation, it is this long arc of living in an otherwise racialized, queer, and othered body. I think of emancipation as being collective work not just for people of the African diaspora but more universal for all humans. How are we still having conversations around the significance of teaching the effects and aftermath of colonial terror and racism? What would it look like to abandon the pressure of hegemonic social and political structures?

This exhibition is landing in a moment when a global pandemic, systemic inequities of race and class, and climate precarity are front and center as we think about new futures. In what ways have current events transformed or shifted your work, if at all?

During the summer of 2020, I had a paradigm shift. I thought about how Black death became such a spectacle and how the hashtag became a bottomless abyss for this trauma. What does it mean to reduce an entire human existence to a symbol on the internet? I needed to shift the gaze. My work oscillated away from the trauma and

Jeffrey Meris, Photo by Merik Goma

violence of racialization and became much more invested in care, healing, and futurity. Since then, a major part of my practice is actually self-care. This radical act of tending to the body and spirit is often reflected in my work: paintings made using fabric that had cleansed my rusted sculptures, installations that use plants and require tenderness and routine care. Of course, unpacking anti-Black colonial violence is important, but so is caring for ourselves. What would caring for this deep history of inequity, colonial violence, and otherness look like?

Could you speak to the material points of balance, tautness, and suspension that often occur in your work?

I make work that is both bodily and architectural. By stretching fabric, cotton is suddenly transformed and functions as skin. The body becomes architecture; the body becomes the home. What better way to talk about society than to talk about the most intimate part of it (the home)? Architecture is relation; it tells us how and where we are in space. In a work such as *The Block Is Hot* (following page) I suspend a forty-pound cinderblock from the wall using aircraft cable and custom-welded mount to balance a Hydrocal cast of my torso. This suspension is both technical (to help reduce torque on the motor attached below) as well as conceptual, considering the balance of self with other societal pressures. In the Bahamas, T1-11 plywood is often used to construct homes. A more stable upper-class home would be constructed using cinderblocks, so in many ways I am balancing myself against a wider pressure of upward (class) mobility. The block also becomes a cultural synonym in urban culture indicating a uniquely Black experience where the likes of rap and graffiti were produced as a response to the state

Jeffrey Meris, *The Block Is Hot*, 2020, plaster cast, AC motor, steel, concrete, U link, pulleys, ratchet strap, 96 × 66 × 32 in., Courtesy of the artist, © Jeffrey Meris

of Blackness. I am moving up the capitalist ladder only to be ground down by its pressure. This system wasn't built for my people to succeed, much less survive.

> **This exhibition is deeply tied to threads of emancipation emerging from the American Civil War. As an artist who was born and raised in a different geographical place with a different history of race and gender than the United States, what themes or perspectives on emancipation most deeply resonate for you?**

African Americans are a part of the Global South. I am from the Global South. We share a diasporic spiritual and cultural connection, although geographically we are different. The Civil War was about the emancipation from slavery, but the subjugation of Blackness never ended, much like it remains for Black people in my homeland. A deep reimagining of country and nation is needed to go beyond this colonial violence. We have to rethink our institutions—cultural, architectural, and civic institutions, among others.

Q & A

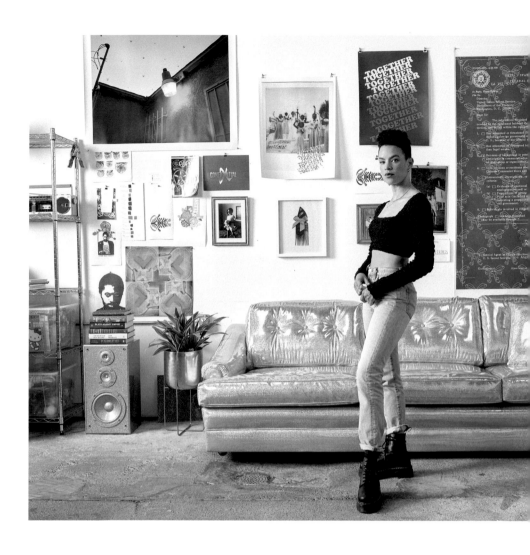

SADIE BARNETTE

Is there a particular definition or concept of emancipation that holds true to you or your work?

When I think about emancipation I think about abolition. I think about letting go of how we currently organize our societies and planting something new. I think about letting go of capitalism and imperialism . . . I imagine a world where no one wants to be "The Richest Man in the World." A world where wealth is measured by how much you share. I'm thinking of a world where not everything is for sale—health and dignity for example. Housing and healthcare would be decommodified and prisons would be no more. I think of the writing and scholarship of Angela Davis and Ruth Wilson Gilmore.

Much of your work relates to lived histories and often directly incorporates historical documents. To what extent do the material brilliance of glitter, rhinestones, and color contrast or contribute to that historical inquiry?

In relation to my FBI project, splashing the documents with pink or glitter was one of the first times that I felt the power of weaponizing that type of glittery, high-shine aesthetic. To me it is a "high-femme" aesthetic that exists beyond a binary notion of gender. I'm thinking about over-the-top manicures, jewelry, and flamboyant adornment as a language and a tool that people use to find each other and see each other and take up space in a way that is very much about showing out—an extra flex of a high-femme play, performance, and embodiment. I figured pink glitter would be a kind of kryptonite to J. Edgar Hoover's tortured ghost. The holographic material I use also proposes an imagined restorative technology, a type of countersurveillance. The glitter and

brilliance also point to another dimension of human possibility . . . political and social structures are often the foundation of my work, but I'm also dreaming beyond those realities, and the glitter holds space for that imagining (following page).

Some of your works deal directly with moments of oppression, discrimination, and abuses of power. Does your practice of including vital elements of the fantastical, the futuristic, and the joyous influence your conception of freedom?

I make space for hope in my work, not because I always feel hopeful but so that the work can be a light for when I don't. I make the work beautiful because we are beautiful and aren't waiting for the revolution or a perfect world in order to fully inhabit our perfect selves. I think about all the struggles and violence that my family, my ancestors, have endured but/and/also they are still falling in love, they're still looking fly, they're still writing poetry, they're still making music. We don't need to attain a political utopia or a perfect world (although we deserve it) to be our fully formed beautiful selves. Here we are.

Are terms like healing and liberation apropos to an understanding of your work?

For the powdered-graphite reproductions of FBI pages, I ask myself while I work: Can something happen in this process of me rubbing graphite into this paper, by adding flowers or diamonds or Hello Kitty to these FBI files? It's adornment and has a lot to do with beauty and care, but it's also about adding another layer of annotation and redaction that comes from my lexicon.

Sadie Barnette, Courtesy of the artist and Jessica Silverman, San Francisco, Photo by Chanell Stone

I embellish with roses to honor, to mourn and memorialize, to add life, and to suggest evidence of the domestic and rituals of care. The slowed-down, labor-intensive act of making these pages into drawings affords me time to meditate on the bravery, the politic, the real-life people, sisters, fathers. My interest in activism of the 1960s and 1970s is not hypothetical or aesthetic; there is so much at stake. Though public opinion about the Black Power movement has changed favorably in the last decade or so, no real repair has come to the individuals and families harmed by the state-sanctioned violence. Perhaps these drawings are my spells—drawing as incantation, cast for healing and real justice. They are evidence of a fierce love (opposite page).

Sadie Barnette, *Untitled (Agitator Index)*, 2018, collage and aerosol paint on archival pigment prints, mounted to plexiglass, 62¾ × 48 in., Courtesy of the artist and Jessica Silverman, San Francisco, © Sadie Barnette

Sadie Barnette, *FBI Drawings: Do Not Destroy*, 2021, powdered graphite on paper, 60 × 48 in., Courtesy of the artist and Jessica Silverman, San Francisco, © Sadie Barnette, Photo by John Wilson White

U. S. Department of Justice

(MATERIAL MUST NOT BE REMOVED FROM OR ADDED TO THIS FILE)

FEDERAL BUREAU

of

INVESTIGATION

USE CARE IN HANDLING THIS FILE

Transfer-Call 3421

THE FREEDMAN IN MULTIPLE:

A LOOK AT ITS CASTING HISTORY

THAYER TOLLES

One hundred sixty years have passed since John Quincy Adams Ward created *The Freedman* (see fig. 6.1), representing a seated seminude Black man with broken shackles and chains of enslavement. During this time, the statuette has accumulated multivalent, shifting layers of resonance—individual, generational, social, racial, emotional, political, and institutional. It yields itself to boundless avenues of inquiry and response; its narrative intentionally eludes a clear outcome—as did the trajectory of African-American emancipation itself. Yet on the simplest level, *The Freedman* is a three-dimensional object with compelling stories to tell us about its facture and replication. What does its production and casting history reveal about Ward's own perceptions of and ambitions for the sculpture, not to mention those of White critics and patrons who were his contemporaries? And how does focusing on its materiality inform how twenty-first-century viewers bring their own life experiences and perspectives to bear in responding to this object?

As object origin stories go, it is said, though not documented, that Ward was likely inspired to model *The Freedman* after President Abraham Lincoln issued the Emancipation Proclamation on September 22, 1862. Just over two weeks after it took effect on January 1, 1863, freeing 3.5 million enslaved African Americans in secessionist Confederate states, first notice of the sculpture appeared in the *Boston Evening Transcript*: "J. Q. A. Ward . . . is just finishing a statuette, 'The Freedman,' being the figure of a negro slave, who has just broken his manacles. The expression, posture and modelling of this figure are extremely fine."[1] Indeed, what we know of *The Freedman*'s journey from clay to plaster, and from plaster to bronze, may be traced through archival sources ranging from letters to exhibition

catalogues to newspaper and journal articles. Equally important are the eight located bronzes and one plaster in institutional collections (listed at end). Their respective physical characteristics as well as provenance histories inform an overall casting chronology while very much reinforcing their status as individual objects within an edition produced over a fifty-year span, both during Ward's lifetime and posthumously.

Ward established himself in New York in 1861 after time spent modeling portraits in Washington, DC (1858–60), and in his home state of Ohio (1860–61). With no commissions for monuments during the lean Civil War years, he immersed himself in the replicative possibilities of bronze and other alloys to generate much-needed income. He designed decorative metal elements for specially commissioned handheld objects—for instance, grips for pistols, handles for canes, and hilts for presentation swords (fig. 6.2).[2]

Ward was employed in 1862–63 by Ames Manufacturing Company of Chicopee, Massachusetts, a firm he became familiar with during his tenure as a studio assistant to New York sculptor Henry Kirke Brown between 1849 and 1856. Ames was a munitions operation that by the mid-1850s had emerged as the leading art bronze foundry of its day, which were then very few. It cast Brown's smaller bronzes, as well as *DeWitt Clinton* (1850–52; Green-Wood Cemetery, Brooklyn) and *George Washington* (1853–56; Union Square, New York), the latter on which Ward's name was inscribed alongside Brown's in recognition of his contribution to its production. While working with Ames on decorative work, Ward also engaged with the New York foundry L. A. Amouroux, producer of sculpture and "fancy bronzes" for small utilitarian objects, among them a matchbox and a vase.[3]

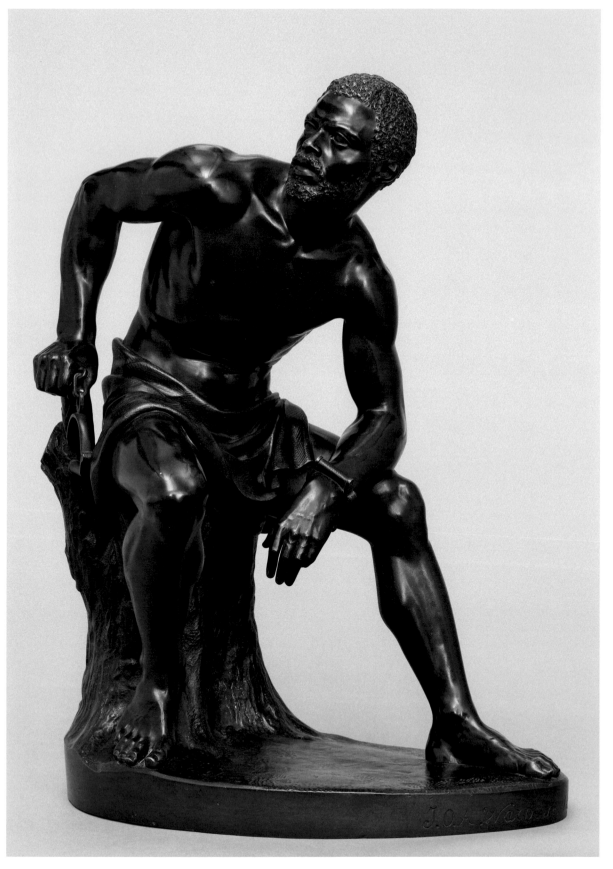

6.1 John Quincy Adams Ward (1830–1910), *The Freedman*, 1863, bronze, 19½ × 14¹¹⁄₁₆ × 9⅝ in., Courtesy of the Boston Athenaeum

6.2 John Quincy Adams Ward (1830–1910), Manufacturer: Ames Manufacturing Company (1829–1935), *Naval Presentation Sword*, ca. 1865, steel, copper alloy, gold, walrus tusk, wood, 37⅛ × 4⅝ in., The Metropolitan Museum of Art, Promised Gift of Edward V. LaPuma, in celebration of the Museum's 150th Anniversary, L.2020.14a, b, image © The Metropolitan Museum of Art, image source: Art Resource, NY

While Ward gained valuable experience under Brown's tutelage, he was by no means an established sculptor when he completed *The Freedman*. Thus this statuette specifically, and small-scale sculpture generally, factored significantly into his aspirations to become a successful professional artist among New York's cultural elite. While not as prestigious as monumental commissions, by the mid-nineteenth century domestic-scale sculptures served several important promotional functions for their makers. They attracted prospective clients, they represented a potential revenue stream, and they provided critics with the artistic fodder to (ideally) boost reputations. Ward's first editioned statuette, *The Indian Hunter*, a lithe Indigenous youth with a dog (fig. 6.3) was exhibited in plaster in 1859 and cast in bronze, probably at Ames Manufacturing Company, as early as 1860, the date inscribed on located examples. Its display two years later in bronze at the annual exhibition of the National Academy of Design was well received and led to Ward's election as an associate member of the organization, then the epicenter of the American art world.

That Ward saw *The Freedman* as a potential agent of commodification is attested to by how and where he exhibited it, strategically putting it before an abolitionist audience to whom it might appeal. By April 1863, he had produced at least two plasters of the sculpture (fig. 6.4) and quickly moved to put it to public test and grant it institutional imprimatur. That spring Ward submitted casts to the annual exhibitions at the National Academy of Design and the Pennsylvania Academy of the Fine Arts; each catalogue notes that the submission was a "model for bronze."[4] Sculptors often exhibited their works in plaster, both to get critical feedback before translating

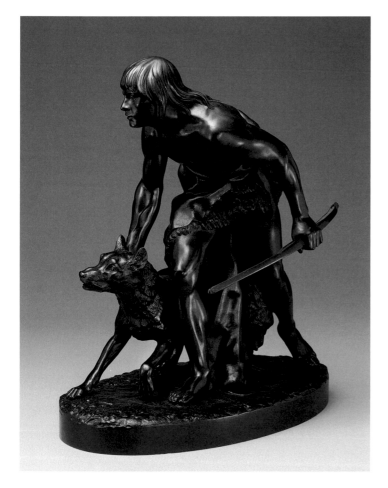

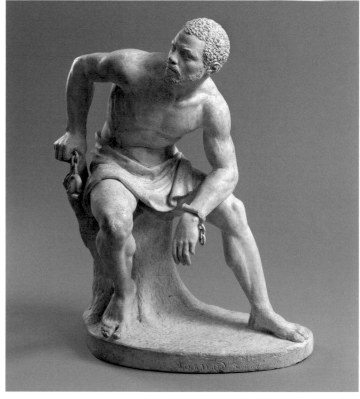

6.3 John Quincy Adams Ward (1830–1910), *The Indian Hunter*, 1860, bronze, 16⅛ × 10½ × 15¼ in., The Metropolitan Museum of Art, New York, Morris K. Jesup Fund, 1973, 1973.257

6.4 John Quincy Adams Ward (1830–1910), *Freedman*, 1863, plaster, tinted yellow ochre, 20¼ × 15 × 7 in., Courtesy of the Pennsylvania Academy of the Fine Arts, Philadelphia. Gift of the artist, 1866.2

them to the permanent materials of marble and bronze, and to attract patrons who might underwrite that effort. Reviews of *The Freedman* were enthusiastic, and Ward was elected a full Academician of the National Academy at a comparatively accelerated pace. With the successful displays of *The Indian Hunter* in 1862 and *The Freedman* in 1863 at the National Academy, he garnered the attention of art writers who acknowledged the timeliness and resonance, indeed the urgency of creating Indigenous and Black subjects in sculptural form. At the same time these artworks were celebrated by White audiences as signaling distinctive American identity and independence from generic European-inspired ideal subjects, they blatantly sidestepped the cultural and

political cruelties of Indian removal and African-American enslavement.

Ward's rising profile was aided greatly by the power of the popular press. The earliest known illustration of *The Freedman* is a wood engraving (fig. 6.5) that appeared on March 12, 1864, in *Frank Leslie's Illustrated Newspaper*, a weekly literary and news publication with a broad circulation.[5] It is unclear whether the faithfully reproduced image depicts a bronze or a plaster, likely the latter given the lack of firm documentation for bronze statuettes earlier than this date. The first published mention of a bronze cast dates to November 1864, when a statuette was on view at Goupil & Co., the New York outpost of a Parisian firm known for bringing French paintings and prints to

6.5 *The Freedman*, in "The Freedman, by Ward," *Frank Leslie's Illustrated Newspaper* XVIL, no. 441 (March 12, 1864): 389. Courtesy of Accessible Archives Inc.

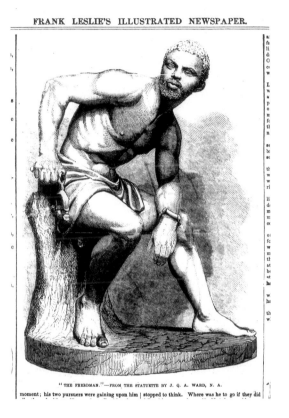

FRANK LESLIE'S ILLUSTRATED NEWSPAPER.

"THE FREEDMAN."—FROM THE STATUETTE BY J. Q. A. WARD, N. A.

number of copies, as it should be seen and possessed by the great mass of the people. Why cannot we have copies in clay-colored material? It would fill a great want in our available sculpture—something to educate the people, to point out the legitimate province of that dignified art, of which Mr. WARD is one of the most illustrious and honored disciples.[6]

That Ward was resolute in his choice of permanent material of bronze is telling, for beyond its symbolic potential (see Parnell, pp. 22–38) it was seen as democratic and durable, more affordable and accessible than the Italian marble that for three decades had dominated American sculptural production both at home and abroad. Art bronze production through the sand-casting method, while highly operational in Europe, was in its infancy in the United States. It emerged in the late 1840s through the efforts of Clark Mills in Washington, DC, and Henry Kirke Brown in Brooklyn.[7] During this time, Brown, the first American sculptor to consistently sand-cast bronzes, produced two statuettes in editions of twenty, *Filatrice* (1849) and *Choosing of the Arrow* (1850), for distribution by lottery through the American Art-Union. He recognized the appeal of the small bronze for American audiences, and his successful example resonated with Ward who had learned the fundamentals of casting and finishing bronze while in his employ.

Ward eschewed a legitimate path suggested by the *New York Times* critic—replicating and selling *The Freedman* in tinted plaster for "the great mass of people." This approach was exemplified by John Rogers, the New York-based sculptor who marketed his Rogers Groups to a broad populace for ten to twenty-five dollars apiece. His Civil War subjects hit a responsive and

American shores. In an extended description, the writer for the *New York Times* called out the long gestation between the plasters of spring 1863 and the bronzes, presumably of fall 1864, as well as the pedagogical potential represented by the circulation of casts:

> For more than a year we have patiently awaited its reproduction in some permanent material: and if so much time was necessary to produce it in its present form, we do not regret it, for certainly it is a triumph mechanically as well as artistically—the casting and chasing being as fine as could have been done even in Europe. . . . It is to be regretted that the cost of this work in bronze must necessarily limit the

profitable chord, including *Union Refugees* (fig. 6.6), also displayed at the National Academy in 1863, which depicts a White Southern Unionist family. For Ward, however, plaster remained an intermediary medium, a transactional means to a high-art end. Furthermore, plaster statuettes such as the Rogers Groups were generally grounded in sentimental, time-based storytelling, whereas Ward preferred a nonspecific liminal approach; the figure's liberation is incomplete (indeed, as the sculptor wrote in 1863, "the struggle is not over with him").[8] A *New York Times* reviewer for the 1863 National Academy exhibition aptly distilled why Ward ultimately opted for the permanence of bronze: "The work has been

inspired by a mind ambitious of the higher reaches of the sculptor's art."[9]

Perhaps for that reason, along with a hiatus in the steady casting of fine art bronze during the Civil War years, Ward experimented in the realm of popular commercial distribution just once during the 1860s. He engaged with illustrator Felix Octavius Carr Darley to produce a relief portrait of Union general George B. McClellan on horseback (fig. 6.7).[10] Darley created a design drawing that Ward translated to sculptural form; a patent was issued to James F. Drummond of New York on January 15, 1864.[11] The relief was produced in two heights, and in silver or bronze with accompanying frames, a collectible for the presidential election of 1864 when McClellan mounted an unsuccessful effort to unseat Abraham Lincoln.

What we know about the earliest bronze casts of *The Freedman*, which appeared concurrently with the production of the *McClellan* relief, may be gleaned from correspondence. Of the eight located bronzes, four (Amon Carter Museum of American Art, see fig. 1.1; Boston Athenaeum, see fig. 6.1; Cincinnati Art Museum; and Detroit Institute of Arts) almost certainly date to the earliest years of the casting sequence, yet none may be tied to specific records or assigned to a certain foundry. A bill from L. A. Amouroux of December 1864 is itemized and lists two "bronzed" casts on October 8 and December 3, each at a cost of $150. A second bill from the Ames Manufacturing Company dating to June 1866 is for one cast at $105, a significant reduction in price from the two Amouroux casts.[12] Again, because these four earliest casts do not have foundry marks, whether any of these are the same as those listed in the foundry records is not possible to ascertain. Nor is the number of total casts from this early period of the 1860s. The esteemed critic Henry T. Tuckerman noted

6.6 John Rogers (1829–1904), *Union Refugees*, 1863, painted plaster or terracotta, 11 × 22½ × 12½ in., Gift of Mr. Samuel V. Hoffman, New-York Historical Society, 1929.111

6.7 John Quincy Adams Ward (1830–1910), *General George B. McClellan*, 1864, 18 × 18 in., The Metropolitan Museum of Art, Gift of Donna Hassler, 2015, 2015.755

in his *Book of the Artists* that Ward modeled and "made six copies in bronze" in 1863; the casting date may be refuted by these foundry records, but the edition size is plausible.[13] It is corroborated by Ward himself, who wrote in 1900 that "five or six copies only were made in bronze by subscription,"[14] meaning that patrons commissioned individual casts from him rather than purchasing them through retail establishments or other third parties.

The names of some of these early patrons are documented, but only one is connected to a located cast: that belonging to James Morrison Steele MacKaye, now at the Detroit Institute of Arts. Years later, Ward referred to him as "one of the original subscribers."[15] The sculptor sent a cast of *The Freedman* to George E. Baker at the Department of State in Washington, DC, in January 1864, but it is unconfirmed whether it was a plaster or a bronze.[16] Jessie Benton Frémont, wife of explorer, US general, and

politician John C. Frémont, and herself an abolitionist activist, commissioned a cast (see fig. 5.5). Correspondence suggests that a fragment from a rebel cannon used to vanquish the African-American Fifty-Fourth Massachusetts Infantry Regiment at Fort Wagner in July 1863 was used in the production of the Frémont cast, an embodiment of the sacrifice made by free Black men to emancipate the enslaved (see Walker, pp. 80–87).[17] And when John J. Barton, a Cincinnati art dealer, received a bronze in 1866, he expressed pleasure at its quality and determined to exhibit it "to give Cincinnati public a chance to find out, that some things may be done, as well as others, without crossing the Atlantic."[18]

That Ward wanted to facilitate the steady and high-quality production of *The Freedman* is evidenced in L. A. Amouroux's entry of October 8, 1864, for a "pattern" or pin model for $100.[19] The investment in a bronze pattern for use during the sand-casting process was shrewd as softer plaster casts wear down after several molds because the bronzes have been pulled from their surfaces. Pattern models retain crisp detail and accurate scale with metal pins at the joins that secure multiple pieces from which elements are cast separately in piece molds and then assembled during the finishing process. Ward had produced a pattern for *The Indian Hunter* (American Academy of Arts and Letters), and he did so for *The Freedman* as well; many years later his stepdaughter-in-law recalled the model came apart in three pieces.[20] Casts made from pattern models maintain consistency in scale and detail; indeed, the earliest located *Freedman* bronzes share remarkable attention to surface texture—in the veining of the man's hands and limbs and the loincloth around his waist, for example. Interestingly, this conformity does not extend to the exact

recording of the signature and date on the front of *The Freedman*'s base, or more significantly, to the positioning of the shackles and the number of visible chain links. No two bronzes are the same in this regard, indicating that those elements were determined more spontaneously at the time of casting and finishing.

While Ward did not produce an unlimited commercial edition of *The Freedman* for popular distribution, he did promote it as a signature work, one with which his name soon became synonymous. Bronze casts of *The Freedman* were exhibited regularly through the late 1860s. After early showings in New York and Philadelphia, additional exhibitions in pro-Union cities with robust local art communities proved an effective means of circulating the sculptor's name to an expanded audience for bronzes "for sale," including those in Boston (1864), Chicago (1865), Philadelphia (1865), and Cincinnati (1868).[21] Most significant was the inclusion of a bronze cast in the Exposition Universelle in Paris in 1867, a world's fair that included American sculpture by expatriate Harriet Hosmer and US-based John Rogers, Launt Thompson, and Leonard Wells Volk. For Ward, his entrée onto the international stage was significant for he showed both *The Freedman* as well as the full-scale bronze *Indian Hunter*.[22] That enlargement, with certain details remodeled from the statuette, was cast by L. A. Amouroux in 1866 and unveiled in Central Park in 1869, having been funded through subscription.

Critics aspired for *The Freedman* to serve as a public symbol of freedom, equating success with enlarged scale. For instance, James Jackson Jarves observed in 1864 upon seeing *The Freedman* statuette: "It is the hint of a great work, which, put into heroic size, should become the companion of the Washington of our nation's Capitol, to commemorate the crowning virtue of democratic institutions in the final liberty of the slave."[23] Paired with Horatio Greenough's seminude *George Washington* (1840; now Smithsonian American Art Museum), a government-commissioned icon of national independence, *The Freedman* was envisioned by Jarves as a commemorative marker of personal liberation.

Whether Ward ever intended to scale up *The Freedman* to a life-size monument, as he did successfully with *The Indian Hunter*, is not documented. He had aspired to secure a commission to enlarge his earlier plaster statuette of Midwest settler-colonizer Simon Kenton (1857; Cincinnati Art Museum) while he was in Ohio in 1860–61, but plans were scuttled by the onset of the Civil War. Timing for *The Freedman* would have also been a factor, as would funding support, whether public or private. Perhaps Ward recognized, as Freeman Henry Morris Murray succinctly put in 1916: "This was a statuette only twenty inches high but it embodied large ideas. . . . There is no work in American sculpture which has a higher claim to be profound."[24] Furthermore, as scholar Kirk Savage has astutely noted, Ward opted to work at a smaller scale that invited compositional experimentation and departed from customary representations of Black men as kneeling and subservient (see fig. 1.3): "this allowed the work to acknowledge more frankly the obvious questions of emancipation's prospects."[25] It remains an interesting case study in whether bigger is necessarily better or more impactful as a vehicle to express in three dimensions the theme of African-American emancipation.

By the early 1870s, Ward's career as a monumental sculptor was flourishing, buoyed by the popular impulse to commemorate Union heroes and martyrs as well as significant historical and modern-day

figures. He completed portrait busts of American luminaries of commerce as a means to generate income and please patrons, but he turned away from producing editioned statuettes or casting *The Freedman* again in bronze until the early 1890s. In a letter that Ward wrote to Ames in 1871, he stated that he was contemplating creating plaster replicas of *The Indian Hunter* and *The Freedman* but no longer had the original piece molds. He asked for the return of the bronze patterns (with "*all the parts*") so that he could take molds off them to produce plasters.[26] That additional plasters were cast at an unknown date is verifiable; for instance, one (now unlocated) was presented to New York University in 1922 by Ward's widow as part of the Ward Memorial Collection.[27]

The Freedman was cast in bronze by at least three American foundries during Ward's lifetime, L. A. Amouroux and Ames Manufacturing Company during the 1860s, and after a hiatus of more than two decades, Henry-Bonnard Bronze Company in New York.[28] Established around 1872, that foundry grew to dominant status during the 1880s and '90s, providing a reliable alternative to casting bronze sculpture in Europe, notably producing works of a monumental scale. This firm, like others, employed European immigrants who collectively brought the skills for the many steps of sand-casting from mold making to chasing and patination. Ward was one of Henry-Bonnard's most prominent and consistent clients, collaborating with the foundry to produce several major public commissions, among them *George Washington* (1883; Federal Hall, New York) and *The Pilgrim* (1884–85; Central Park, New York).

Ward engaged with Henry-Bonnard to produce additional bronze casts of *The Freedman*; the two located ones are at the Metropolitan Museum of Art (1891) and the National Academy of Design (1899). The production of a bronze statuette in 1891 corresponds exactly to Henry-Bonnard's well-publicized casting of the monument to Henry Ward Beecher (1891; Cadman Plaza, Brooklyn), which has at its base a subsidiary figure of a girl, one of at least two African-American subjects Ward completed following *The Freedman*. Like the seminude *Freedman*, this girl is not empowered— she is a roughly clothed participant who acknowledges Beecher's role in the abolitionist movement by placing a palm branch at his feet.

In positing why Ward returned to casting *The Freedman* in the early 1890s, it is also worth considering that his relationship with the sculpture may have morphed from reputation-establishing to legacy-building. The casting date also aligns to a period of rising interest in producing small bronzes in unlimited editions—both in the US and France—to generate additional income. By the late 1890s, Ward was fully engaged with this strategy as was Henry-Bonnard, which published a catalogue of available small bronzes ranging from contemporary American and French reliefs and statuettes to copies after the antique (fig. 6.8). It records that *The Freedman* was available for purchase for $300, as were *The Indian Hunter* ($325) and a paperweight, *Head of a Black Man* ($5), available mounted either on marble or brass (fig. 6.9).[29] Freeman Henry Morris Murray enticingly asserted of *The Freedman* in 1916: "Soon the demand became so great that a company of metal founders began turning out the statuettes in bronze by the dozens; though at a cost of several hundred dollars each."[30] Yet with just two located Henry-Bonnard *Freedman* casts, that number may speak to a relative lack of ongoing commercial interest in subjects treating the

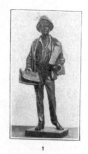

I **Newsboy.**

Statuette, by Caspar Buberl.
Height, 20 inches.

$60.00

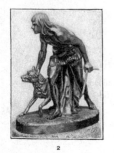

2 **Indian Hunter.**

Group, by J. Q. A. Ward.
Height, 17 inches.

325.00

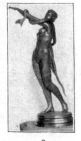

3 **Snake-charmer.**

Original bronze made for the
Emperor of Germany.
Statue, by Robert Toberentz.
Height, 39 inches.

275.00

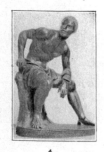

4 **"Emancipation."**

Statuette, by J. Q. A. Ward.
Height, 20 inches.

300.00

5

6.8 *Bronzes d'Art, The Henry-Bonnard Bronze Company*, n.d. [ca. 1899], p. 5., Courtesy of the Smithsonian Libraries and Archives, Washington, DC

theme of African-American emancipation. As a sculpture dating to a significant historical moment, *The Freedman* garnered consistent respect in treatments of Ward's career and the establishment of an American sculptural history, but as an object of consumer desire, its moment seems to have passed. Its ongoing personal importance to Ward is evidenced in his gift of the 1891 cast to architect and occasional collaborator Charles Rollinson Lamb in 1909, presumably having kept it for himself before then.[31] Likewise, the sculptor presented the 1899 bronze to the National Academy of Design as a replacement for his original diploma presentation, a requirement for artists upon their election as Academician.[32]

While sand-cast bronzes are generally assembled from multiple pieces, lost-wax casts are usually of one piece with any additional elements added during the finishing process (e.g., the chain links dangling from the freedman's shackles). French foundries had undertaken lost-wax casting to some degree of success by the 1880s in addition to sand-casting, while the latter was practiced exclusively in the US between the late 1840s and the late 1890s. Only one of the eight located *Freedman* bronzes is cast in this method (Art Institute of Chicago), so one possible scenario for its facture is that it was produced by Henry-Bonnard then, which advertised its capability to do so.[33] Alternatively, it may have been cast after the turn of the twentieth century by Henry-Bonnard or another foundry when the lost-wax method gained prominence in the US. The cast bears no foundry mark and carries an alternative version of the signature: "J. Q. A. Ward. Scp. 1863," rather than the customary "Sc."[34]

Like other sculptors of his day, Ward was concerned about spurious replication of his models by unauthorized parties. While

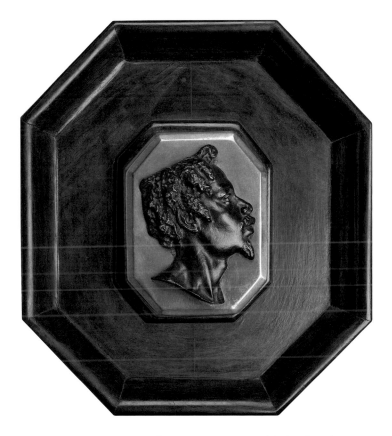

6.9 John Quincy Adams Ward (1830–1910), *Head of a Black Man*, 1898, bronze on brass and wood mount, relief: 4 × 3 in., mount: 5 × 3¾ in., Smithsonian American Art Museum, Gift of Janis Conner and Joel Rosenkranz, New York, 2012.69A-B

involvements and distinctions. His widow, Rachel Ostrander Smith Ward—likely following the example of Augusta Saint-Gaudens and Eva Remington, whose husbands Augustus and Frederic had died in 1907 and 1909, respectively—sought to establish his posthumous reputation by casting small works, exhibiting them, and attempting to place them in institutional settings.[36] It was at this point that *The Freedman* took on an enhanced role as a shaper of Ward's artistic legacy. By December 1910, Rachel Ward contracted with Gorham Manufacturing Company of Providence, Rhode Island, to sand-cast bronzes from eight small-scale models—some were reductions after such monuments as *William Shakespeare*, *George Washington*, and *Henry Ward Beecher*; others like *Simon Kenton* and *The Freedman* never were enlarged. Gorham records note that each sculpture received a Q serial mark, its unique system of cataloguing its models that was often inscribed on individual bronze casts; for instance, *The Freedman* is QGG.[37] It is not known how many Gorham casts of *The Freedman* may have been produced beyond the one at the American Academy of Arts and Letters. Rachel Ward put it on deposit there before 1923 and bequeathed it upon her death in 1933, along with a large collection of Ward artworks and memorabilia.[38] But there are tantalizing clues that additional authorized casts of *The Freedman* may one day surface. A case in point is an undated photograph (fig. 6.10) with casts of *The Indian Hunter*, *The Freedman*, and *William Shakespeare* displayed in the Athens, Ohio, home of Rachel Ward's close friend, the classicist scholar Anna P. McVay. As additional bronzes may surface in coming years, they will not only enhance our understanding of the casting history of this remarkable sculpture but also play a role in how we shape and reshape our views of it.

copyright restrictions established at the turn of the twentieth century offered greater protections to sculptors and their estates, it remained an unavoidable challenge to monitor illicit production. Ward was aware of the possibility that pirated casts of *The Freedman* were being produced in France. In 1900, he wrote James J. Robinson, the owner of the cast now at the Detroit Institute of Arts and for a time in Paris: "Some one informed me . . . that copies were being made in Paris, but I could not ascertain that such was the case." Robinson hastily replied, "I take pleasure in being able to assure you that this piece, at least, is not one of the Paris forgeries."[35]

When Ward died on May 1, 1910, at the age of seventy-nine, he was eulogized for his contributions as a monumental sculptor as well as for his many professional

LOCATED CASTS OF *THE FREEDMAN*

American Academy of Arts and Letters, New York

1863; cast 1910 or after (by 1923)
Bronze, 19½ × 14¼ × 7¼ in. (49.5 × 36.2 × 18.4 cm)
Signed and dated (front of base): J. Q. A. WARD. Sc./ 1863
Foundry mark (back of base): GORHAM CO. FOUNDERS
Provenance: Rachel Ostrander Smith Ward, 1910 or after; on deposit, American Academy of Arts and Letters, by 1923; Rachel Ward bequest to American Academy of Arts and Letters, 1933

This bronze is an authorized posthumous cast produced at Gorham Manufacturing Company in 1910 or soon thereafter. Ward was a founding member of the American Academy of Arts and Letters in 1898, and his widow, Rachel Ward, bequeathed this cast and numerous other items to this organization in 1933.

Amon Carter Museum of American Art, Fort Worth, Texas

1863; cast 1860s
Bronze, 19¾ × 14¼ × 10½ in. (50.2 × 36.2 × 26.7 cm)
Signed and dated (front of base): J. Q. A. Ward. Sc/ 1863
Inscribed (across arch of shackle): FORT WAGNER JULY 18TH 1863; (across barrel of shackle): 54th Mass. / Colored Vols
Provenance: Dr. Zelma Watson George, Cleveland, OH, d. 1994; her sister Vivien Edwards, Cleveland, OH, until 1996; [Cleveland, OH auction, 1996]; David Enochian, Chardon, OH; [Sotheby's, 3/15/2000, lot 71, not sold]; [Conner-Rosenkranz, New York, 2000]; Amon Carter Museum of American Art (2000.15)

This example differs from other casts dating to the 1860s in two distinctive ways: a brass key locks and unlocks the operable shackle, and the shackle is inscribed to the African-American soldiers of the Fifty-Fourth Massachusetts Infantry Regiment, many of whom perished in the July 18, 1863, assault on Fort Wagner, South Carolina. It is likely, but not verified, that this cast was produced for Jessie Benton Frémont, who provided Ward with a fragment from a rebel cannon used at Fort Wagner to be melted down and used for her statuette (see fig. 1.1).

Art Institute of Chicago

1863; cast probably late 1890s or after
Bronze, 19⅝ × 15¾ × 9⅜ in. (49.9 × 40 × 23.9 cm)
Signed and dated (front of base): J. Q. A. Ward. Scp. 1863
Provenance: Samuel L. Stone, Boston, mid-1940s; given by his widow to their son, Stephen Stone, Las Vegas, NV, by 1995 [purchased by Samuel Stone after 1945 and given to Stephen Stone following Samuel's death; according to letter from Stephen Stone, June 7, 1995 [copy in Art Institute of Chicago curatorial object file]; [Sotheby's, New York, May 25, 1995, lot 177]; [Conner-Rosenkranz, New York, 1995–98]; Art Institute of Chicago (1998.1)

Of the eight located *Freedman* bronzes, this cast is the only one fabricated by the lost-wax method. The earliest possible date it could have been produced in the United States is the late 1890s when Henry-Bonnard Bronze Company made protean efforts at lost-wax production. Beginning around 1900 several foundries skillfully employed this technology. This bronze features a black lacquer patina mixed with pigment and has a variant inscription with Scp. rather than Sc.

Boston Athenaeum

1863; cast 1860s
Bronze, 19½ × 14¹¹⁄₁₆ × 9⅝ in. (49.5 × 37.3 × 24.5 cm)
Signed and dated (front of base): J. Q. A. Ward. Sc. 1863
Provenance: Elizabeth Frothingham (Mrs. William L.) Parker, until 1922; gift to Boston Athenaeum (UH87)

The Frothinghams and Parkers were prominent Boston abolitionist families. It is not possible at this time to trace the provenance back to the 1860s when this finely detailed cast was produced. Its inscription varies slightly from other early bronzes with its enhanced decorative treatment of the lettering and placement of "1863" next to the signature, rather than below it (see fig. 6.1).

6.10 Statuettes by John Quincy Adams Ward, [John Quincy Adams Ward Collection], Mahn Center for Archives and Special Collections, Ohio University Libraries

Cincinnati Art Museum

1863; cast 1860s
19⅝ × 14⅝ × 7⅛ in. (49.8 × 37.1 × 18.1 cm)
Signed and dated (front of base): J. Q. A. WARD. Sc./ 1863
Provenance: Alice Keys Hollister and Mary Eva Keys, until 1921; gift to Cincinnati Art Museum (1921.502)

This cast from the 1860s descended in the Baker family, one of prominent Cincinnati lineage.[39] Although it is not possible to make a connection to this specific cast, the Baker name was associated with *The Freedman* by 1864 when Ward sent a cast to George E. Baker, and in 1868 when a John Baker lent a cast to the National Academy of Design. John S. Baker was an uncle of the donors.

Detroit Institute of Arts

1863; cast 1860s
Bronze, 19½ × 14½ × 7 in. (49.5 × 36.8 × 17.8 cm)
Signed and dated (front of base): J. Q. A. WARD. Sc/ 1863
Provenance: James Morrison Steele MacKaye, until ca. 1890; Richard Solomon Waring, Paris and Pittsburgh, ca. 1890; his daughter Anna Waring Robinson and her husband James Johnson Robinson, Lakeville, CT, by 1900; Ernest Kanzler, until 1945; gift to Detroit Institute of Arts (45.5)

The esteemed actor and playwright James Morrison Steele MacKaye purchased this cast directly from Ward in the 1860s. Mac-Kaye, a member of New York's Seventh Regiment during the Civil War, served as the model for Ward's Seventh Regiment Memorial (1869) and *William Shakespeare* (1870; both Central Park, New York). When Ward traveled to Paris in 1887, he saw this cast in MacKaye's home. Several years later it was sold through a Paris dealer to Richard Solomon Waring.

The Metropolitan Museum of Art, New York

1863; cast 1891
19½ × 14¾ × 9¾ in. (49.5 × 37.5 × 24.8 cm)
Signed and dated (front of base): J. Q. A. WARD. Sc/ 1863
Foundry mark (back of base, cursive): Cast by the Henry-Bonnard Bronze Co. / New York 1891.
Provenance: the artist, until 1909; Charles Rollinson Lamb, 1909–d. 1942; by descent in family; his grandchildren Charles Anthony Lamb and Barea Lamb Seeley, until 1979; gift to Metropolitan Museum of Art (1979.394)

This bronze is the earliest located cast produced at the Henry-Bonnard Bronze Company. Ward presented this cast to his close associate Charles Rollinson Lamb in March 1909. Lamb was an architect who designed the temporary Dewey Arch (1899; Madison Square Park, New York), for which Ward produced the quadriga *Victory Upon the Sea*. Lamb served as vice president of the National Sculpture Society at the time Ward was its president (see fig. 1.10).

National Academy of Design, New York

1863; cast 1899
Bronze, 20 × 14¾ × 7 in. (50.8 × 37.5 × 17.8 cm)
Signed and dated (front of base): J. Q. A. WARD. Sc/ 1863
Foundry mark (rear of base): THE HENRY-BONNARD BRONZE CO. / FOUNDERS. N-Y. 1899.
Provenance: the artist, 1899; NA diploma presentation replacement, ca. 1900 (126-S)

When Ward was named an Academician in 1863, he presented a plaster bust of artist Henry Peters Gray as his diploma work. It was damaged or destroyed, and Ward substituted this bronze statuette as a replacement around 1900. It was an appropriate choice as his submission of *The Freedman* in plaster to the National Academy annual in 1863 led to his elevation to Academician. Ward later served as president of the Academy in 1873–74, the first sculptor to hold that office.

Pennsylvania Academy of the Fine Arts, Philadelphia

1863
Plaster, tinted yellow ochre, 20¼ × 15 × 7 in. (51.4 × 38.1 × 17.8 cm)
Signed and dated (front of base): J. Q. A. Ward. Sculptor.
Provenance: the artist, until 1866 (on deposit, Pennsylvania Academy of the Fine Arts, 1863–66); gift to Pennsylvania Academy of the Fine Arts, 1866 (1866.2)

In April 1863 Ward sent a plaster cast to Academy board member James R. Lambdin, almost certainly the one that was exhibited in its 1863 annual exhibition. The sculptor gifted this tinted plaster in spring 1866, at which time he was elected an honorary member. The only extant plaster, and the first in the sequence of located casts, it varies from the bronzes in that there is no date inscribed on the base (see fig. 2.2).

Thayer Tolles is Marica F. Vilcek Curator of American Paintings and Sculpture at the Metropolitan Museum of Art.

NOTES

1 Barry Gray, "An Evening at the Century Club," *Boston Evening Transcript*, January 16, 1863, 1.

2 The definitive reference for Ward is Lewis I. Sharp, *John Quincy Adams Ward: Dean of American Sculpture, with a Catalogue Raisonné* (Newark: University of Delaware Press, 1985). For decorative commissions, see pp. 40–41.

3 Sharp, *ohn Quincy Adams Ward*, 41, 163; and bill, L. A. Amouroux to Ward, December 3, 1864, John Quincy Adams Ward Papers, 1800–1933, CM 544, Albany Institute of History & Art Library, Albany, NY (hereafter Ward Papers, AIHA), box 3, folder 1.

4 *Catalogue of the Thirty-Eighth Annual Exhibition of the National Academy of Design 1863* (New York, 1863), 32, no. 467, as "Freedman—Model for Bronze Statuette"; and *Catalogue of the Fortieth Annual Exhibition of the Pennsylvania Academy of the Fine Arts . . . 1863* (Philadelphia, 1863), 25, no. 394, as "Statuette—The Freedman (Model for Bronze)." This plaster cast was included in subsequent PAFA annual exhibitions in 1864, 1867, 1868, and 1869. See Susan James-Gadzinski and Mary Mullen Cunningham, *American Sculpture in the Museum of American Art of the Pennsylvania Academy of the Fine Arts* (Philadelphia: Museum of American Art of the Pennsylvania Academy of the Fine Arts, 1997), 80–81.

5 "'The Freedman.' From the Statuette by J. Q. A. Ward, N.A.," *Frank Leslie's Illustrated Newspaper*, March 12, 1864, 389.

6 "Art Notes," *New York Times*, November 19, 1864, 2.

7 See Michael Edward Shapiro, *Bronze Casting and American Sculpture, 1850–1900* (Newark: University of Delaware Press, 1985), 34–60.

8 Ward to J[ames] R. Lambdin, April 2, 1863, Albert Rosenthal Papers, 1860–1940, Archives of American Art, Smithsonian Institution, Washington, DC, microfilm reel D34, frame 1303.

9 "The National Academy of Design," *New York Times*, June 24, 1863, 2.

10 Sharp, *John Quincy Adams Ward*, 161–63.

11 Sharp, *John Quincy Adams Ward*, 161–62.

12 Bill, Ames Manufacturing Company to Ward, June 20, 1866, Ward Papers, AIHA, box 3, folder 1.

13 Henry T. Tuckerman, *Book of the Artists: American Artist Life* (New York: G. P. Putnam's Sons, 1867), 581.

14 Ward to James J. Robinson, March 5, 1900 (copy), *The Freedman* object file, Detroit Institute of Arts.

15 Ibid.

16 R[obert] S. Chilton to Ward, January 28, 1864, Ward Papers, AIHA, box 1, folder 2. Chilton and Baker were employed by the US Department of State.

17 Benton to Ward, December 23, [1865], and two undated letters, likely late 1865 and 1866, Ward Papers, AIHA, box 2, folder 3. See also Eleanor Jones Harvey, *Humboldt and the United States: Art, Nature,*

and Culture, exh. cat. (Washington, DC: Smithsonian American Art Museum, 2020), 231, 233.

18 John J. Barton to Ward, August 23, 1866, Ward Papers, AIHA, box 1, folder 5.

19 Bill, L. A. Amouroux to Ward, December 3, 1864, Ward Papers, AIHA, box 3, folder 1.

20 Marion H. Smith (Rachel Ward's daughter-in-law) to John Davis Hatch, Director, Albany Institute of History and Art, June 4, 1943, curatorial department general file for John Quincy Adams Ward, AIHA. In 2017 a pattern of *The Freedman* was sold at Fifth Avenue Estate Gallery, Boca Raton, FL, August 6, 2017, lot 53. It is not possible to determine whether that cast is the same as the pattern mentioned in archival correspondence, nor is its present location known to this author.

21 James L. Yarnall and William H. Gerdts, comps., *The National Museum of American Art's Index to American Art Exhibition Catalogues from the Beginning through the 1876 Centennial Year* (Boston: G. K. Hall, 1986), vol. 5, 3790; for the Boston showing at John Sowle Company (Sowle's Gallery), see C. K. W., "Ward's 'Freedman,'" *Liberator* 34 (December 30, 1864): 210. The catalogue *First Annual Prize Exhibition of the Philadelphia Sketch Club held at the Pennsylvania Academy of the Fine Arts* (Philadelphia, 1865), 36, no. 349, lists "The Freedman—in bronze" as "for sale."

22 Exposition Universelle de 1867, *Catalogue Général . . . Première Partie (Groupes 1 á V) Contenant les Oeuvres d'Art* (Paris: E. Dentu, 1867); reprint (New York and London: Garland Publishing, 1981), 205, no. 9, as *L'Affranchi [The Freedman]*. Works from the American section of the fair subsequently were shown at the National Academy of Design. See *Catalogue of the First Winter Exhibition of the National Academy of Design (1867–8) including the First Annual Collection of the American Society of Painters in Watercolors, and the Works from the American Art Department of the Paris Universal Exposition* (New York, 1868), 37, no. 690, as "The Freedman—bronze," owned by John Baker.

23 James Jackson Jarves, *The Art-Idea: Sculpture, Painting, and Architecture in America* (1864; New York: Hurd and Houghton, 1877, 4th ed.), 284. That the sculpture was on the steps of the US Capitol was erroneously repeated in literature; see, for instance, Clara Erskine Clement and Laurence Hutton, *Artists of the Nineteenth Century and Their Works: A Handbook Containing Two Thousand and Fifty Biographical Sketches* (Boston: Houghton Mifflin, 1880), vol. 2, 334; and Freeman Henry Morris Murray, *Emancipation and the Freed in American Sculpture: A Study in Interpretation* (Washington, DC, 1916), 196–97, which acknowledges and clarifies the error.

24 Murray, *Emancipation and the Freed in American Sculpture*, 12, 13–14.

25 Kirk Savage, *Standing Soldiers, Kneeling Slaves: Race, War, and Monument in Nineteenth-Century America*

(Princeton: Princeton University Press, 1997), 55; see also 64.

26 Ward to Ames, November 7, 1871, cited in Shapiro 1985, 185n20.

27 Sharp, *John Quincy Adams Ward*, 154.

28 For a broad discussion of Ward's relationships with American foundries, see Shapiro, *Bronze Casting and American Sculpture*, esp. 61–76.

29 *Bronzes d'Art* (New York: Henry-Bonnard Bronze, n.d. [ca. 1899]), 5, no. 4, as "Emancipation." Along with the *Head of a Black Man* paperweight, Ward also produced an undated paperweight of an Indigenous girl that was not included in the catalogue. See Sharp, *John Quincy Adams Ward*, 278–79.

30 Murray, *Emancipation and the Freed in American Sculpture*, 19.

31 Charles R. Lamb to Mrs. J. Q. A. Ward [Rachel Ostrander Smith Ward], March 16, 1909, John Quincy Adams Ward Papers, 1857–1915, New-York Historical Society, box 3. See also Thayer Tolles, ed., *American Sculpture in the Metropolitan Museum of Art: Volume 1. A Catalogue of Works by Artists Born before 1865* (New York: Metropolitan Museum of Art, 1999), 140–42.

32 David B. Dearinger, ed., *Paintings and Sculpture in the Collection of the National Academy of Design: Volume 1, 1826–1925* (New York and Manchester: Hudson Hills Press, 2004), 566.

33 *Bronzes d'Art* (New York: Henry-Bonnard Bronze, n.d. [ca. 1899]), 4; and Janis Conner, "Frishmuth and Her Foundries," in Janis Conner, Leah Lehmbeck, and Thayer Tolles, *Captured Motion: The Sculpture of Harriet Whitney Frishmuth, a Catalogue of Works* (New York: Hohmann Holdings, 2006), 56–57.

34 An unlocated cast stolen from the Museum of the American China Trade (now Forbes House Museum) in Milton, MA, before 1984 bears the same inscription. See Sharp, *John Quincy Adams Ward*, 154, which notes that "several deviations make its authenticity suspect."

35 Ward to James J. Robinson, March 5, 1900 (copy), *The Freedman* object file, Detroit Institute of Arts; and Robinson to Ward, March, 8, 1900, Ward Papers, AIHA, cited in Sharp, *John Quincy Adams Ward*, 155.

36 For instance, *The Freedman* and eight other sculptures by Ward were exhibited at the 1915 Panama-Pacific Exposition in San Francisco. See *Official Catalogue of the Department of Fine Arts, Panama-Pacific International Exposition* (San Francisco: Wahlgreen, 1915), 246, no. 2712. Likewise, Rachel Ward sold three bronzes to the Metropolitan Museum of Art in 1917, having promoted the ambitious idea that the museum acquire one example in reduction of each of his sculptures. See Tolles, ed., *American Sculpture in the Metropolitan Museum of Art*, XX, 144.

37 Casting records, Bronze Division of the Gorham Company Records, Archives of American Art, Smithsonian Institution, Washington, DC, microfilm reel 3680, frame 78. The models were returned to Rachel Ward on September 10, 1911.

38 Mrs. William Vanamee [Grace Vanamee], Secretary to the President, American Academy of Arts and Letters, to Rachel Ward, January 26, 1923 (copy), John Quincy Adams Ward Papers, AAAL, confirms that the cast of *The Freedman* was on deposit by that date.

39 Julie Aronson, Curator of American Paintings, Sculpture, and Drawings, Cincinnati Art Museum, to Thayer Tolles, email, October 4, 2021.

Q & A

MAYA FREELON

Is there a particular definition or concept of emancipation that holds true to you or your work?

To me, being resourceful and using recycled materials is emancipatory. I love using accessible materials and elevating them to a place of honor within the white walls of a gallery or museum. Challenging the idea of "high" and "low" art is part of my mission. I make art that is collaborative and inclusive, as well as transformational and boundary-breaking.

My grandmother used to tell me we came from a family of sharecroppers that never got their fair share. She was born in Texarkana in 1928, and I was born in Houston in 1982. We had a sacred bond. She grew up during the Great Depression and knew what it was like to need and not have. She instilled in me as a child the value of maximizing the minimal. So I use every element of tissue paper in my artwork. With the bleeding tissue paper, I developed a process I call Tissue Ink Monoprints. I also weave the pieces of paper into various sculptures. The tissue quilts help tell the evolving story of my artwork. My grandmother also emphasized the ability to know my own worth and value. She constantly reminded me that is something only I could determine.

This exhibition is landing in a moment when a global pandemic, systemic inequities of race and class, and climate precarity are front and center as we think about new futures. In what ways have current events transformed or shifted your work, if at all?

Creating tissue quilts now has even more significance for me than pre-pandemic. We are finally reentering spaces and finding new ways to connect. Folks are excited to be out and experiencing the world again in a new, interactive, and safe way. The pandemic provided an opportunity for everyone to question what's important to them. The time away from others allowed me to clarify my purpose and vision as an artist. It helped me see the power of artists and art used for political action, transformation, and healing. As a mom home with three kids out of school, it was also a challenge for me to stay financially stable when many folks were not buying art, visiting galleries, or attending speaking events. Thankfully, with the support of emergency art grants, museums, and other organizations, I didn't have to give up my passion amidst the uncertainty.

How did you come to the medium of tissue paper? Are there material qualities of the medium that continue to surprise you?

My grandmother, Queen Mother Frances J. Pierce (1928–2011), was a schoolteacher and owned a hair salon. She was also dear friends with Dr. Maya Angelou (my godmother and namesake). As a child, I spent summers with Granny Franny, and she taught me how to make something out of nothing, how to make a way out of no way, and how to make quilts piece by piece. When I attended graduate school at the School of the Museum of Fine Arts in Boston, I lived with my grandmother and one day was searching her basement for inspiration. Floor to ceiling was filled with items she had been collecting for over seventy-eight years. Confederate money, old *Jet* and *Ebony* magazines, cast-iron hot combs, books signed by James Baldwin and Alex Haley, a real treasure trove for a found-object sculptor! Then I came across a stack of assorted tissue paper that was folded in half and tucked between dusty books (following spread).

In the middle of the paper was a beautiful stain that blended all the colors together. This watermark, what many would call an accident from an old leaking pipe, changed the trajectory of my artistic career. When I asked her if I could have the stack of stained tissue paper, of course all my grandmother said was "Yes, I was saving it for you!" That moment changed my creative direction. So far, I am still amazed at how versatile tissue paper is. I'm not sure if I'll ever be done playing with it!

Maya Angelou described your work as "visualizing the truth about the vulnerability and power of the human being." What do you see as the relationship between vulnerability and power?

When I create tissue quilts, they usually start with a community workshop, and when I work with the community, tissue paper becomes a way for adults to remember their childhood and for children to explore joy and wonder. When we make something together, we are coming to the table at the same level, same ability. Without judgment there is no power dynamic. Adults need to be open and vulnerable about a process new to them, and so do children. It's important for me to start every workshop from a place of equality. Tissue quiltmaking workshops, similar to quilting bees, often bring up conversations about family, memory, storytelling, and exploring creativity. When you sit next to someone who is different from you and you begin to connect your section of the quilt to theirs, you create a bond that is beyond the physical. The combination of working together, strategic planning, excitement, and growth helps each participant leave having the shared experience of watching one tiny piece of paper grow into a quilt larger than themselves. That duality, that simultaneous strength and vulnerability, is what excites me most about working with tissue paper.

Do you think your conception of freedom is more celebratory than mournful?

Freedom is a state of mind and something to be celebrated. You can have everything money can buy and still be caged mentally, spiritually, and physically. Speaking up is freedom, and my grandmother always used to tell me "NO" is a love word and a full sentence. The freedom to say no is one of the most powerful lessons she shared with me.

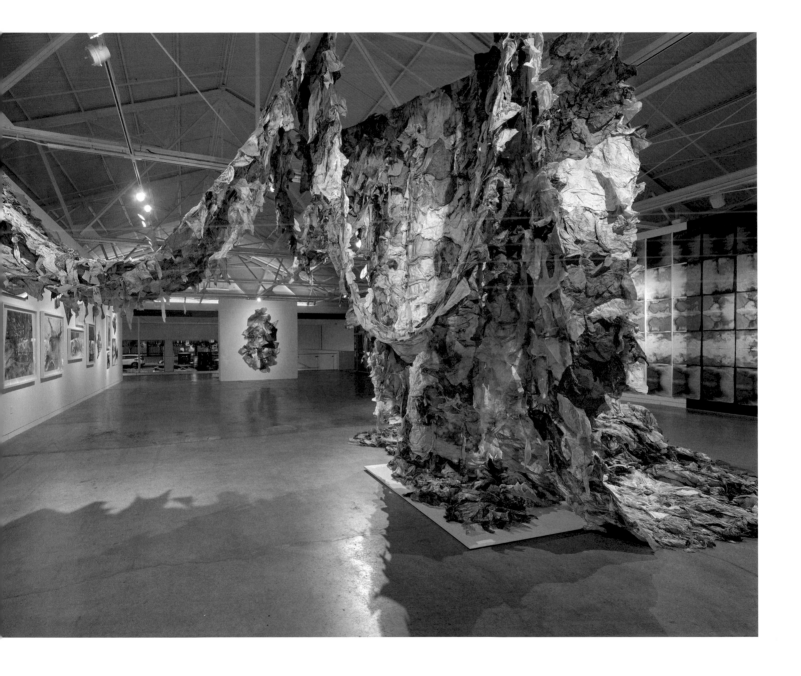

Maya Freelon, *Greater Than or Equal To*, 2020, tissue paper and adhesive, Courtesy of the artist, © Maya Freelon, Photo by Chris Ciccone

AN ANTIDOTE TO MELANCHOLY

MARGARET C. ADLER

In her renowned treatise *The Melancholy Art* (2013), scholar Michael Ann Holly writes about the psychological difficulties of the discipline of studying the past. As museum professionals, though the objects we study are physically present in our world, the work originates in a time no longer accessible to us. According to Holly, this disjunction can give rise to melancholic sentiments in historians who write about art. So why do we attempt to do so? What power or resonances are lost in the attempt to unlock history?

If given the choice, I do not believe that one of us would seek to put ourselves in the position of Ward's *Freedman*, to integrate into a society of uncertainty, war, and conflict over fundamental human rights, to interrogate White supremacy from such a tenuous and torturous position.

Yet, as made manifest by the artists you have just encountered, those oppressions are part of the realities of our moment. We can only try to understand history through our own lenses colored by our families, the injustices faced, the pathways forged by ancestors who could only dream of our successes. These artists, selected to react to and create work based on what could be thought of as an inert historical object, Ward's *The Freedman*, breathe their own breath into their objects. In so doing, they not only bring new art into the world, but they combat the melancholy so lamented by historians and fill our lungs with the breath of a new understanding of the past.

Letitia Huckaby and Sadie Barnette revive the stories of their fathers. Sable Elyse Smith evokes institutions of oppression. Jeffrey Meris and Alfred Conteh concern themselves with the decay and destruction of the body that comes from struggle. Hugh Hayden celebrates materials and craftsmanship while acknowledging the sharpness of discomfort. And Maya Freelon bombards us with the colors of hope. All of them do so with thoughtfulness, conflicted emotion, and a firm grasp of communicating through the media of paper, metal, plaster, and fabric. Very much representatives of the present moment and even future aspirations, they are the interlocutors of history, the guardians against melancholy, and the champions of artistic input into how we view our world.

Margaret (Maggie) C. Adler is curator of paintings, sculpture, and works on paper at the Amon Carter Museum of American Art.

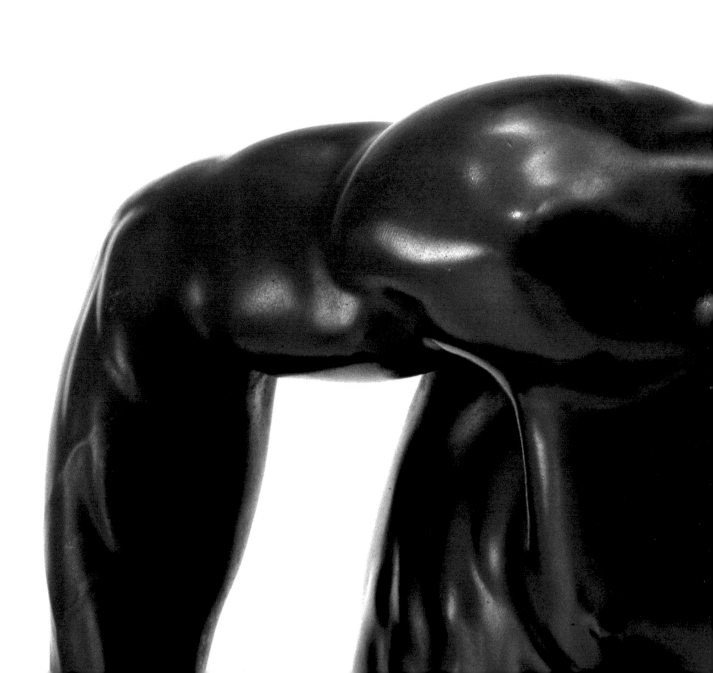

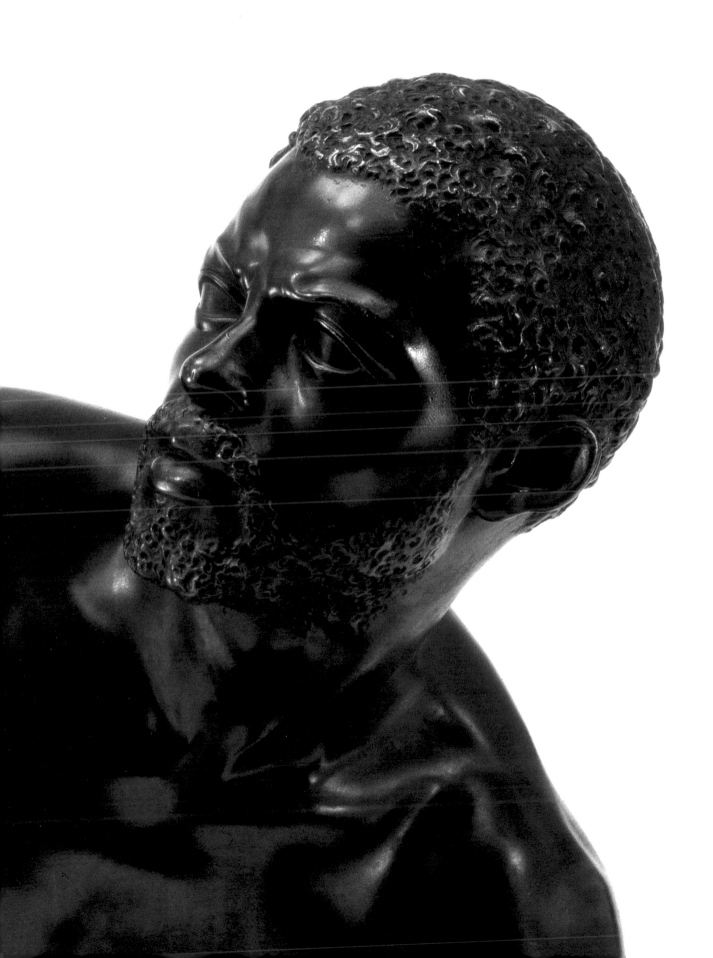

WALKING AWAKE

N. K. JEMISIN

The Master who came for Enri was wearing a relatively young body. Sadie guessed it was maybe fifty years old. It was healthy and in good condition, still handsome. It could last twenty years more, easily.

Its owner noticed Sadie's stare and chuckled. "I never let them get past fifty," the Master said. "You'll understand when you get there."

Sadie quickly lowered her gaze. "Of course, sir."

It turned the body's eyes to examine Enri, who sat very still in his cell. Enri knew, Sadie could see at once. She had never told him—she never told any of the children, because she was their caregiver and there was nothing of *care* in the truth—but Enri had always been more intuitive than most.

She cleared her throat. "Forgive me, sir, but it's best if we return to the transfer center. He'll have to be prepped—"

"Ah, yes, of course," the Master said. "Sorry, I just wanted to look him over before my claim was processed. You never know when they're going to screw up the paperwork." It smiled.

Sadie nodded and stepped back, gesturing for the Master to precede her away from the cell. As they walked to the elevator they passed two of Sadie's assistant caregivers, who were distributing the day's feed to Fourteen Male. Sadie caught Caridad's eye and signed for them to go and fetch Enri. No ceremony. A ceremony at this point would be cruel.

Caridad noticed, twitched elaborately, got control of herself and nodded. Olivia, who was deaf, did not look up to catch Sadie's signing, but Caridad brushed her arm and repeated it. Olivia's face tightened in annoyance, but then smoothed into a compliant mask. Both women headed for cell 47.

"The children here all seem nicely fit," the Master commented as they stepped into the elevator. "I got my last body from Southern. Skinny as rails there."

"Exercise, sir. We provide a training regimen for those children who want it; most do. We also use a nutrient blend designed to encourage muscle growth."

"Ah, yes. Do you think that new one will get above two meters?"

"He might, sir. I can check the breeder history—"

"No, no, never mind. I like surprises." It threw her a wink over one shoulder. When it faced forward again, Sadie found her eyes drawn to the crablike form half-buried at the nape of the body's neck. Even as Sadie watched, one of its legs shifted just under the skin, loosening its grip on the tendons there.

She averted her eyes.

Caridad and Olivia came down shortly. Enri was between the two women, dressed in the ceremonial clothing: a plain low-necked shirt and pants, both dyed deep red. His eyes locked onto Sadie, despairing, *betrayed*, before he disappeared through the transfer room's door.

"Lovely eyes," the Master remarked, handing her the completed claim forms. "Can't wait to wear blue again."

Sadie led it into the transfer center. As they passed through the second gate, the airy echoes of the tower gave way to softer, closer acoustics. The center's receiving room had jewel-toned walls, hardwood floors, and luxuriant furniture upholstered in rich, tasteful brocades. Soft strains of music played over the speakers; incense burned in a censer on the mantel. Many Masters liked to test their new senses after a transfer.

This Master gave everything a perfunctory glance as it passed through. Off the receiving room was the transfer chamber itself: two long metal tables, a tile floor set with drains, elegant mirror-glass walls, which were easy to wash and sterilize. Through the open doorway Sadie could see that Enri had already been strapped to the left table, facedown with arms outstretched. His head was buckled in place on the chin rest, but in the mirrored wall his eyes shifted to Sadie. There was nothing of anticipation in that gaze, as there should have been. He knew to be afraid. Sadie looked away and bowed at the door as the Master passed.

The Master walked toward the right-hand table, removing its shirt, and then paused as it noticed the room's door still open. It turned to her and lifted one of the body's eyebrows, plainly wanting privacy. Sadie swallowed, painfully aware of the passing seconds, of the danger of displeasing a Master, of Enri's terrible unwavering stare. She should stay. It was the least she could do after lying to Enri his whole life. She should stay and let his last sight through his own eyes be of someone who loved him and lamented his suffering.

"Thank you for choosing the Northeast Anthroproduction Facility," she said to the Master. "At Northeast, your satisfaction is always guaranteed."

She closed the door and walked away.

• • •

That night Sadie dreamed of Enri.

This was not unusual. Her dreams had always been dangerously vivid. As a child she had sleepwalked, attacked others in the confusion of waking, heard voices when no one had spoken, bitten through her lip and nearly drowned in blood. Her caregivers sent away for a specialist, who diagnosed her as something called bipolar—a defect of the brain chemistry. At the time she had been distraught over this, but the policies were very clear. No Master would have anything less than a perfect host. They could have sent her to Disposal, or the plantations. Instead, Sadie had been given medicines to stabilize her erratic neurotransmitters and then sent to another facility, Northeast, to begin training as a caregiver. She had done well. But though the other symptoms of her defect had eased with adulthood and medication, her dreams were still strong.

This time she stood in a vast meadow, surrounded by waist-high grass and summer flowers. She had only seen a meadow once, on the journey from her home anthro to caregiver training, and she had never actually walked through it. The ground felt uneven and soft under her feet, and a light breeze

rustled the grass around her. Underneath the rustling she thought she could hear snatches of something else—many voices, whispering, though she could not make out the words.

"Sadie?" Enri, behind her. She turned and stared at him. He was himself, his eyes wide with wonder. Yet she had heard the screams from the transfer room, smelled the blood and bile, seen his body emerge from the room and flash a satisfied smile that no fourteen-year-old boy should ever wear.

"It *is* you," Enri said, staring. "I didn't think I would see you again."

It was just a dream. Still, Sadie said, "I'm sorry."

"It's okay."

"I didn't have a choice."

"I know." Enri sobered, and sighed. "I was angry at first. But then I kept thinking: It must be hard for you. You love us, but you give us to them, over and over. It's cruel of them to make you do it."

Cruel. Yes. But. "Better than . . ." She caught herself.

"Better than being chosen yourself." Enri looked away. "Yes. It is."

But he came to her, and they walked awhile, listening to the swish of grass around their calves and smelling the strangely clean aroma of the dirt between their toes.

"I'm glad for this," Sadie said after a while. Her voice seemed strangely soft; the land here did not echo the way the smooth corridors of the facility did. "To see you. Even if it's just a dream."

Enri spread his hands from his sides as they walked, letting the bobbing heads of flowers tickle his palms. "You told me once that you used to go places when you dreamed. Maybe this is real. Maybe you're really here with me."

"That wasn't 'going to places,' that was sleepwalking. And it was in the real world. Not like this."

He nodded, silent for a moment. "I wanted to see you again. I wanted it so much. Maybe that's why I'm here." He glanced at her, biting his bottom lip. "Maybe you wanted to see me, too."

She had. But she could not bring herself to say so, because just thinking it made her hurt all over inside, like shaking apart, and the dream was fragile. Too much of anything would break it; she could feel that instinctively.

She took his hand, though, the way she had so often when they were alive, and alone. His fingers tightened on hers briefly, then relaxed.

They had reached a hill, which overlooked a landscape that Sadie had never seen before: meadows and hills in a vast expanse broken only occasionally by lone trees, and in the distance a knot of thick variegated green. Was that a . . . jungle? A forest? What was the difference? She had no idea.

"The others think I came here because we used to be close," Enri said, a little shyly. "Also because you're so good at dreaming. It wouldn't matter, me reaching out for you, if you weren't meeting me halfway."

Others? "What are you talking about?"

Enri shrugged. It made his shirt—the low-necked smock she'd last seen him wearing—slip back a little, revealing the smooth unblemished flesh of his neck and upper back. "After the pain, there's nothing but the dark inside your head. If you shout, it sounds like a whisper. If you hit yourself, it feels like a pinch. Nothing works right except your thoughts. And all you can think about is how much you want to be free."

She had never let herself imagine this. Never, not once. These were the dangerous thoughts, the ones that threatened her ability to keep doing what the Masters wanted or to keep from screaming while she did those things. If she even thought the word *free*, she usually made herself immediately think about something else. She should not be dreaming about this.

And yet, like picking at a scab, she could not help asking, "Could you . . . go to sleep? Or something? Stop thinking, somehow?" Pick, pick. It would be terrible to be trapped so forever, with no escape. Pick, pick. She had always thought that taking on a Master meant nothingness. Oblivion. This was worse.

Enri turned to look at her, and she stopped.

"You're not alone in it," he said. Whispering, all around them both; she was sure of it now. His eyes were huge and blue, and unblinking as they watched her. "You're not the only person trapped in the dark. There's lots of others in here. With me."

"I, I don't—" She didn't want to know.

Pick, pick.

"Everyone else the Masters have taken."

A Master could live for centuries. How many bodies was that? How many other Enris trapped in the silence, existing only as themselves in dreams? Dozens?

"*All* of us, from *every* Master, down all the years that they've ruled us."

Thousands. Millions.

"And a few like you, ones without Masters, but who are good at dreaming and want to be free the way we do. No one else can hear us. No one else needs to."

Sadie shook her head. "No." She put out a hand to touch Enri's shoulder, wondering if this might help her wake up. It felt just as she remembered—bony and soft and almost hot to the touch, as if the life inside him was much brighter and stronger than her own. "I, I don't want to be—" She can't say the word.

Pick, pick.

"We're all still here. We're dead, but we're *still here*. And"—he hesitated, then ducked his eyes—"the others say you can help us."

"No!" She let go of him and stumbled back, shaking inside and out. She could not hear these dangerous thoughts. "I don't want this!"

She woke in the dark of her cubicle, her face wet with tears.

. . .

The next day a Master arrived in a woman's body. The body was not old at all—younger than Sadie, who was forty. Sadie checked the database carefully to make sure the Master had a proper claim.

"I'm a dancer," the Master said. "I've been given special dispensation for the sake of my art. Do you have any females with a talent for dance?"

"I don't think so," Sadie said.

"What about Ten-36?" Olivia, who must have read the Master's lips, came over to join them and smiled. "She opted for the physical/artistic track of training. Ten-36 loves to dance."

"I'll take that one," the Master said.

"She's only ten years old," Sadie said. She did not look at Olivia, for fear the Master would notice her anger. "She might be too young to survive transfer."

"Oh, I'm very good at assuming control of a body quickly," the Master said. "Too much trauma would destroy its talent, after all."

"I'll bring her down," Olivia said, and Sadie had no choice but to begin preparing the forms.

Ten-36 was beaming when Olivia brought her downstairs. The children from Ten had all been let out to line the stairway. They cheered that one of their year-mates had been granted the honor of an early transfer; they sang a song praising the Masters and exhorting them to guide humankind well. Ten-36 was a bright, pretty child, long-limbed and graceful, Indo-Asian phenotype with a solid breeding history. Sadie helped Olivia strap her down. All the while Ten-36 chattered away at them, asking where she would live and how she would serve and whether the Master seemed nice. Sadie said nothing while Olivia told all the usual lies. The Masters were always kind. Ten-36 would spend the rest of her life in the tall glass spires of the Masters' city, immersed in miracles and thinking unfathomable thoughts that human minds were too simple to manage alone. And she would get to dance all the time.

When the Master came in and lay down on the right-hand table, Ten-36 fell silent in awe. She remained silent, though Sadie suspected this was no longer due to awe, when the Master tore its way out of the old body's neck and stood atop the twitching flesh, head-tendrils and proboscides and spinal stinger steaming faintly in the cool air of the chamber. Then it crossed from one outstretched arm to the other and began inserting itself into Ten-36. It had spoken the truth about its skill. Ten-36 convulsed twice and threw up, but her heart never stopped and the bleeding was no worse than normal.

"Perfect," the Master said when it had finished. Its voice was now high-pitched and girlish. It sat down on one of the receiving room couches to run its fingers over the brocade, then inhaled the scented air. "Marvelous sensory acuity. Excellent fine motor control, too. It's a bother to have to go through puberty again, but, well. Every artist must make sacrifices."

When it was gone, Sadie checked the Master's old body. It—she—was still breathing, though unresponsive and drooling. On Sadie's signal, two of the assistants escorted the body to Disposal.

Then she went to find Olivia. "Don't ever contradict me in front of a Master again," she said. She was too angry to sign, but she made sure she didn't speak too fast despite her anger, so that Olivia could read her lips.

Olivia stared at her. "It's not my fault you didn't remember Ten-36. You're the head caregiver. Do your job."

"I remembered. I just didn't think it was right that a Ten be made to serve—" She closed her mouth after that, grateful Olivia couldn't hear her inflection and realize the sentence was incomplete. She had almost added *a Master who will throw her away as soon as she's no longer new*.

Olivia rolled her eyes. "What difference does it make? Sooner, later, it's all the same."

Anger shot through Sadie, hotter than she'd felt in years. "Don't take it out on the children just because *you* can't serve, Olivia."

Olivia flinched, then turned and walked stiffly away. Sadie gazed after her for a long while, first trembling as the anger passed, then just empty. Eventually she went back into the transfer room to clean up.

· · ·

That night, Sadie dreamt again. This time she stood in a place of darkness, surrounded by the same whispering voices she'd heard before. They rose into coherency for only a moment before subsiding into murmurs again.

hereHERE this place remember show her never forget

The darkness changed. She stood on a high metal platform (*balcony*, said the whispers) overlooking a vast, white-walled room of the sort she had always imagined the glass towers of the Masters to contain. This one was filled with strange machines hooked up to long rows of things like sinks. (*Laboratory.*) Each sink—there were hundreds in all—was filled with a viscous blue liquid, and in the liquid floated the speckled bodies of Masters.

Above the whispers she heard a voice she recognized: "This is where they came from."

Enri.

She looked around, somehow unsurprised that she could not see him. "What?"

The scene before her changed. Now there were people moving among the sinks and machines. Their bodies were clothed from head to toe in puffy white garments, their heads covered with hoods. They scurried about like ants, tending the sinks and machines, busy busy busy.

This was how Masters were born? But Sadie had been taught that they came from the sky.

"That was never true," Enri said. "They were created from other things. Parasites—bugs and fungi and microbes and more—that force other creatures to do what they want."

Enri had never talked like this in his life. Sadie had heard a few people talk like this—the rare caregivers educated with special knowledge like medicine or machinery. But Enri was just a facility child, just a body. He had never been special beyond the expected perfection.

"Most parasites evolved to take over other animals," he continued. If he noticed her consternation, he did not react to it. "Only a few were any threat to us. But some people wondered if that could be changed. They put all the worst parts of the worst parasites together, and tweaked and measured and changed them some more . . . and then they tested them on people they didn't like. People they thought didn't *deserve* to think for themselves. And eventually, they made something that worked." His face hardened suddenly into a mask of bitterness like nothing Sadie had ever seen beyond her own mirror. "All the monsters were right here. No need to go looking for more in space."

Sadie frowned. Then the white room disappeared.

She stood in a room more opulent than a transfer center's receiving room, filled with elegant furnishings and plants in pots and strange decorative objects on plinths. There was a big swath of cloth, garishly decorated with red stripes and a square, patterned patch of blue, hanging from a polished pole in one corner; it seemed to have no purpose. A huge desk of beautiful dark wood stood to one side, and there were windows—windows!—all around her. She ignored the desk and all the rest, hurrying to the window for the marvel, the treasure, of looking outside. She shouldered aside the rich, heavy hangings blocking the view and beheld:

Fire. A world burnt dark and red. Above, smoke hung low in the sky, thick as clouds before a rainstorm. Below lay the smoldering ruins of what must once have been a city.

A snarl and thump behind her. She spun, her heart pounding, to find that the opulent chamber now held people. Four men and women in neat black uniforms, wrestling a struggling fifth person onto the wooden desk. This fifth man, who was portly and in his fifties, fought as if demented. He punched and kicked and shouted until they turned him facedown and pinned his arms and legs, ripping open his clothing at the back of the neck.

A woman came in. She carried a large bowl in her hands, which she set down beside the now-immobile man. Reaching into the bowl, she lifted out a Master. It flexed its limbs and then focused its head-tendrils on the man's neck. When it grew still, the woman set the Master on him.

"No—" Against all reason, against all her training, Sadie found herself starting forward. She didn't know why. It was just a transfer; she had witnessed hundreds. But it was wrong, wrong. (*Pick, pick.*) He was too old, too

fat, too obviously ill-bred. Was he being punished? It did not matter. Wrong. It had *always* been wrong.

She reached blindly for one of the decorative objects on a nearby plinth, a heavy piece of stone carved to look like a bird in flight. With this in her hands she ran at the people in black, raising the stone to swing at the back of the nearest head. The Master plunged its stinger into the pinned man's spine and he began to scream, but this did not stop her. Nothing would stop her. She would kill this Master as she should have killed the one that took Enri.

"No, Sadie."

The stone bird was no longer in her hands. The strangers and the opulent room were gone. She stood in darkness again and this time Enri stood before her, his face weary with the sorrow of centuries.

"We should fight them." Sadie clenched her fists at her sides, her throat choked with emotions she could not name. "We never fight."

I never fight.

"We fought before, with weapons like yours and much more. We fought so hard we almost destroyed the world, and in the end all that did was make it easier for them to take control."

"They're monsters!" Pleasure, such shameful pleasure, to say those words.

"They're what we made them."

She stared at him, finally understanding. "You're not Enri."

He fell silent for a moment, hurt.

"I'm Enri," he said at last. The terrible age-old bitterness seemed to fade from his eyes, though never completely. "I just know things I didn't know before. It's been a long time for me, here, Sadie. I feel . . . a lot older." It had been two days. "Anyway, I wanted you to know how it happened. Since you can hear me. Since I can talk to you. I feel like . . . you should know."

He reached out and took her hand again, and she thought of the way he had first done this, back when he had been nothing more than Five-47. She'd taken his hand to lead him somewhere, and he'd looked up at her. Syllables had come into her mind, just a random pair of sounds: *Enri.* Not as elegant as the names that the Masters had bestowed upon Sadie and her fellow care-givers, and she had never used his name where others could hear. But when they were alone together, she had called him that, and he had liked it.

"If you had a way to fight them," he said, watching her intently, "would you?"

Dangerous, dangerous thoughts. But the scabs were off, all picked away, and too much of her had begun to bleed. "Yes. No. I . . . don't know."

She felt empty inside. The emotion that had driven her to attack the Masters was gone, replaced only by weariness. Still, she remembered the desperate struggles of the captured man in her dream. Like Enri, that man had faced his final moments alone.

Perhaps he, too, had been betrayed by someone close.

"We'll talk again," he said, and then she woke up.

· · ·

Like a poison, the dangerous ideas from the dreams began leaching from her sleeping mind into her waking life.

On fifthdays, Sadie taught the class called History and Service. She usually took the children up on the roof for the weekly lesson. The roof had high walls around the edges, but was otherwise open to the world. Above, the walls framed a perfect circle of sky, painfully bright in its blueness. They could also glimpse the topmost tips of massive glass spires—the Masters' city.

"Once," Sadie told the children, "people lived without Masters. But we were undisciplined and foolish. We made the air dirty with poisons we couldn't see, but which killed us anyway. We beat and killed each other. This is what people are like without Masters to guide us and share our thoughts."

One little Six Female held up her hand. "How did those people live without Masters?" She seemed troubled by the notion. "How did they know what to do? Weren't they lonely?"

"They were very lonely. They reached up to the skies looking for other people. That's how they found the Masters."

Two caregivers were required to be with the children anytime they went up on the roof. At Sadie's last words, Olivia, sitting near the back of the children's cluster, frowned and narrowed her eyes. Sadie realized abruptly that she had said "they found the Masters." She had intended to say—was *supposed* to say—that the Masters had found humankind. They had benevolently chosen to leave the skies and come to Earth to help the ignorant, foolish humans survive and grow.

That was never true.

Quickly Sadie shook her head to focus, and amended herself. "The Masters had been waiting in the sky. As soon as they knew we would welcome them, they came to Earth to join with us. After that we weren't lonely anymore."

The Six Female smiled, as did most of the other children, pleased that the Masters had done so much for their sake. Olivia rose when Sadie did and helped usher the children back to their cells. She said nothing, but glanced back and met Sadie's eyes once. There was no censure in her face, but the look lingered, contemplative with ambition. Sadie kept her own face expressionless.

But she did not sleep well that night, so she was not surprised that when she finally did, she dreamt of Enri once more.

· · ·

They stood on the roof of the facility, beneath the circle of sky, alone. Enri wasn't smiling this time. He reached for Sadie's hand right away, but Sadie pulled her hand back.

"Go away," she said. "I don't want to dream about you anymore." She had not been happy before these dreams, but she had been able to survive. The dangerous thoughts were going to get her killed, and he just kept giving her more of them.

"I want to show you something first," he said. He spoke very softly, his manner subdued. "Please? Just one more thing, and then I'll leave you alone for good."

He had never yet lied to her. With a heavy sigh she took his hand. He pulled her over to one of the walls around the rooftop's edge, and they began walking up the air as if an invisible staircase had formed beneath their feet.

Then they reached the top of the wall, and Sadie stopped in shock.

It was the city of the Masters—and yet, not. She had glimpsed the city once as a young woman, that second trip, from caregiver training to Northeast. Here again were the huge structures that had so awed her, some squat and some neck-achingly high, some squarish and some pointy at the tops, some flagrantly, defiantly asymmetrical. (*Buildings.*) On the ground far below, in the spaces between the tall structures, she could see long ribbons of dark, hard ground neatly marked with lines. (*Roads.*) Thousands of tiny colored objects moved along the lines, stopping and progressing in some ordered ritual whose purpose she could not fathom. (*Vehicles.*) Even tinier specks moved beside and between and in and out of the colored things, obeying no ritual whatsoever. People. Many, many people.

And there was something about this chaos, something so subtly counter to everything she knew about the Masters, that she understood at once these were people *without* Masters. They had built the vehicles and they had built the roads. They had built the whole city.

They were free.

A new word came into her head, in whispers. (*Revolution.*)

Enri gestured at the city and it changed, becoming the city she remembered—the city of now. Not so different in form or function, but very different in feel. Now the air was clean, and reeked of *other*. Now the mote-people she saw were not free, and everything they'd built was a pale imitation of what had gone before.

Sadie looked away from the tainted city. Maybe the drugs had stopped working. Maybe it was her defective mind that made her yearn for things that could never be. "Why did you show me this?" She whispered the words.

"All you know is what they've told you, and they tell you so little. They think if we don't know anything they'll be able to keep control—and they're right. How can you want something you've never seen, don't have the words for, can't even imagine? I wanted you to know."

And now she did. "I . . . I want it." It was an answer to his question from the last dream. *If you had a way to fight them, would you?* "I want to."

"How much, Sadie?" He was looking at her again, unblinking, not Enri and yet not a stranger. "You gave me to them because it was all you knew to do. Now you know different. How much do you want to change things?"

She hesitated against a lifetime's training, a lifetime's fear. "I don't know. But I want to do *something*." She was angry again, angrier than she'd been at Olivia. Angrier than she'd been throughout her whole life. So much had been stolen from them. The Masters had taken so much from *her*. She looked at Enri and thought, *No more*.

He nodded, almost to himself. The whispers all around them rose for a moment too; she thought that they sounded approving.

"There is something you can do," he said. "Something we think will work. But it will be . . . hard."

She shook her head, fiercely. "It's hard now."

He stepped close and put his arms around her waist, pressing his head against her breast. "I know." This was so much like other times, other memories, that she sighed and put her arms around him as well, stroking his hair and trying to soothe him even though she was the one still alive.

"The children and caregivers in the facilities will be all that's left when we're done," he whispered against her. "No one with a Master will survive. But the Masters can't live more than a few minutes without our bodies. Even if they survive the initial shock, they won't get far."

Startled, she took hold of his shoulders and pushed him back. His eyes shone with unshed tears. "What are you saying?" she asked.

He smiled despite the tears. "They say that if you die in a dream, you'll die in real life. We can use you, if you let us. Channel what we feel, through you." He sobered. "And we already know how it feels to die, several billion times over."

"You can't . . ." She did not want to understand. It frightened her that she did. "Enri, you and, and the others, you can't just *die*."

He reached up and touched her cheek. "No, we can't. But you can."

. . .

The Master was injured. Rather, its body was—a spasm of the heart, something that could catch even them by surprise. Another Master had brought it in, hauling its comrade limp over one shoulder, shouting for Sadie even before the anthro facility's ground-level doors had closed in its wake.

She told Caridad to run ahead and open the transfer chamber, and signed for Olivia to grab one of the children; any healthy body was allowed in an emergency. The Master was still alive within its old, cooling flesh, but it would not be for much longer. When the Masters reached the administrative level, Sadie quickly waved it toward the transfer chamber, pausing only to grab something from her cubicle. She slipped this into the waistband of her pants, and followed at a run.

"You should leave, sir," she told the one who'd carried the dying Master in, as she expertly buckled the child onto the other transfer table. An Eighteen Female, almost too old to be claimed; Olivia was so thoughtful. "Too many bodies in a close space will be confusing." She had never seen a Master try to take over a body that was already occupied, but she'd been taught that it could happen if the Master was weak enough or desperate enough. Seconds counted, in a situation like this.

"Yes . . . yes, you're right," said the Master. Its body was big and male, strong and healthy, but effort and fear had sapped the strength from its voice; it sounded distracted and anxious. "Yes. All right. Thank you." It headed out to the receiving room.

That was when Sadie threw herself against the transfer room door and locked it, with herself still inside.

"Sadie?" Olivia, knocking on the door's other side. But transfer chambers were designed for the Masters' comfort; they could lock themselves in if they felt uncomfortable showing vulnerability around the anthro facility's caregivers. Olivia would not be able to get through. Neither would the other Master—not until it was too late.

Trembling, Sadie turned to face the transfer tables and pulled the letter opener from the waistband of her pants.

It took several tries to kill the Eighteen Female. The girl screamed and struggled as Sadie stabbed and stabbed. Finally, though, she stopped moving.

By this time, the Master had extracted itself from its old flesh. It stood on the body's bloody shoulders, head-tendrils waving and curling uncertainly toward the now-useless Eighteen. "You have no choice," Sadie told it. Such a shameful thrill, to speak to a Master this way! Such madness, this freedom. "I'm all there is."

But she wasn't alone. She could feel them now somewhere in her mind, Enri and the others. A thousand, million memories of terrible death, coiled and ready to be flung forth like a weapon. Through Enri, through Sadie, through the Master that took her, through every Master in every body . . . they would all dream of death, and die in waking, too.

No revolution without blood. No freedom without the willingness to die.

Then she pulled off her shirt, staring into her own eyes in the mirrored wall as she did so, and lay down on the floor, ready.

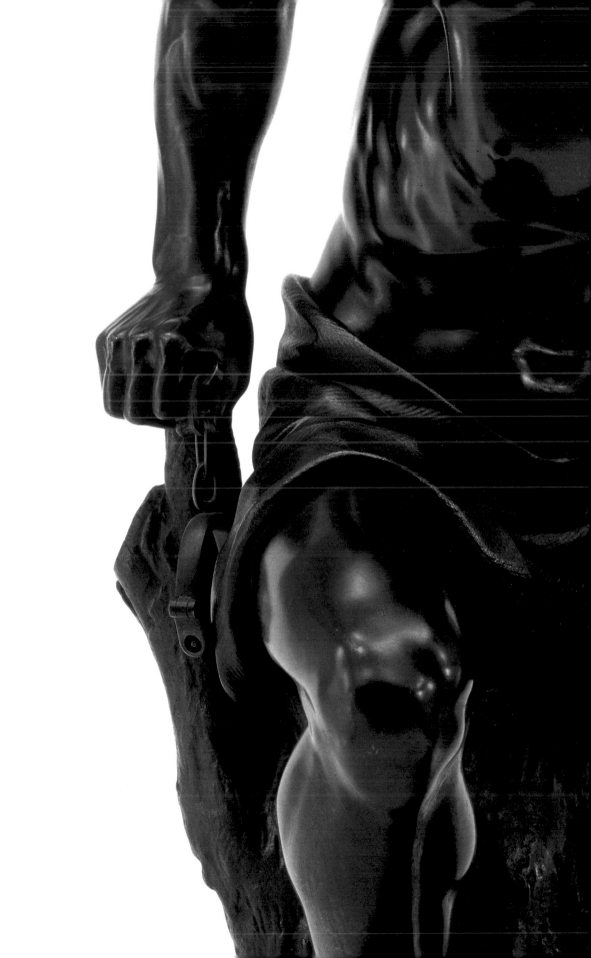

INDEX

Published on the occasion of the exhibition *Emancipation: The Unfinished Project of Liberation*, organized by the Amon Carter Museum of American Art, Fort Worth, Texas, and the Williams College Museum of Art, Williamstown, Massachusetts.

EXHIBITION DATES
Amon Carter Museum of American Art,
Fort Worth, Texas
March 12 through July 9, 2023

Newcomb Art Museum at Tulane University,
New Orleans, Louisiana
August 5 through November 11, 2023

Williams College Museum of Art,
Williamstown, Massachusetts
February 16 through June 16, 2024

Published in association with University of California Press, Oakland, California.

Library of Congress Cataloging-in-Publication Data

Names: Amon Carter Museum of American Art, organizer, host institution. | Newcomb Art Museum, host institution. | Williams College Museum of Art, organizer, host institution.
Title: Emancipation : the unfinished project of liberation
Other titles: Emancipation (Amon Carter Museum of American Art)
Description: Fort Worth : Amon Carter Museum of American Art, [2023] | Includes bibliographical references and index.
Identifiers: LCCN 2022038230 | ISBN 9780520393301 (hardcover)
Subjects: LCSH: Liberty in art—Exhibitions. | Art and race—Exhibitions. | Ward, John Quincy Adams, 1830–1910. Freedman—Exhibitions. | Slaves—Emancipation—United States—Exhibitions. | Sculpture, Black—Exhibitions.
Classification: LCC NB1952.L53 E43 2023 | DDC 730.973--dc23/eng/20220928
LC record available at https://lccn.loc.gov/2022038230

The Amon Carter Museum of American Art was established through the generosity of Amon G. Carter Sr. (1879–1955) to house his collection of paintings and sculpture by Frederic Remington and Charles M. Russell; to collect, preserve, and exhibit the finest examples of American art; and to serve all communities through exhibitions, publications, and experiences devoted to the celebration of American creativity.

Amon Carter Museum of American Art
3501 Camp Bowie Blvd.
Fort Worth, Texas 76107
cartermuseum.org

FOR THE AMON CARTER MUSEUM OF AMERICAN ART
Selena Capraro / Associate Registrar
Will Gillham / Editor and Publisher
Paul Leicht / Photographer
Steve Watson / Imaging and Digital Asset Manager

Produced by Lucia|Marquand, Seattle
luciamarquand.com

Edited by Will Gillham
Designed by Thomas Eykemans
Typeset by Brynn Warriner in Halyard, designed by Joshua Darden, Darden Studio
Indexed by David Luljack
Proofread by Molly Spain and Carrie Wicks
Color management by I/O Color, Seattle
Printed and bound in China by Artron Art Group

Cover image and all details of *The Freedman* throughout are of the cast at the Amon Carter Museum of American Art.